THE WORLD'S WORST

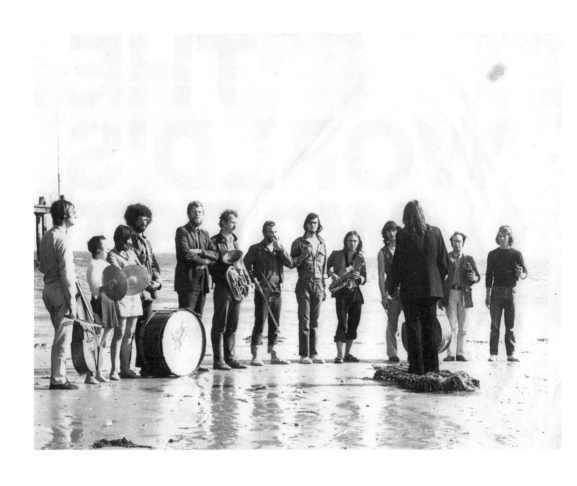

The Portsmouth Sinfonia on Southsea Beach, in their earliest known photograph. This image was used for the 1970 Portsmouth College of Fine Art Diploma show. **(L–R)** Noel Forster, Marilyn Ryan, unidentified, Robin Mortimore, Maurice Dennis, Gavin Bryars, Gary Rickard, unidentified, James Lampard, Pete Clutterbuck, John Farley (back to camera), Adrian Rifkin, unidentified. Photographer unknown. Courtesy of Gavin Bryars.

THE WORLD'S WORST

A Guide to the Portsmouth Sinfonia

Edited by Christopher M. Reeves and Aaron Walker

SOBERSCOVE PRESS | CHICAGO

Soberscove Press
Chicago, Illinois
soberscove.com

The publisher greatly acknowledges permission granted to reproduce the copyrighted
materials in this book. Every effort has been made to contact copyright holders and to obtain
their permission for the use of copyrighted material. The publisher apologizes for any errors or
omissions in the credits herein and would be grateful if notified of any corrections that should
be incorporated in future reprints and editions of this publication.

In many images, there are unidentified individuals. Please contact the publisher if you can
identify anyone who is currently unidentified; this information will be incorporated into future
reprints and editions. In addition, if you performed with the Sinfonia and are not included in
the list of members at the back of the book, we will happily add your name to the list in future
reprints and editions.

Additional information about the Portsmouth Sinfonia can be found at portsmouthsinfonia.com.

ISBN 978-1-940190-23-5
Library of Congress Control Number: 2019953104
The World's Worst: A Guide to the Portsmouth Sinfonia
Edited by Christopher M. Reeves and Aaron Walker

Design: Aaron Walker
Printed in Lithuania

Distributed by
ARTBOOK | D.A.P.
75 Broad Street, Suite 630
New York, NY 10004
artbook.com

CONTENTS

FOREWORD

Gavin Bryars

When I was awarded a music professorship in 1987, the *Times Higher Education Supplement* ran an article in which it praised the courage of the institution in elevating someone who had founded the Portsmouth Sinfonia to this position.

I had taught at Portsmouth Art College from January 1969 to the summer of 1970, doing music projects with visual arts students. We worked on experimental performances—verbal and graphic notations, realisations of Fluxus pieces, and events where the students devised remarkable things beyond anything a musician might have attempted. But in May 1970, we decided to do different performances. Someone had the idea that we'd have a day called *Opportunity Knocks*, based on the TV show talent contest hosted by Hughie Green. There were five of us talking together in the college's hall: myself, Robin Mortimore, Gary Rickard, James Lampard, and Ivan Hume-Carter. Someone has said that Ivan was painting the college piano white, though I'm not sure about this. Ivan did all sorts of projects, though—one I recall was *Make More Noise*, which involved him running through the college, pursued by John Farley and screaming at the top of his voice.

I don't think it was any one of us in particular, but we somehow collectively decided that we should have an orchestra, a proper one, and we formed the Portsmouth Sinfonia. The first question was: What

would we play, i.e., which instruments and what music? We chose Rossini's *William Tell Overture* not because of our love of opera, but rather because it was the theme music to the *Lone Ranger* TV series. We would only play when the fast tempo began, and of course, it would be recognisable no matter how badly we played. I put together a simple arrangement based on the piano reduction. Some people could read music a little, or at least follow the shape of the music; some people already had instruments, and others had to acquire them. I bought a euphonium from a bicycle shop, and Jimmy Lampard got a saxophone, something he'd always wanted to play. Robin bought a violin (which turned out to be quite a good one). We had three days to learn how to play the instruments, as well as work out how to play the piece. Even during the performance, as well as the score, some people had the first page of *A Tune a Day* open for their instrument, which gave basic fingerings, or the names of the strings.

And then, of course, we had to have a conductor—and we chose John Farley. John had long, flowing hair and a fantastic profile, like a picture of Chopin. He looked at photographs of the gestures of Bernstein and the facial expressions of Von Karajan, and he bought *Understanding Music* by Otto Karolyi, though he never seemed to get past the first page. He didn't understand what to do—his gestures were meaningless in terms of giving us direction—but he knew what he should look like.

Eventually the day came. We performed *The Lord is My Shepherd* with the choir, did the acrobatics, and the quartet played its Borodin—and then we performed the *William Tell Overture*. At the end of the show we were pronounced the winners—the judge was Maurice Dennis, who taught philosophy at the college by day, and played banjo in traditional jazz bands by night—and we were the hit of the show. Of course, when you win a talent competition, you come back and play again, and we tried. But by then the lips of the wind players weren't up to it, and they produced very little sound, so it was even less coherent than before.

We thought that would be it, but the college film department had a decent sound studio, so we got ourselves together and recorded the piece a few days later. Somehow, I persuaded the college to pay for a floppy single—like the insert for a magazine—and we printed a thousand to be sent as invitations to the end-of-year art show. The

baffled letter from Lyntone Recordings Ltd., the manufacturer (found in the 1972 *Music Now* programme reprinted in this book), is a classic. The records were sent to people all over the world: Leonard Bernstein, Mao Tse-Tung, Rodney Marsh (the QPR footballer), Pierre Boulez, all kinds of people. In some cases, we got a response, and in most cases nothing at all.

So, we had this one recording, and there was no plan to do anything else. But then we thought about it and thought perhaps we should do more things. This book documents the Sinfonia's remarkable history through reminiscences, documents, programmes, and archival photographs. There were many special and extraordinary occasions. One of my favourites was our performance at Wandsworth Prison, where the prison chaplain organised concerts each Sunday: for short-term inmates one weekend, and more hardened criminals the next. We played for the latter. Martin [Lewis] tells a lovely story about our pianist turning up at the wrong prison (knocking on the door at Wormwood Scrubs: "I am Sally Binding and I have come to play the Tchaikovsky Piano Concerto with the Portsmouth Sinfonia. . . ."). I loved the prison audience's response to our opening notes—"Let me out of here!"—and to an obviously wrong entry from the clashed cymbals: "Hang 'im!"

Our last performance was for West German TV in Cologne. The rock group 10cc was also to perform, but they refused to dress up in zipped-up bananas. We played "Telstar," from our *Rock Classics* album. For this cosmic music, we were placed on a set that was supposed to be Heaven, where we were surrounded by Valkyries—rather scantily dressed large German operatic ladies placed around the stage, whose bodies formed the front part of harps. . . .

Gavin Bryars
Billesdon
January 2020

PREFACE

PORTSMOUTH SINFONIA
★ **Portsmouth Sinfonia Play the Popular
Classics / Col. KC-33049**
An orchestra of fifty-odd musicians, mostly
untrained, attacks the William Tell Over-
ture, Beethoven's Fifth and seven others,
with predictably devastating results. This is
a by-product of Brian Eno's experiments
into the nature of the accident in music.
Perhaps the worst record ever made; best
dismissed as an intellectual joke. Liner
notes, however, a must-read.

So issued Frank Rose in his 1974 *Rolling Stone* review of *Portsmouth Sinfonia Plays the Popular Classics*, the first album released by the Sinfonia.[1]

Rather than undercut the ambitions of the orchestra, reviews such as Rose's became an integral part of the Portsmouth Sinfonia's appeal as a deskilled orchestra, whose working premise—that accidental mistakes could be considered a fundamental quality of the music—dismissed much of music criticism's standard tools and methods of assessment. While undoubtedly an important part of the ensemble's unexpected decade-long career, the self-styling of the Sinfonia as "the world's worst" also obscures their rather remarkable accomplishments.

Best remembered as a footnote to the careers of its more famous members, the Portsmouth Sinfonia can now be appreciated for the highly unusual artifact that it was: a populist, collectively organized project that inhabited the outré edges of avant-garde sound through its approach to music as conceptual art. Unlike many of its intellectual peers, the comedic effect of earnestly "butchering the classics" gave the Sinfonia an appeal and legibility that found them an audience well-beyond the gates of experimental and improvised music, with the ensemble even breaking into the UK Top 40 Singles Chart at the end of the 1970s with a medley of their renditions, aptly titled *Classical Muddly*.

To quote member Robin Mortimore:

> What qualities must a Sinfonia member have then? 'A passion
> for music. That's all. We have a very serious attitude to it. In some
> cases our interpretations (including wrong notes) would have
> been preferred by Beethoven, Mozart et al., over some of the slick,
> technically perfect performances we are accustomed to—just because
> it's the spirit that counts.'... So the Sinfonia's riches are manyfold.
> There is the immediate and obvious humorous anarchy of a group
> of untrained musicians playing the most precious and respectable of
> musical forms—but beyond that natural humor of dissonance, you
> may find a certain beauty and charm in hearing the world's greatest
> melodies, played with almost childlike naiveté and seriousness. You
> may find a freshness and excitement in its simplicity. Or you may not.[2]

The Portsmouth Sinfonia and their defining constraint were conceived
in 1970 by composer Gavin Bryars and thirteen students enrolled in his
complementary studies course at the Portsmouth College of Art. The
1970s found composers like Bryars pushing hardest at the boundaries
of their discipline, lecturing inside art schools and teaching courses
aimed at giving students a more general education in social and cultural
history. To quote composer Jolyon Laycock, "The challenge of these
courses was to find ways of working with students who were musically
unskilled but eager to encounter new and experimental ideas."[3]

With its open-door policy and expansive membership, the ranks of the
Sinfonia included individuals now synonymous with the development
of British psychedelia and glam (Brian Eno), minimalist music (Gavin
Bryars), aleatoric music (Michael Parsons), and free improvisation
(Steve Beresford). The story of the Sinfonia, though tied to a remarkable
who's who of artists and musicians working in and around London
at that time, also emerged from European creative music-making
traditions that stretched back to include composers like Gustav Holst
and Benjamin Britten, both of whom took interest in writing music
for children and amateur performers, as well as Zoltán Kodály, who
was committed to public musical literacy and hands-on instruction.
Although often read as performing the punchline to a one-liner joke, the
Sinfonia built upon a preexisting strain within British composition—an
interest in collaborative music education, in which the composer and
ensemble work together to construct compositions.

The World's Worst: A Guide to the Portsmouth Sinfonia aims to bring the Portsmouth Sinfonia out of the novelty bin and beyond the footnote, looking at the milieu and achievements of the ensemble through out-of-print texts from the time, album liner notes (all still must-reads), present day interviews with members, and an original essay by Christopher M. Reeves. The story of the ensemble and its collective recollections, while seemingly a niche musical anecdote, engenders wide-ranging conversations that touch upon the legacy of interdisciplinary art pedagogy, the power of popular music, the investment necessary in order to work and learn together, and the effects of destabilizing canonization.

1 Frank Rose, review of *Portsmouth Sinfonia Play the Popular Classics, 1979 Rolling Stone Record Guide.* Copyright © Rolling Stone LLC 1979. All Rights Reserved. Used by Permission.

2 Robin Mortimore, Liner Notes from *The Best/Worst of the Portsmouth Sinfonia* (Australian repackage of *Plays the Popular Classics*, Transatlantic Records, 1977).

3 Jolyon Laycock, *A Changing Role for the Composer in Society* (Peter Lang, Bern Switzerland, 2005), p. 45.

Following: The Portsmouth Sinfonia performing at the Mermaid Theatre in London on March 10, 1974. Photograph © Doug Smith.

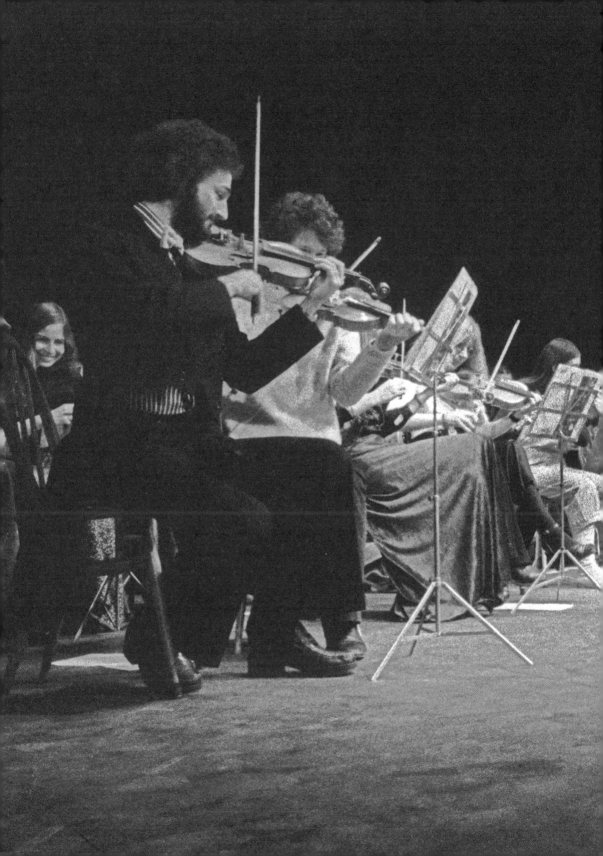

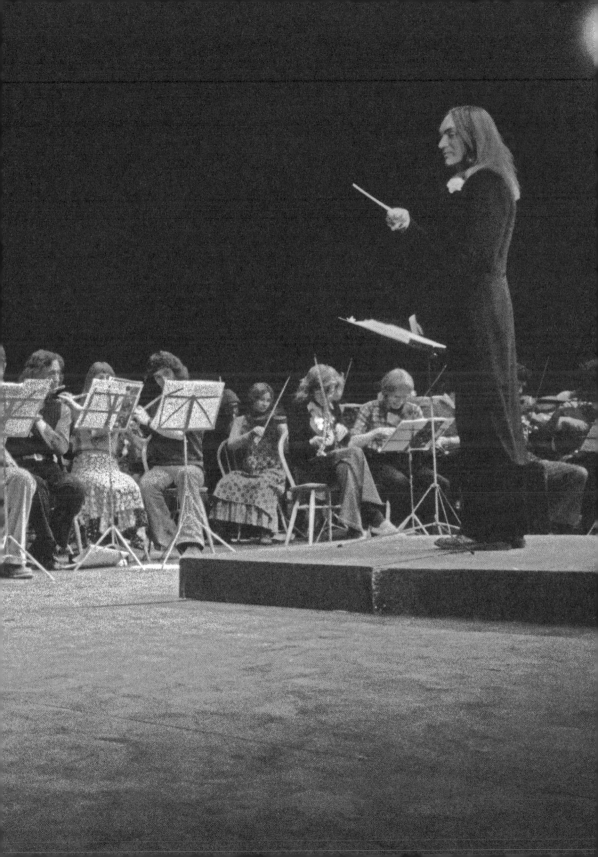

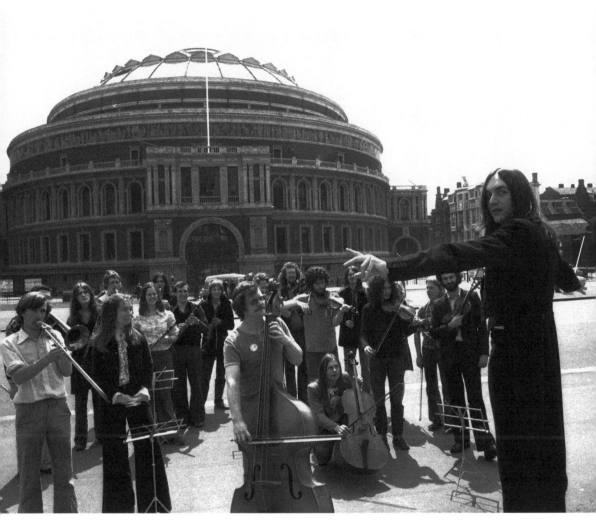

John Farley with members of the orchestra in front of the Royal Albert Hall, May 1974. Photograph © Doug Smith.

Liner Notes from
PORTSMOUTH SINFONIA
PLAYS THE POPULAR CLASSICS

John Farley (1974)

Within the collective minds of a small group of friends eager to air
a mixture of musical feelings at the College of Art, the Portsmouth
Sinfonia was first conceived, and with all opposition brushed aside,
born into the summer of 1970. Struggling to find its own path amongst
the forests of musical activities, it parted its lips, one May afternoon,
to speak for the first time. The occasion was the memorable Festival
of Light Entertainment, where the excited audience waited patiently,
wide-eyed in anticipation. Forthcoming was the very special though
vaguely recognizable rendering of *The William Tell Overture*. Through
the flushed cheeks of the brass section and unaccustomed fingering
of the violinists a certain passion and desire was evident, though
clearly, control and restraint [were] in [their] infancy. The months to
follow produced more pieces to play and more people to play them,
[as] concerts became more frequent and a deeper interest was about to
flourish.

Characteristic of the time was the precocious interpretation of
Beethoven's *Fifth* [*Symphony*] at the Purcell Room. It was for many a
high point and the Sinfonia, now compromising fourteen members,
flattered itself with the reassuring response. However, such "success"
was not allowed to outweigh and overpower more sober qualities the
Sinfonia had to accomplish. The "high seriousness" was not to be fogged
by complacent whims or pretentious eccentricities. The Sinfonia was

growing in maturity and Robin Mortimore, a found[ing] member whose unequalled devotion during the past years has proved indispensable, can be quoted as saying, "In every respect the Sinfonia plays to the same rules as the London Philharmonic, the only difference is the sound. The freshness and excitement is in its simplicity, and its concerts prove to be high entertainment." Since these early days the Sinfonia has gone from strength to strength. Few have deserted it and therefore its survival and its unique nature as a learning experience has been ensured.

Forcing itself into the future, striving for even greater heights, the Sinfonia does not lose sight of its original belief and remains faithful in allowing freedom for new members to enter [into] a musical situation which hopes to foster and encourage the evolution of a musical language enabling individuals of varying degrees of ability to participate in unearthing latent talents and undiscovered faculties which otherwise could pass unrecognized and remain hidden forever!

Liner Notes from
PORTSMOUTH SINFONIA
PLAYS THE POPULAR CLASSICS

Brian Eno (1974)

The Portsmouth Sinfonia usually claims a membership of about fifty . . .
the number fluctuates. Within the orchestra is represented the full
range of musical competence. Some members playing difficult
instruments for the first time; others, on the other hand, concert
standard. This tends to generate an extraordinary and unique musical
situation where the inevitable errors must be considered as a crucial,
if inadvertent, element of the work. It is important to stress the main
characteristic of the orchestra—that all members of the Sinfonia share
the desire to play the pieces as accurately as possible. One supposes
that the possibility of professional accuracy will forever elude us since
there is a constant influx of new members and a continual desire to
attempt more ambitious pieces from the realms of the popular classics.

My own involvement with the Sinfonia is on two levels—I am a non-
musician in the sense of never having "studied music," yet at the same
time, I notice that many of the more significant contributions to rock
music, and to a lesser extent avant-garde music, have been made by
enthusiastic amateurs and dabblers. Their strength is that they are
able to approach the task of music-making without previously acquired
solutions and without a too firm concept of what is and what is not
musically possible. Coupled with this, and consequent to it, is a current
fascination with the role of the "accident" in structured activities.

Opposite: Brian Eno (September 22, 1973). Members of the Portsmouth Sinfonia—Robin Mortimore, John
Farley, and Jim Lampard—took Eno to Bill Lewington's Music Store in London's West End to choose a
clarinet, which they presented to him as a gift in recognition of his work as producer on the first Portsmouth
Sinfonia album. Photograph © Doug Smith.

Legend has it that Beethoven, among other composers, enjoyed performances of his music by enthusiastic music-makers, who may well have possessed a similar range of abilities to those of the members of the Sinfonia. Whether he would have enjoyed our rendering of the *Fifth Symphony* is, of course, something we will never know.

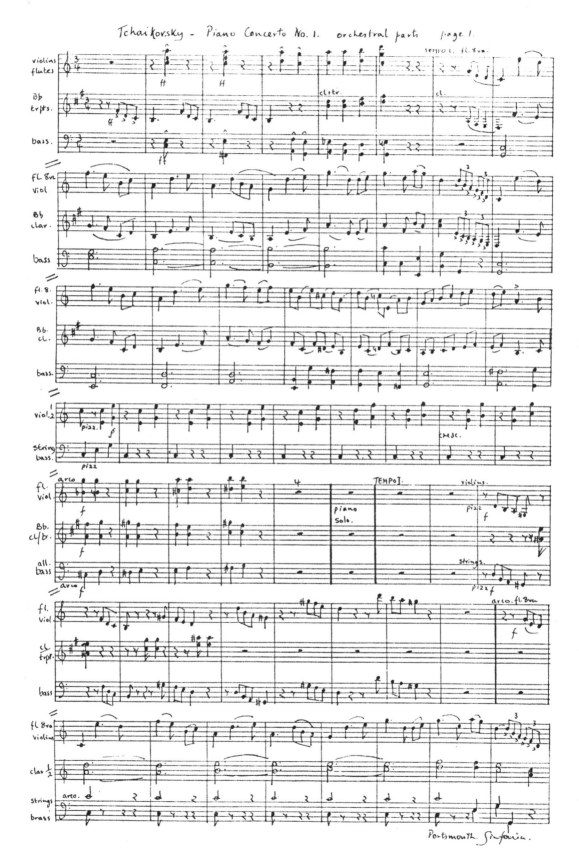

Portsmouth Sinfonia.

ROLL OVER BEETHOVEN, IT'S A CLASSICAL GAS

Charles Nicholl
Rolling Stone (March 13, 1975)

LONDON—It's been called "the funniest thing since Attila the Hun," "a magnificently decadent joke," and "a disgusting waste of time," but the Portsmouth Sinfonia, a collection of amateur musicians who are doing to the classics what Mrs. Miller did to the ballad, shrug off the insults. After bemusing English audiences with their contorted interpretations of Beethoven and Bach, the Portsmouth Sinfonia is being set up for some dates in the U.S. Founder and first violinist Robin Mortimore was a guest recently at the annual CBS conference in Los Angeles (the shrine of one of his heroes, Liberace) and brought home news of a possible concert at Carnegie Hall. Concertgoers should note that the ugly rumors which will precede the Sinfonia's stateside debut are probably all true.

The Sinfonia cultivates its self-definition as "the orchestra that can't play." The criterion for membership—currently about 40 strong—is passion rather than proficiency, enthusiasm rather than polish. For four years, the Sinfonia has been ingeniously mangling the classics in various citadels of classical pomp—most recently the Purcell Room, the Queen Elizabeth Hall, and the Albert Hall—and delighting audiences with their vigorous if approximate renditions of such favorites as Tchaikovsky's *Piano Concerto No. 1 in B-flat* (transposed to A-minor because the notation is tricky), Strauss's *Also Sprach Zarathustra*, and Beethoven's *Fifth*.

Opposite: Transposed sheet music for *Piano Concerto No. 1*. Courtesy of Suzette Worden.

Mortimore, a part-time art school teacher and the Sinfonia's spokesman, is anxious to point out that there is no element of prank or travesty intended. "We're not against good orchestras," he assures, "and we're not a caricature of a straight orchestra either. We're playing it straight and as well as we can. We're just not very good, that's all." It's natural, organic lousiness you're listening to, an unholy alliance of incompetence and showmanship. "The nearer we get, the funnier it is, somehow."

The Sinfonia is charming a remarkable number of listeners. Nearly 3,000 turned up at the [Royal] Albert Hall concert and sales of their first LP, *Portsmouth Sinfonia Plays the Popular Classics*, are around 6,000. The idea was started at the College of Art in Portsmouth. "Being at an art college," Mortimore says, "everyone was into art jokes. So we decided we should throw ourselves in at the deep end and start playing concerts." John Farley became conductor, "because I knew the least about music."

By late 1972, they had developed sufficient sham proficiency to attract a record contract with Transatlantic, and their LP was produced with Brian Eno, late of Roxy Music. Eno's involvement with the Sinfonia predates his excursion into the more metallic strata of London rock, and he is still to be seen sporting a clarinet and the ubiquitous red beret at several Sinfonia venues. "Eno was a friend right from the start," say Mortimore. "He was into a similar scene at Winchester Art School, but he was on his own there. He did concerts with 44 tape recorders; we did concerts with 44 people."

The Sinfonia's 45 RPM romp through Rossini's *William Tell Overture* was mailed out to Mao, Lennon and ex-prime minister Heath, taken back to the States by Leonard Bernstein so Pierre Boulez could bend and ear, and was distributed to all and sundry by John Cage.

Since its inception, over 80 members have passed through the ranks of the Sinfonia, and on account of this influx, Eno suggests "that the possibility of professional accuracy will forever elude us."

The motive does not seem to be pranksterish, but its effect, thinks Farley, is similarly refreshing. "The classics are becoming too familiar.

Our music makes you realize how often you listen without listening". What you are getting is all the sweat and ragged persistence that is always hidden, polished over, by professional orchestras. "Why is everyone so obsessed with trying to hide mistakes?," asks Mortimore. "Mistakes are so vital. They're part of the whole process of learning. Why shouldn't they be interesting?"

Pages 28–31: Pages from a Portsmouth Sinfonia promotional flyer, March 1973. Courtesy of Suzette Worden.

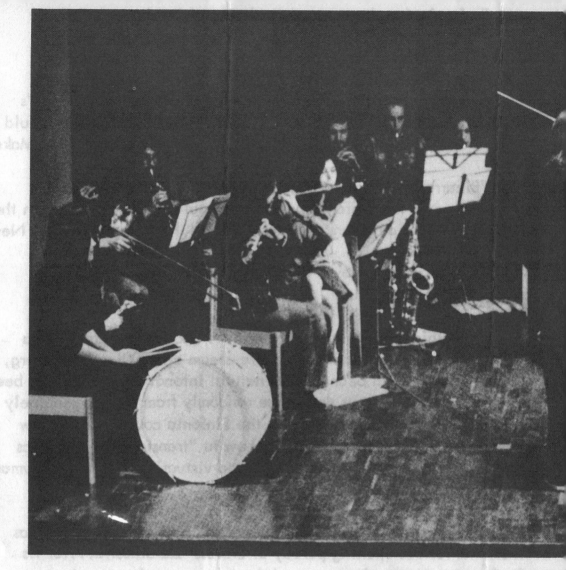

PORTSMOUT

Conductor – Jo

Violins: Jeremy Main, John Ryder, Robin Mortimore,
Tamara Steele, Michael Parsons, Russell Coates,
Joy Wadsworth, Imogen Morley, Robert Swales,
Cherill Smith, Pamela Niblett.

Viola: Simon Dale, Linda Adams. Cello: Gavin Bryars,
Gary Rickard. Bass-viol: Peter Clutterbuck,
Ian Southwood, Brian Young, Angus Fraser.

Flutes: Deborah Smith, Sue Astle, Brian Watterson.

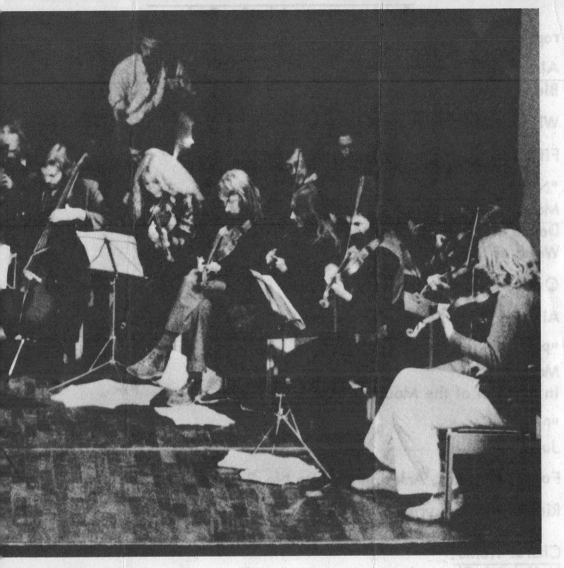

SINFONIA

arley

Saxophone, clarinet, glockenspiel; James Lampard
Clarinets; Suzette Worden, Nicky Holford, Gwen Fereday,
 Brian Eno. Bassoon: Peter Best, Tosh Potts
Trumpets; Ted Brum, Chris Turner, Steve Beresford, Barry Wills.
 French horn; Alex Potts
Euphonium; Michael Nyman, David I. Saunders
Trombones; Jeffrey Steele, Maurice Joyce, Nigel Morley,
 Dave Saunders.
Percussion; Maggie Wooton, Jenni Adams.

THE PORTSMOUTH SINFONIA
Conductor - John R. Farley.

repertoire includes:

Also Sprach Zarathustra	Richard Strauss
Blue Danube Waltz opus 314	Johann Strauss
William Tell Overture	Rossini
Fifth Symphony C minor opus 67	Beethoven
"Nutcracker Suite" opus 71a	Tchaikovsky
Marche	
Dance of the Sugar Plum Fairy	
Waltz of the Flowers	
Overture "1812" opus 49	Tchaikovsky
Air from Suite No.3 D major	J.S.Bach
"Peer Gynt" Suite No. I opus 46	Edvard Grieg
Morning	
In the Hall of the Mountain King	
"Planet Suite"	Gustav Holst
Jupiter	
Farandole from L'Arlesienne Suite No.2	Bizet
Ride of the Valkyries	Wagner

Choral Works:

Hallelujah Chorus from "Messiah", Part II	Handel
Polovtsian Dances from Prince Igor	Borodin
"Jesu, joy of Man's desiring" Cantata 147	J.S.Bach

for information contact;

Portsmouth Sinfonia or Victor Schonfield
228 Elmhurst Mansions Music Now,
Elmhurst Street 26 Avondale Park Gdn
London SW 4 01-622-7945 London WII. 01-727-1133

...."a farcical and truncated rendering of Beethoven's Fifth
by the Portsmouth Sinfonia was not even in the same class..."
Daily Telegraph.

...."a music that approaches the cosmic, and totally alters one's
aesthetic apprecation of Rossini....Suffice it to say, Rossini would
have clapped until his hands bled..." Michael Watts, Melody Maker.

...."Bizarre is almost too mild a word to use to describe the
Sinfonia....if the Sinfonia became a popular idea it would turn the
music world upside down..."Paul Mitchell, Portsmouth Evening News.

...."2001 as you've never heard it... Totally insane but quite
amazing." Frendz No.9.

...."refreshingly daft antique charm...Also Sprach Zarathustra
which would be appropriate to a pre-steam age 2001...Schonberg,
who could not even bear to hear natural intonation, would have been
horrified...the humour does arise randomly from factors genuinely
beyond the orchestra's control...the Sinfonia could indeed show
Stockhausen and Maxwell-Davies how to "transform" the classics
with far less expenditure of energy and virtuosity." Michael Nyman,
Financial Times.

...."As always the first ten minutes was hilarious, best of all was
their marvellous opening parody of Strauss' Zarathustra...for its
freshness, unpretentiousness and sheer happy exuberance it was
easily the evening's best part." Dominic Gill, Financial Times.

...."The Portsmouth Sinfonia with a highly individual approach to
the classics." Radio Times.

...."they should be given a Prom, preferably the last night..."
Brian Dennis, Musical Times.

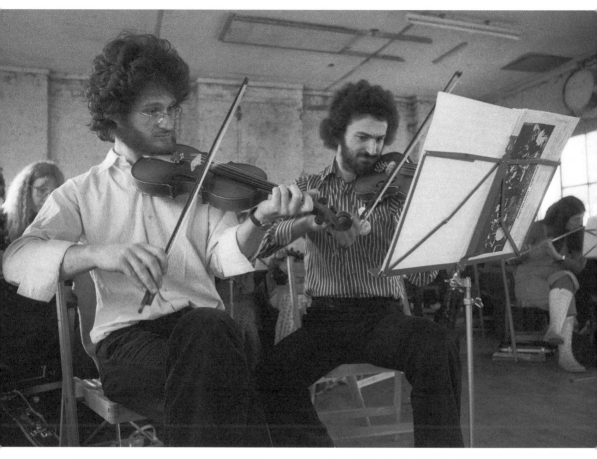

(**L-R**) Stefan Klima and Robin Mortimore at a Portsmouth Sinfonia rehearsal. Camden Town, London, 1974.
Photograph © Doug Smith.

ROBIN MORTIMORE

Violin

It was in the canteen at Portsmouth College of Art in May 1970 that
it was decided to form a "symphony orchestra." Key people in the
formation of the Portsmouth Sinfonia were having tea at the table that
day: myself, Gavin Bryars (visiting lecturer in "Experimental Music"),
and students Ivan Hume-Carter, James Lampard, John Farley, Gary
Rickard, Pete Clutterbuck, and soon Jeff Steele (Head of Fine Arts) and
Adrian Rifkin (Art History) were involved in intellectual discussions
on the idea. We decided that as many performers as possible should
arrive at the first rehearsal with an orchestral instrument—no guitars,
recorders, or toys. I went to a junk shop and bought a violin for a few
pounds (it turned out to be a Mansuy make, French c. 1750, which I
sold for a ridiculously small sum, but that's another story). I had no
musical education at all. The only other musical instrument I had was
a guitar, and like so many teenagers in the 1960s, I learned three chords
and tried to play songs by Bob Dylan and the Beatles. So a stringed
instrument seemed the right thing to get. Being one of two violins at the
first concert, I became "leader" of the orchestra by default.

By the first rehearsal, Bryars had made a simple, three-part, notated
arrangement of part of Rossini's *The William Tell Overture*. Did everyone
know that one? Yes, and that became the foundation of the Sinfonia
repertoire—popular classical themes that everyone would recognize.
We rehearsed and then performed a short *William Tell* at a college event,

a sort of *Opportunity Knocks* talent contest, and were amazed at the effect it had on the performers and audience. A bad Elvis impersonator won, and the Sinfonia came in second.

Bryars somehow got approval to record *William Tell* (in the college film studio) and pressed a floppy 45 RPM vinyl. This was sent out to promote the end of the year Diploma show to a mailing list that included Edward Heath (then Prime Minister and musician), Mao Zedong, Leonard Bernstein, and John Lennon. Probably a few hundred discs were sent out. It was claimed that the Portsmouth Sinfonia, as it now was named, was not "music for the ear alone."

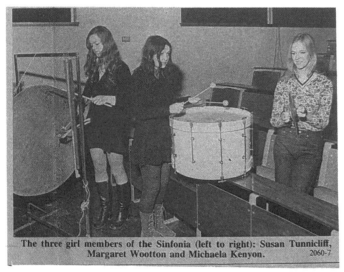

The three girl members of the Sinfonia (left to right): Susan Tunnicliff, Margaret Wootton and Michaela Kenyon. 2060-7

Portsmouth Evening News, 1971. Photographer unknown. Used with permission.

EXPERIMENTAL MUSIC CLASSES AT PORTSMOUTH

These classes were started by Bryars and I found them very interesting. For someone with no musical education, and not inspired by the fine arts courses on offer, to be exposed to John Cage, Charles Ives, Erik Satie, Robert Ashley, Christian Wolff, Terry Riley, and LaMonte Young was liberating, as was discovering [Cage's] *4'33"* and [George Brecht's] *Drip Music*—the idea of a piece with the audience not knowing when it starts or finishes (some rare performances by the Sinfonia were like this!). We had visiting lectures by George Brecht and Morton Feldman

and visits from members of the Scratch Orchestra. Bryars was a great fan of non-serious art, like the Marx Brothers and Patience Strong. I remember a class of his devoted to Lee Marvin's recording of "Born Under a Wandering Star." It seemed that Portsmouth College of Art was generating social music making of a not-too-serious attitude.

Bryars left Portsmouth and was replaced by Michael Parsons and John Tilbury, both prominent members of the Scratch Orchestra, a group that prioritized experimental and social music-making over technical abilities or conventional musical forms. In 1971–72, I organized two works by Cornelius Cardew: a complete performance of *The Great Learning*, with probably sixty performers that lasted all day in the Portsmouth Cathedral, and a performance of Cardew's graphic notation piece, *Treatise*, with Tilbury, Parsons, and Keith Rowe. We did a long version of Terry Riley's *In C*—a very influential piece at the time, and we collected seven pianos and performed piano pieces. Ivan Hume-Carter put on *The Big Noise*, which was basically as much noise as possible for a day (not very popular with college authority). My *Very Circular Pieces* were influenced by conceptual and graphic notation (i.e., *Treatise*). They were very challenging to perform and we did them for hours on end—probably until the pub opened.

The Scratch Orchestra was performing around London, mainly with Cardew's composition and encouragement, and the idea of the Portsmouth Sinfonia fit into their "new music" scene. The serious avant garde did not like the Sinfonia (but never said so to our face). It was too "popularist" and frivolous, or just downright silly. But that was the point. The Portsmouth Sinfonia was not from the Western puritanical culture of expertise, technical brilliance, or competence, which was the basis of classical music. 1950s pop culture had led young people to non-elitist music, but even pop culture could not resist the idea of technical brilliance when matured. The Sinfonia idea was possibly political, certainly democratic, social music-making. Anyone could do it. Was that valid?

A La Monte Young instruction piece could have initiated the Sinfonia—for example, "Take any piece and play it the best you can."[1] Sound was music, traditional structures and forms were not necessary, and judgement by technical ability was not interesting. Accidentals,

Following: Robin Mortimore, *Very Circular Pieces* score, 1970. Courtesy of Robin Mortimore.

very circular pieces
started in April 1970.

first performance – selections –
Thursday 3rd December 1970,
by the composer and Michael Parsons.

Robin P. Mortimore 1971.

very lengthy piece.

performers note:
play for a long time.

very nice piece

performers note:
make circle perfect.

circular piece.

silence piece.

performers note:

repeat.

performers note:

a time between two
sounds – now enter
the circle.

very long piece when
written in April 1970.

hunting piece :

performers note:

play until 2000 A.D.

performers note.

find two perfectly
spherical stones.
Don't look too hard

possibly a vocal piece.

very easy piece

almost a circular poem:-

performers note:

start in the middle.

probably a cantus:-

absolutely a sentence of sounds,
partly imperfect:-

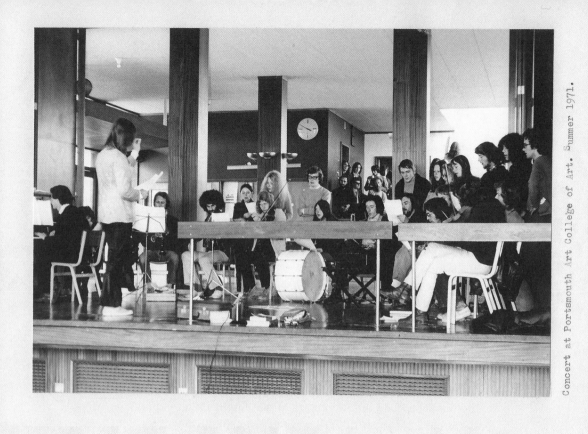

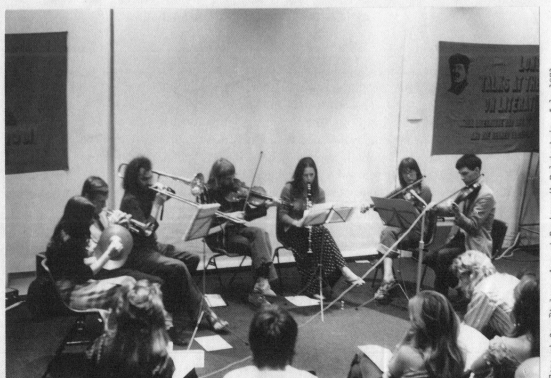

indeterminacy, and mistakes were part of the process. Each moment was unique and could not be repeated (of course, making recordings changed that). All this applied to the Sinfonia, and to that, add a disregard for tradition, instantly recognizable themes, unintentional humor, and a gentle anarchy, and the classical tradition was up for grabs. We saw the Sinfonia as a direct link to musicians like Florence Foster Jenkins and Satie (but definitely not [Gerard] Hoffnung); in the visual arts, Henri Rousseau and Alfred Wallis; in literature, to William McGonagall's poetry.

Michael Nyman wrote about us in his influential book, *Experimental Music*, and wrote an early review of the Sinfonia for the *Financial Times*. He always stayed in touch with the Sinfonia and played as often as he could. He formed the Michael Nyman Band, playing minimalist rhythmic pieces, and some members of that group played with the Sinfonia in the later days. In the early 1970s, Nyman lived close to Bryars in London, and a group of us used to meet at Queen Park Ranger FC's football ground. I remember watching football matches with George Brecht, Tilbury, and Harrison Birtwhistle. George, an American, did not get soccer, but he remarked that he liked the "chants," meaning the singing of the crowd. Tilbury and I thought he meant the "chance." He corrected us.

AFTER THE FIRST PERFORMANCE

Now what, for an orchestra with a repertoire of two minutes of Rossini? We got an offer to perform at the Beethoven Today concert at the Purcell Room of the Royal Festival Hall, London, on September 25, 1970, with the Scratch Orchestra. The concert was an "avant-garde" take on Beethoven: a string quartet played on four double basses; a piano sonata played on the tuba. Now, any classically trained musician given a chance to play in the Purcell Room would see this as a major achievement in a career after years of training and practice. This was the Sinfonia's second performance ever. We decided that the mighty *Opus 67: The Fifth Symphony* was there for the taking. Hume-Carter, Lampard, Farley, and myself somehow managed to get a version of the main themes of the first and second movements simple enough for a performance. In fact, the opening motif was enough to carry it through. This was the moment that it seemed possible that the Sinfonia was more than a one-off act.

I took on the role of organizing concerts and rehearsals. James Lampard and I did the musical direction and arrangements. Bryars always offered sound advice and had many contacts, but wanted to leave it to us (his students) to develop the idea. John Farley was a perfect conductor—just looked great in tails, waving a baton, and was an essential ingredient. While the role of conductors in the classical tradition can be mysterious to non-musicians, John was there and not there most of the time. It was best not to try to follow him—when did a piece start?—when did it finish?

Here was an orchestra of as many players as possible with any standard of musical ability aiming to play popular classics from a conventionally notated score. If one could not read music, one had to try and follow the score like a graphic notation. There was to be no improvisation, and high seriousness was needed to produce the best possible performance: as near to the original composer's intentions. So, every performance would be different, depending on the instrumental proficiency of the group and instruments available. Certainly the Royal Festival Hall had not seen anything like this before. It was anarchy and outrageous, "farcical and truncated" was our first review in the *Daily Telegraph*.

THE FINAL YEAR AT PORTSMOUTH

The founding members started their final year at Portsmouth College of Art. Surely, the Sinfonia could not become part of the curriculum. Ivan formed the Ross and Cromarty Orchestra (chamber group) from mainly Sinfonia members (including myself, James Lampard, Ian Southwood, Suzette Worden, and Michael Parsons) to perform his compositions. These were simple songs and waltzes performed by players of varying musical abilities. Ivan thought the music had both political and Scottish Nationalist messages. The RCO performed at the Edinburgh Fringe Festival in 1971 and then toured the Highlands of Scotland, performing in village halls for small (and non-existent) audiences. After this tour, Ivan left the Sinfonia for musical and personal differences. James Lampard, Ian Southwood, and I kept the idea going with a group called the Majorca Orchestra, and we started composing pieces for the group, as well as playing Edwardian chamber and theatre pieces by the likes of Ezra Read and Crawshaw Crabtree. The Majorca Orchestra rehearsed weekly and performed around London until 1978.

Opposite: Sheet music for *Also Sprach Zarathustra*. Arrangement by James Lampard and Robin Mortimore, 1973. Courtesy of Suzette Worden.

Also sprach Zarathustra · Op. 30. Richard Strauss.

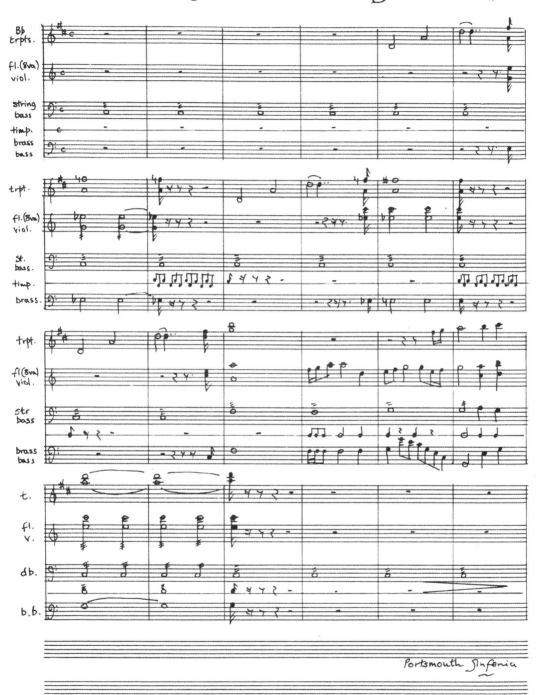

Portsmouth Sinfonia

Meanwhile, the Sinfonia got concerts around parts of Portsmouth Polytechnic and other colleges: Reading University, Slade School of Art, Newport College of Art, a rock concert with Keef Hartley and the Groundhogs.[2] Fifteen appearances in all during 1971. The repertoire now expanded—*Also Sprach Zarathustra* and *Blue Danube* were added, along with Grieg's *Peer Gynt*. Often over twenty players turned up. Members outside of Portsmouth joined in and an announcer was used to read notes written by Farley—serious musical history of the pieces on offer. This added an accidental humor to the proceedings. In September 1972, Lampard and I moved to London and were determined to keep the momentum going. Getting information to members was not easy in the 1970s—no social media, not everyone had phones; so it was telegrams, letters, word of mouth.

There was a definite social aspect to Sinfonia gatherings. There was always at least one rehearsal before a concert. No new member was allowed to sit in at a concert without at least that rehearsal. Various musicians brought in other musicians, from professionals (e.g., the Michael Nyman Band) to amateurs. This mix was essential. Everyone enjoyed rehearsals as much as concerts and [they were] often more interesting performances. The numbers grew steadily. It was essential to have as many players as possible for each section, especially the strings. At least four violins playing approximately the same note would sound interesting. There were evolved leaders in each section of the orchestra to help new members with their parts. Of course nobody got paid except expenses and the small fees we asked for help to cover travel, etc.

We had no real plan or ambitions other than to expose unexpecting audiences to the delights of the Portsmouth Sinfonia. At the Sinfonia's early performances, the audience was not expecting what they got, and that was wonderful. That changed as we exposed ourselves to more audiences. Some pieces were just uniquely beautiful, as unaccustomed fingers struggled for notes, tempos varied considerably, and the conductor failed to begin or end a piece. Then maybe the next piece would be hilarious, as the orchestra attempted the majesty of Beethoven's *Fifth Symphony*. Then a piece might be so unrecognizable that the audience was left bewildered. By the time of the Albert Hall, the audience knew what was coming and that produced moments when they were ahead of events, like laughing before the punch line. There

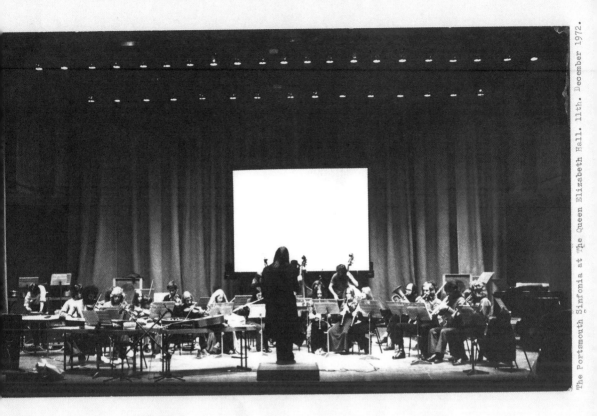

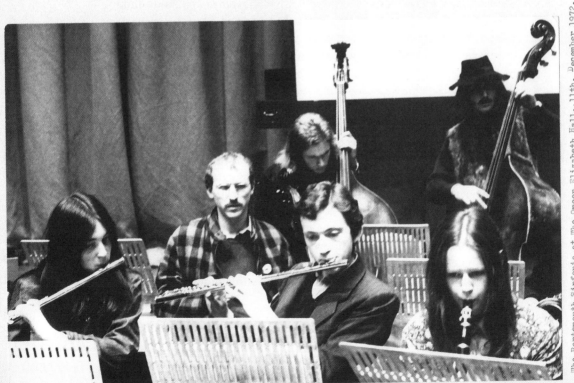

were obvious cultural connections, too, for example, after Stanley Kubrick's *2001: A Space Odyssey*, *Also Sprach Zarathustra* became a space anthem. Our version would be represented often as the heroic failure of a symbolic space launch.

On December 11, 1972, we returned to the Queen Elizabeth Hall for a Bryars and *Music Now* ensemble concert. In the audience that night was Laurence Aston from Transatlantic Records. He came backstage and asked me to contact him. The orchestra was now thirty-five members strong: the sound was getting good, and with more rehearsals, performances got "better." The same people returned again and again to play. Better performances were true to the principles of the Sinfonia. Like much of a Sinfonia performance, humor was purely accidental. Never was a funny noise, or a bum note, made on purpose to get a laugh. Sometimes audiences sat and enjoyed the beautiful and fragile sound. Sometimes they stomped to the beat and energy of a march of overture. Sometimes they laughed at the crazy realization of a theme not quite making it, or a tempo being so out that it created a new sound piece all together (that's when it sounded like Charles Ives)—all these passed in a moment. There was always an interest in the sound of many instruments trying to play in unison and harmony but creating something different. James Lampard and I would look at each other after a piece ended and acknowledge, either, "That was great," or, "That was not so good—let's get on with the next piece." If the Sinfonia had played for fourteen consecutive nights at the Albert Hall, would we have given "better" (meaning more like the composer's intention) performances each night? Not if different players came. We did not control the performance in that way. Each night would be different.

On January 7, 1973, we recorded at BBC TV Centre for *Omnibus*. We played "Morning" and "In the Hall of the Mountain King" from Grieg's *Peer Gynt Suite, No. 1*. The BBC tried to keep the high seriousness by having a Radio 3 announcer in evening dress introduce us to an unexpecting TV audience. It would have worked so much better if they had left it like that, but then at the last minute they decided to have John Peel, the "voice of alternative rock music" on radio and much respected, make an introduction explaining the joke. Good old BBC.

The program was enough for Transatlantic Records to see potential in

recording and releasing an LP. We signed a standard recording contract and in our naïvety gave world rights to the record company. We did get total artistic control of the recordings. Transatlantic was a small independent company with an office in London. They specialized in folk and jazz imports from the US and home talent like Pentangle, Gerry Rafferty, Billy Connolly, and the Dubliners. Transatlantic had a young and enthusiastic Special Projects Manager, Martin Lewis, who took the Sinfonia under his wings and produced a mass of publicity. Lewis came up with the "World's Worst Orchestra" tag, while we also described it as the "rare and beautiful" music of the Portsmouth Sinfonia. It was a natural for the voracious media, but worked best when taken seriously, as various BBC radio stations did. He has remained our "manager" and a close friend to me and John Farley ever since.

The first album was *Portsmouth Sinfonia Plays the Popular Classics*. Rehearsal and recording days were arranged for July/August of 1973 at the Royal College of Art film studio and recorded by Bob Woolford Sound. The recordings were mixed directly on to two tracks to capture the real sound. At this time we played a concert with Roxy Music in York. The tapes were due to be presented to Transatlantic Records and at this stage we asked Eno if we could use his services for sound production. The extent of this (which he offered willingly) was free studio time at Island to edit the tapes and prepare the master tapes. There was obviously a publicity benefit for us to be associated with him but it led to some confusion. Because Eno was credited a "sound producer," and had a new reputation as an electronic sound producer, some people thought that the Sinfonia was electronically created by him and dressed up as an orchestra.

BRIAN ENO

I first met Eno when he was at Winchester College of Art. I was impressed by his charm, intelligence, and enthusiasm for the avant garde. I contacted him in London, 1972, and he told me he was rehearsing with a new band (signed to Island) in a theatre, near where I was living. I went along, but could not get into the building, so didn't hear Roxy Music before anyone else. The Sinfonia played the Roundhouse for *ICES-72* (International Carnival of Experimental Sounds) arranged by Harvey Matusow, and this was Brian Eno's first appearance with the group.

Following: Brian Eno in the recording studio with Sinfonia conductor John Farley, 1973. Photograph © Doug Smith.

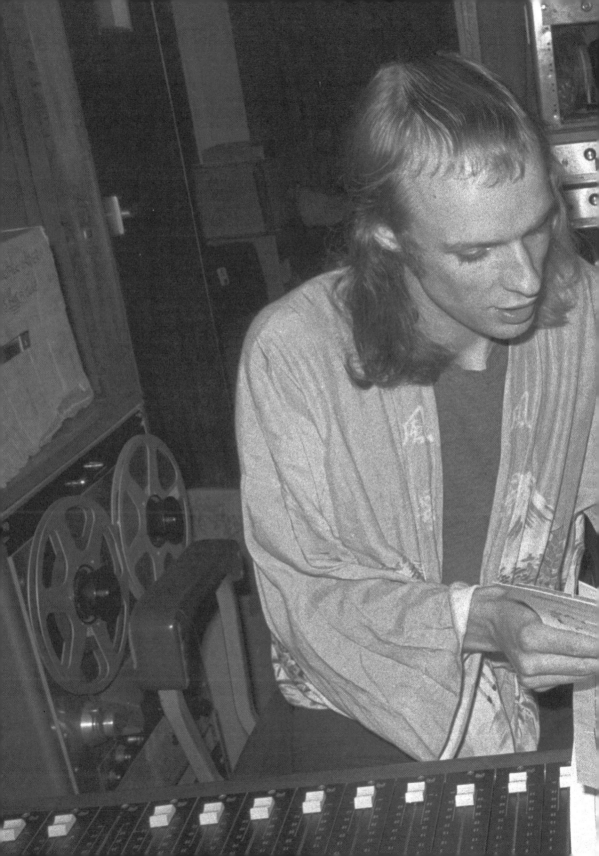

Hear the rare and beautiful music of the

PORTSMOUTH SINFONIA

IN CONCERT AT

THE MERMAID THEATRE

Puddle Dock, London EC4 248 7656 ⊖ Blackfriars tube

Sunday 10th March at 8.00pm

Tickets available from box office price £1.00, 75p.

Album: 'Portsmouth Sinfonia Plays The Popular Classics' TRA 275
Single: 'William Tell Overture'/'Blue Danube Waltz' BIG 515
Both available now on Transatlantic Records

Eno asked me to do some work in his flat in Maida Vale. He was converting a room into a studio, and I decorated and put up shelves. I was there for about six months on and off, and during that time Roxy Music released their first album and toured America. He told me that Roxy Music was a means to an end for him and he wanted to do his own pop and more esoteric music on record. At this time, early 1974, the Sinfonia's first LP was released and my proximity to Eno certainly helped him getting involved.

His management did not want him to have anything to do with the Sinfonia. He had to disguise himself in glasses and a silly hat to play at York. He refused to be dictated by them, was always his own man, and to this day I am impressed by his originality and integrity. He has done some amazing things, yet maintains his "non-musician" stance and the principles of Cage and Young. The strings of the Sinfonia played on "Put a Straw Under Baby" on Eno's *Taking Tiger Mountain (By Strategy)*—the wonderful Robert Wyatt did vocals. John Farley played violin on this session, along with myself, Nigel Coombes, Stephen Luscombe, and a few others.

PLAYS THE POPULAR CLASSICS

Britain was in political turmoil with strikes and there were power and fuel shortages, delaying the release of *Plays the Popular Classics* until after Christmas [1973]. It came out with a single of *William Tell*, to extraordinary reviews in the music and mainstream press, as well as radio and TV. These were relatively heady times for me, as I was doing radio interviews and TV appearances. I had to answer all kinds of stupid questions from people not wanting to accept the reality of what the Sinfonia really was. Some preferred to think it was proper musicians swapping instruments and making silly sound on purpose. The music establishment did not like the idea, but it made for good copy on arts programs and news items. Many years after the Sinfonia had stopped performing, the BBC decided to do a magazine piece on the Portsmouth Sinfonia to be shown in the interval of a Proms concert.[3] It was scrapped because the concert was by the Bournemouth Symphony Orchestra, who did not want to be confused with the Portsmouth Sinfonia. I enjoyed that little episode.

The whole orchestra was invited on to an early evening magazine program called *Nationwide,* watched by millions on March 8, 1974. A few days later we had our first solo London concert at the Mermaid Theatre. For this, our pieces included the *Overture of 1812* and other Tchaikovsky and Bach. Two hours of the Portsmouth Sinfonia—could an audience take that?

Transatlantic licensed the rights of the first album to CBS in America. Martin Lewis and I were invited by the Head of CBS, the legendary Goddard Lieberson, to attend the CBS 1974 annual convention in LA. CBS, at that time, was one of the leading labels in the world, with stars like Barbara Streisand, Bob Dylan, Simon and Garfunkel, and Bruce Springsteen, as well as classical, jazz, and MOR artists. How on earth could the Sinfonia fit into this? Well, of course it didn't, and when we got there no one really understood it or what to do with us. We were introduced to "God," as he signed his memos, who sat a table with a frail Groucho Marx. Then a week later we went to New York and tried to get CBS to understand what they had. The album sank without a trace, even though we returned (with John Farley) in September and toured the East Coast colleges, doing radio shows every day. The audience got it, but CBS didn't. At Yale University we met the people starting a major project of archiving and establishing the Charles Ives resource. They got it, as would Mr. Ives.

The commercial recordings became definitive versions of each piece, but since we unashamedly used the popular classic as our point of reference, this seemed appropriate. Also they had commercial value—people liked them, not a lot though! Some purists saw this as opportunistic and not politically correct, even though that expression [was not circulated much] in the early 1970s. We never got paid royalties due—sales of *The Popular Classics* were about 19,000 in the UK and Europe. It would have been nice!

HALLELUJAH! LIVE AT THE ROYAL ALBERT HALL

Back in the UK, we went for the big one. The Royal Albert Hall was booked for a night of "popular classics," on May 28, 1974. The Royal Albert Hall is the home of the Proms and the status of Carnegie Hall for performers. A few weeks before the Albert Hall concert we received a

letter from one, Miss Sally Binding, who was then studying piano at the Royal College of Music and wanted a provincial orchestra to play with as a soloist. I arranged to meet the delightful Sally and explain that we were not your conventional orchestra, but our next performance was to be at the Royal Albert Hall, and would she like to play Tchaikovsky's *Piano Concerto No. 1*?

The concert poster listed the popular classics to be played and a RAH stagehand was heard to say, "We'll be here all bloody night if they play that lot." A coachful of US tourists were apparently herded in for an evening of easy listening to familiar classics. They were shocked into leaving early. We very seldom experienced angry heckling like Cage and Stockhausen experienced. We added a choir of some 200 people (given free tickets!) and ended with the *Hallelujah Chorus*. The concert was recorded live and filmed. I remember sitting on the steps outside after the concert and just laughing uncontrollably. What had we done?

It was a challenge to fill the Albert Hall but it was the biggest audience we ever had, and it was the definitive performance. *Hallelujah: The Portsmouth Sinfonia Live at the Royal Albert Hall* was released in late 1974.

AFTER THE ROYAL ALBERT HALL

The Albert Hall would be difficult to follow. We now had an orchestra of more than fifty players and a potential choir of hundreds. In November 1974, we did a concert in Cardiff, Wales. It was billed as our "World Tour," which opened and closed on that night. The concerts were becoming unwieldy and too difficult to manage and we could not go back to playing small venues. It could not become a professional orchestra—that would not work. We enjoyed considering new ventures like a ballet or opera, with the Sinfonia in the pit and plans were made to record *Peter and the Wolf* with Spike Milligan. Sadly, this was unfulfilled.

In the late seventies in the UK, and perhaps illustrating the poor state of popular music, the London Symphony Orchestra had hit records with a series called *Hooked on Classics*. Martin Lewis thought that these were the worst records ever made, and the Sinfonia could do better. We then presented the idea of the Sinfonia playing "Rock Classics" to record companies, and Polygram took it. This was a departure from

the original concept, but musically it was in-line with the Majorca Orchestra—playing simple pieces of popular music from the early-twentieth century or original compositions. The orchestra now was a smaller manageable number of original members. We did one concert at the Rainbow in London (a major rock venue at the time) and also a few guest appearances on TV shows in Munich and Cologne, a track on BA Roberston's album [*Initial Success*], and a commercial for Toblerone chocolate. But this was not the high seriousness of taking on the classical tradition.

A farewell concert was arranged at, where [other] than, Her Majesty's Prison at Wandsworth. The orchestra was locked in a hall and the audience came in and the doors locked again. It was actually a great audience, whom enthusiastically applauded and cheered.

There was one last classical concert on October 28, 1980, in the RTE Concert Hall, Paris. The concert was broadcast as part of *Atelier de creation radiophonique*. John Farley and leaders of each section rehearsed for three days with about fifty local musicians. It was organized by Daniel Caux, who presented a music program on French radio and he got listeners to come to rehearsal. There was a tremendous energy and seriousness with these players, and that is apparent in the recording. It showed that the Sinfonia could be presented with new players and a language barrier! A memorable experience. This was a fitting end to the performing career of the Portsmouth Sinfonia, as it embodied the true spirit and ethos of its music making.

(Correspondence, 2017–18)

1 Mortimore is likely referencing *Composition 1960 #13 to Richard Huelsenbeck*, which reads, "The performer should prepare any composition and then perform it as well as he can. La Monte Young, November 9, 1960."

2 In 1970, the Portsmouth College of Art became part of Britain's polytechnic system, which mandated a breadth of non-studio courses (philosophy, music, etc.). The college was rechristened as Portsmouth Polytechnic, which it remained until 1992, when it was renamed University of Portsmouth.

3 The Proms is an eight-week summer season of daily orchestral classical music concerts held annually, predominantly in the Royal Albert Hall in central London.

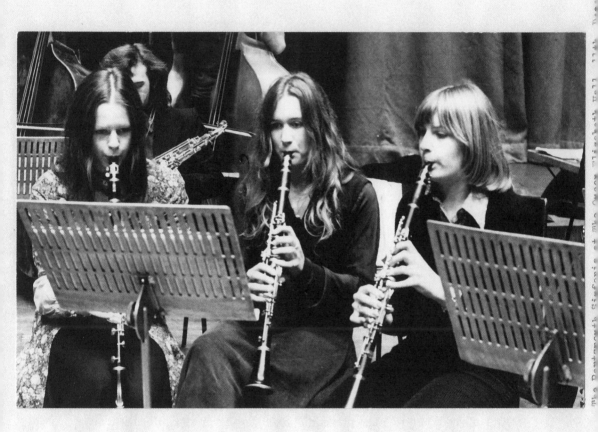

(L-R) Suzette Worden, Gwen Fereday, Nicky Holford.

SUZETTE WORDEN

Clarinet

I was involved with the Sinfonia from 1972 through 1975, as a clarinet player. The events were sporadic but great fun and exciting social occasions. There was a small group of regular members but sometimes new people might join or members might drift away due to other interests and commitments. The core group was from the Fine Arts course at Portsmouth Polytechnic. The numbers swelled for the concert at the Royal Albert Hall but for other concerts it was often a much smaller group.

I think my choice of clarinet was made for several reasons. I wasn't interested in any stringed instrument. By the time I joined, several other sections had regular contributors and there weren't many clarinet players. That meant there was encouragement to consider the wind instruments. It was the one that seemed the most accessible to me and affordable. I chose it in the context of joining in at that time: I hadn't played it before. I had played the piano and recorder while at school and had learnt some musical theory as well. This didn't include much playing with other people though.

I don't recall the clarinet section being very big. For [the Albert Hall] concert, the clarinet section was reasonable in size though. For most concerts, especially early ones for example, at other art colleges, if each kind of instrument had some representation it was probably considered a success. There were always plenty of violins though.

CONCERT Monday 2nd July Lecture Theatre

We play the music as well as we can and one of our aims is to be
technically competent. This does not mean that we are trying to emulate
highly trained musicians; technical competence should be regarded as a
means for expressing the ideas in the music more clearly and not as an
end in itself. A performance, because it illustrates the stage we have
reached in our ability to perform a piece and not how the piece can be
perfectly played, shows just one stage of our progress. I would,
therefore, like to emphasise, while not ignoring the performance aspects
of our music, that playing these simple pieces both helps us improve our
technical ability and serves as a practical form of analysis. These two
aspects are developed simultaneously and the pieces were written for this
purpose.

 Suzette Worden

Quartet)
Violin and cello piece)
Violin Duet) composed by Suzette Worden
Waltz in D. Major)

Here's to the Maiden (trad. English air))
The East is Red)both arranged by Suzette Worden

Musicians: Michael Parsons Violin
 Stephanie Tys, Dip.III Violin and Recorder
 Max Evans, Dip.I Recorder and Trumpet
 Simon Dale, Dip.I Viola
 Jeffrey Steele Trombone and Cello
 Maggie Wootton, Dip.II Cymbal
 Suzette Worder, Dip.III Clarinet

I don't remember Brian Eno [who also played clarinet] being at many of the concerts I took part in overall. I do remember him being at the Albert Hall and wearing a red beret. I think his involvement was more on the management side, as he had the contacts for promotion and getting access to recording facilities. I don't recall any system of leadership, other than everyone being open to helping each other as necessary. Perhaps that could have happened in the violin section. I expect leadership came from anyone who had been to a previous event helping any newcomer adapt to the circumstances they found at each event. The concerts were always very different in size of location, number in the orchestra, general atmosphere, and audience. I think any definition of musicianship was very imprecise.

Robin Mortimore had great faith in the potential of the Sinfonia and was the main organizer and communicator for the events. Brian Eno was brought in to help with the editing and production of the records. There were others who played an important role in taking the Sinfonia into the record and entertainment business. I think that Martin Lewis, who was manager of the Sinfonia, continued to try and promote the Sinfonia into the 1970s, and later outcomes of his involvement were the *Classic Rock Classics* LP (1979) and the *Classical Muddly* 7"-record (1981). These later records were not the result of an open invitation, as were the earlier concerts and recordings, but were invitation-only and more controlled, with a view to more commercial [appeal].

The records and the film of the Sinfonia are special as so little [was] documented of the various concerts. The Sinfonia also appeared on TV. I remember going to the BBC for the recording, which would have been a special and unusual event for us all. The program had two presenters for various sections. One, Alvar Lidell, was a famous news presenter, considered "the" voice of the BBC News. The other was John Peel, disc jockey and radio presenter known for his promotion of alternative pop and spotting of new trends. Even though they represented different aspects of radio and TV culture, their stances and bodily preparations for making their introductions was identical.

Opposite: Suzette Worden concert compositions and concert statement for Lecture Theatre performance at Portsmouth College of Art on Monday, July 2, 1973. Courtesy of Suzette Worden.

FINE ART AT PORTSMOUTH

While the Sinfonia was evolving from 1970 to 1972, some members would have been taking part in Scratch Orchestra performances at Portsmouth Polytechnic, with Cornelius Cardew, Gavin Bryars, Michael Parsons, and possibly others visiting the Fine Arts Department. Students also wrote directions for performances. One performance took place in a woods north of Portsmouth. At this time the Polytechnic courses were run from the Portsmouth College of Art building, with temporary accommodation being used for studios until a brand new Fine Arts building was opened next to the architecture department at Lion Terrace, Portsmouth, during 1972. In 1972 there was a student occupation at the Polytechnic and a growing interest in left-wing politics, heightened by concern over events in Northern Ireland. Other musical groupings, such as the Ross and Cromarty Orchestra, reflected these concerns in [their] repertoires. This orchestra was led by Ivan Hume-Carter and influenced by his interest in Scottish history. The orchestra played at the Edinburgh Festival and toured in the Scottish Highlands.

The Fine Arts Department had an exceptional Historical and Critical Studies [track] so the opportunity to engage with theoretical issues was as strong as the support for studio work in painting, sculpture, ceramics, photography, and film. Any involvement in music and performance was supported [by] a theory course. The Fine Arts Degree (the CNAA Dip. AD at that time) attracted students who wanted to experiment and work across different areas. Figurative work and systems-based art coexisted, such as the work of lecturers Jeffrey Steele and David Saunders, but the conceptual side of systems art was reinforced by crossover with the Architecture Department, where there was a strong theoretical focus emerging on design methods.

Composing was not a major activity of mine but it was interesting to experiment. The pieces were very simple. Sometimes they were conventionally melodic, like the waltz for the Ross and Cromarty Orchestra. At this time, I was taking a course on computers and art, so there were also some simple systems pieces, where the choices made were based on rules learned from early computer programming concepts we were studying. This was c. 1972. These were performed at the college rather than in external concerts. Michael Parsons was the main tutor at

Festival appearances and Highland tour 1972. London's

ROSS AND CROMARTY ORCHESTRA

Waltzes, Songs, Flings, Overtures, Highland Railway Symphonic Movement

28th August - 2nd September (inclusive)	1.15p.m.(Opera) 3.00p.m.(Concert) Brodies Close, Lawnmarket, Edinburgh	Admission 25p
Monday 4th September	8.00p.m. Town Hall, Dingwall	Admission 25p
Tuesday 5th September	8.00p.m. Ross Institute, Halkirk	Admission 25p
Wednesday 6th September	8.00p.m. Community Centre, Brora	Admission 25p
Thursday 7th September	8.00p.m. Public Hall, Ullapool	Admission 25p
Friday 8th September	8.00p.m. Town Hall, Inverness	Admission 25p

During the past year the Ross and Cromarty Orchestra, a group of 14 musicians and singers, has given a series of concerts in London, Bath and Portsmouth. This has included work in schools and hospitals as well as normal concert situations.

So called because Ross and Cromarty is representative of the area that has given the inspiration for, if not the underlying structure of, the music composed for the orchestra, the Ross and Cromarty Orchestra's fresh approach to orchestral music making is a joy to the ear in an age of musical distortion.

that stage and we had regular sessions with a small group interested in playing their own compositions. I think Michael would have introduced ideas and concepts from other music to broaden our perspective and encourage us.

Ironically, the Sinfonia was aiming to make traditional music accessible at the same time as drawing on ideas found in conceptual art. At art schools, this was a time when students questioned the relevance of traditional expertise in artistic practices. I would put those ideas in the context of the early 1970s, when there was a strong reaction at some art schools against a singular vision of excellence and also a breaking down of the barriers between the sub-disciplines in the arts. There may also have been a stronger consideration of the nature of the process, rather than the quality of any end result. At that time most students received grants to cover their fees and living costs (if they weren't too extravagant!), so as a student you spent a lot of time in the studio with your peers. This often meant that you learned from one another. The master/apprentice idea of learning was breaking down and so too was any idea of virtuosity or excellence. What I would value from the experience is an understanding of working with others in a group. The activities also encouraged everyone to have a go, which is still a valuable aim.

Alan Sandham on the "red flag" piano, performing with the Ross and Cromarty Orchestra, c. 1973. Photographer unknown. Courtesy of Suzette Worden.

The Ross and Cromarty Orchestra and the Majorca Orchestra were interesting developments alongside the Sinfonia, who also embraced the appreciation of popular melodic musical forms. At that time (1972), Maoist ideas were influential, so politics became an additional factor to be considered, as was the case for the Ross and Cromarty Orchestra repertoire. More generally Marxist politics were also influential on several of the complementary studies courses offered at Portsmouth. For example, [the curricula of] film studies c. 1972 changed to cover Maoist Republic of China films rather than Surrealism, Buñuel, Godard, or Antonioni. (All 16mm copies hired for the classes each week and shown in the lecture theatre.). The venues for the Ross and Cromarty Orchestra concerts were arts festivals, such as the Bath Festival or the Edinburgh Festival, both in 1972.

THE ROYAL ALBERT HALL

Some of the things that have stayed in my mind about the Royal Albert Hall concert include the atmosphere of the place itself, the chance to be part of another concert and reconnect with the group, and the excitement of seeing so many new people arrive to play in the concert or be members of the choir.

These people would have come through very informal word-of-mouth invitations passed along through friends. Other colleges organized mini-buses to bring people for the choir. Their attendance was definitely needed to make the event live-up to the promise of the occasion. The Royal Albert Hall was an imposing building and the venue had a reputation to match, as the Proms were held there each year. I remember the unusualness of its circular form and the plush, but rather dusty and old-fashioned interior, which made me aware of its place in history and association with musical traditions—then to imagine what memories there must have been for others from numerous special occasions held here. However, this sense of the past was contradicted by the incongruous mushroom shapes hanging from the ceiling, which were there to improve the acoustics. It was our special occasion that had to bring the place alive. Even though what I remember most about the rehearsal—seeing the audience arrive in good spirits expecting great things, or rather getting the impression they had come in good faith but didn't know quite what to expect—made us want to do our best to

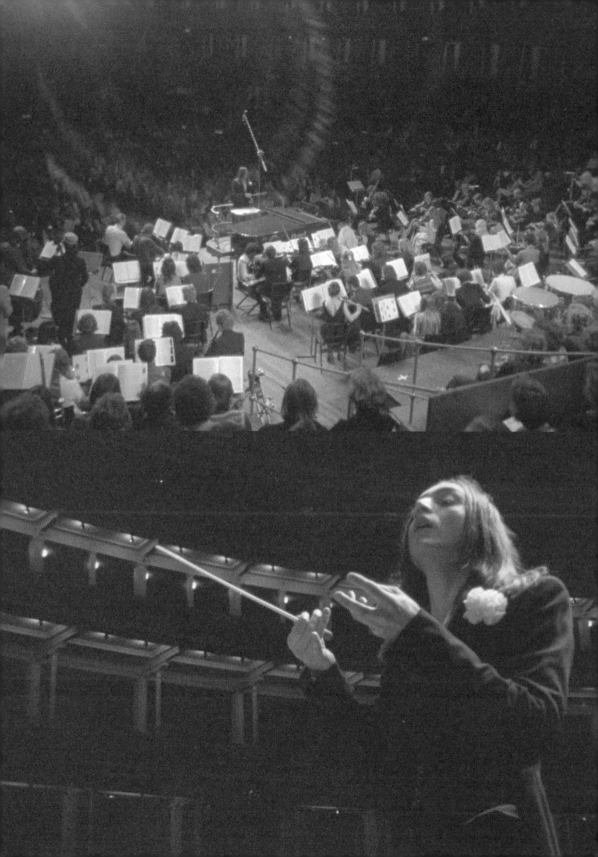

work as a unified group. Being part of something was always important but this concert was much more ambitious than previous ones. I can't remember how many people actually came to the concert but it seemed a respectable crowd; they certainly joined in enthusiastically with their applause and cheers.

Usually the Sinfonia performances were spontaneous and based on bringing things together at the last moment, so they didn't feel that organized when you were taking part. I remember being impressed at the rehearsal for the Albert Hall concert by the way Michael Parsons jumped into the role of getting the choir organized for the *Hallelujah Chorus*. I don't think anyone really realized, until faced with all the excited choristers, that such a role would be needed. Likewise getting the orchestra to work with a soloist was new but that probably gave the soloist more to think about and anticipate than the members of the orchestra. One of the most entertaining aspects of the performance was the firing of the canon in the *1812 Overture*. It was just as well we had a practice getting used to the canon in the rehearsal, as these blasts, using the equipment from the Albert Hall, were truly stunning and magnificent additions to the sounds from the orchestra. I expect the audience was treated to a richer performance than usual and must also have added atmosphere to the recordings too.

The Royal Albert Hall concert stands out as an event more special than other concerts because it was filmed, a record was produced, and so many took part. The atmosphere made it exciting but I also saw it as part of a continuum—an exploration of ideas about anything being possible, everyone being creative and being artists.

(Correspondence, 2015–19)

Opposite: Stills from *Hallelujah!: The Portsmouth Sinfonia at the Royal Albert Hall*, film of the May 28, 1974 concert, directed by Rex Pyke. Courtesy of Martin Lewis and PortsmouthSinfonia.com.

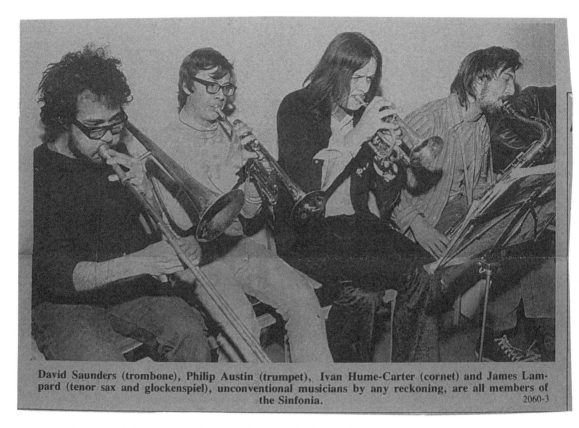

David Saunders (trombone), Philip Austin (trumpet), Ivan Hume-Carter (cornet) and James Lampard (tenor sax and glockenspiel), unconventional musicians by any reckoning, are all members of the Sinfonia.
2060-3

Portsmouth Evening News, 1971. Photographer unknown. Used with permission.

DAVID SAUNDERS

Trombone and Tenor Horn

*What was your role and how did you come to be involved with
the Sinfonia?*

In 1968 I was contracted as a visiting lecturer at the Portsmouth
Polytechnic Art School by the painter Jeffrey Steele, who had just been
appointed Head of Faculty. I was also contracted to teach at the nearby
Winchester Art School, where I became [a] personal tutor to Brian Eno.
Jeffrey ran the faculty at Portsmouth in a way similar to Black Mountain
College, with little distinction between faculty and students and a
variety of disciplines. The most important [aspect] of the latter could
be described as "classical experimental music," which was developing
strongly in Britain at that time due to the teaching and broadcasting
success of the composer Cornelius Cardew. Cardew was a frequent
visitor to Portsmouth, where he found many students who would help
him with rehearsals and performances of his magnum opus, *The Great
Learning*, then under construction. In 1970, I had a residency at the
University of Sussex at Brighton, along the coast from Portsmouth, so I
was not present at the beginning of the Sinfonia. One day I came over
from Brighton to find a group of students trying to render Beethoven's
Fifth Symphony on a motley collection of instruments. They were not
reading from the score but listening to a recording and trying to follow
it. Somebody suggested that it was "a bit fast" and [so they] tried slowing
the turntable down. For some time, I was paralyzed with laughter—then
I was invited to join in and given a tenor horn, which of course, is not an
orchestral instrument.

What was your general experience within the group?

On a scale of one to ten, my musical ability is barely one, but I learned to read and play a single line. I soon realized that this was not a prank but serious and difficult stuff. What was most striking about the Sinfonia was the sense of social responsibility and collective work to overcome great difficulties. In my opinion, what was behind this ethos was the work of Cardew, which was informed by Chinese philosophy—at first, Confucianism, an interest that had come from his father; and later, Maoism. There were several musicians of great ability in the band, and it was the composer Gavin Bryars, a faculty member, who held things together at first. Bryars was greatly influenced by the ideas of John Cage, which he communicated to the students. The other leading musical figure, who joined the faculty in 1970, was the composer Michael Parsons. Parsons had taken a degree in classics at Oxford before going to the Royal College of Music. A third important musician, who, although not a member of faculty, played a role in holding things together, was the composer Michael Nyman.

In 1968 I had helped to found, with Jeffrey Steele, the Systems group of artists. To put it briefly, we wanted to make an art of "self-evident truth," in opposition to the prevailing cultural ethos of self-expression. My way of doing things was to set up conditions, protocols to be followed, which although rigorous, implied the intervention of chance and could lead to surprising and unpredictable results. It's not difficult to see how this could connect with the ethos of the Sinfonia. Steele was also a member of the band.

What do you feel its legacy to be (if anything)?

Over the next forty years some aspects of the Sinfonia style became mainstream. In 1972 I was appointed senior lecturer in painting at the Liverpool Polytechnic Art School (John Lennon's alma mater). There, I assisted in the band Deaf School, led by the student Clive Langer, who became, among many things, cowriter (with Elvis Costello) of the song "Shipbuilding," recorded by Robert Wyatt. He is also a record producer and one-time manager of David Bowie. An account of the influence of the Sinfonia on popular music is given in *Deaf School: The Non-Stop Pop Art Punk Rocky Party* by Paul Du Noyer.[1]

In your artist's biography you discuss how you adapted your painterly investigations into certain musical and mathematical endeavors. In the case of the Portsmouth Sinfonia, it seems to be both an egalitarian exercise and an exercise in restraint. Could you talk a bit about how those certain strategies—if it's fair to call them that, or if you view the group as deploying them—overlapped into your painterly process, and vice versa? Do you still find such methods pertinent in your work today?

Before I encountered the English musical avant garde, I had been making, in the 1960s, paintings that employed strategies for generating visual events. I would describe this as setting a system in motion and letting it run, without interference, until it was exhausted. At that time I knew something of the music of Stockhausen and Xenakis, but very little of Cage or Cardew. I had heard odd bits of Cardew on the radio, but it was when I came into direct contact with this music that I realized that there was quite a lot in common between the musical procedures being developed by the English avant garde and the methods that I had discovered working in isolation.

The finest example I have ever heard of a music resulting from a basic idea allowed to run its course to exhaustion is "Paragraph 7" from Cardew's *The Great Learning*. I have taken part in performances of this several times. I will try to describe it for you, in case you are not familiar with it. The piece is written for a large but indeterminate number of voices. Each performer is given a sheet with several lines of Confucian text. Each performer is instructed to sing the lines in order, on a single note, for the length of a single breath. The note sung is to be taken (copied) from another that can be heard. When breath runs out, [performers are instructed to] sing the next line on a new note. Performers will range from professional to the non-musical. Since at the beginning there is no note to be heard and copied, the piece must begin with each individual inventing a note—the beginning is cacophony. Gradually, as new notes are chosen, a gigantic choral harmony emerges, one that is constantly shifting. The amateurs and the non-musical [participants] will finish before the more experienced, who can control their breathing for longer. As breath begins to run out, the music becomes simpler, purer, and quieter, until eventually the last breath, the last note is heard. I remember the first time I took part in a performance of this piece; there was quite a long silence after the last

Following: The Portsmouth Sinfonia, c. 1971–72. (**L-R**) Margaret Wooton, Michaela Kenyon, Jeffrey Steele, David Saunders, Philip Austin, Ivan Hume-Carter, James Lampard, Gary Rickard, Peter Clutterbuck (standing), Russell Coates, John Ryder, Jeremy Main, Robin Mortimore. Photographer unknown. Courtesy of private collection.

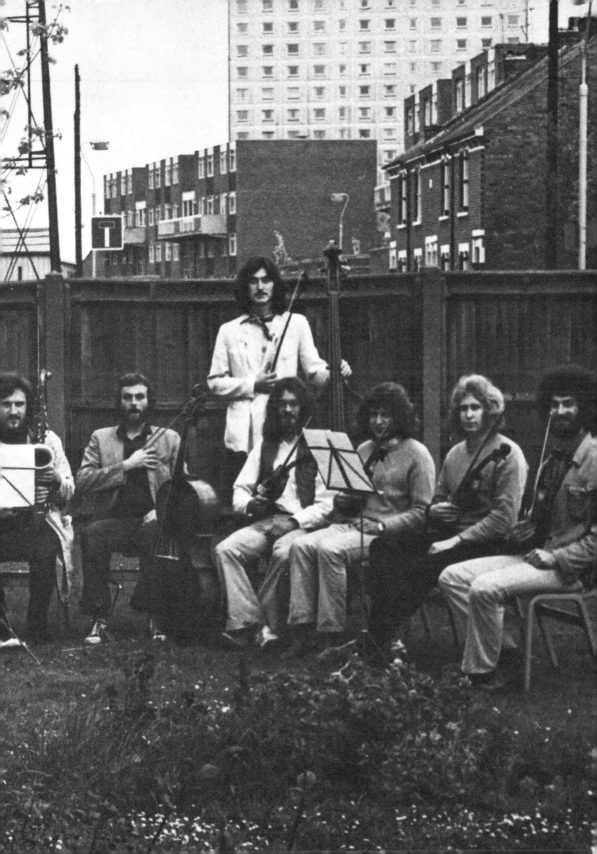

note, then a voice was heard to exclaim: "Fucking hell! Did we do that?" This is a small instance of "failure," an artistic concept that was of great importance to Cardew at that time.

> *Of particular interest is the Sinfonia's close leanings toward a Fluxus mode of creation—a dictum, to generalize the group, might be, "Anything can be art and anyone can do it." Fluxus was born out of Happenings, which found the movement closely aligned with a rejection of abstract expressionism and other then-canonical modes of art making. At the same time, the use of the body to create works of art (or, a work of art, as how we might view Hans Namuth's film of Jackson Pollock as more representative of the man than Pollock's own paintings) seems indebted to "action painting" and other modernist modes of external-to-inner absorption in the work. Do you feel that there is an overlap between a modernist tendency, such as a work of abstraction on canvas, and a postmodern approach, as seen in the Sinfonia? If so, how does that tension play out in your other artistic endeavors?*

In 1970 Cardew gave an interview on the BBC introducing the first broadcast performance of "Paragraph 2" of *The Great Learning*. Here is an extract: "Everyone is failing; our entire experience is this side of perfection. Failure exists in relation to goals; Nature has no goals and so can't fail. Humans have goals and so they have to fail. Often the wonderful configurations produced by failure reveal the pettiness of the goals. Of course we have to go on striving for success, otherwise we could not genuinely fail." Parsons assures me that the Sinfonia was the brainchild of Gavin Bryars, but in my opinion, the ethical teaching of Cardew played a large part in defining its style. It was certainly the case that the musically minded students were familiar with the music and teaching of Cardew as they had taken part in performances of his work. It was also the case that behind the Sinfonia stood the Scratch Orchestra, created in 1969 by Cardew, Parsons, and Howard Skempton. I may be mistaken, but I do not recall any member of Fluxus taking part in Sinfonia concerts, although some members, notably Bryars and Eno, were close to Fluxus in their thinking at that time. Parsons and I met in 1970 and have been close friends ever since. We exchange views on art and music regularly and collaborate on art, music, and performance projects, although he lives in London and I am [based] in the French Pyrenees. Here, in Ariège, in 2008, we presented the project *Walking*, which included the work of photographer Katherine Faulkner. She took

THE PORTSMOUTH SINFONIA

Conductor	John R. Farley
Violins	Linda Adams
	Paul Bevan
	Gavin Bryars
	Jeremy Main
	Robin Mortimore
	John Ryder
	Philip Wells
Cello	Gary Rickard
Double bass	Peter Clutterbuck
Flute	Deborah Smith
Saxophone, trumpet & glochenspiel	James R. Lampard
Trumpet	Philip Austin
Cornet & bassoon	Ivan Hume-Carter
Trombone	Jeffrey Steele
French Horn	Adrian D. Rifkin
Euphoniums	Michael Parsons
	David Saunders
Percussion	Jennifer Adams
	Michaela Kenyon
	Maggie Wooton
also Clarinet	Suzette Worden

1. William Tell Overture — Rossini
2. Fifth Symphony C minor, opus 67 — Beethoven
3. "Nutcracker Suite" opus 71a
 Marche
 Dance of the Sugar-Plum Fairy
 Valse des Fleurs — Tchaikovsky
4. Overture "1812" opus 49 — Tchaikovsky
5. Selections from Space Odyessey "2001"
 Also Sprach Zarathustra — Richard Strauss
 Blue Danube Waltz — Johann Strauss
6. Air from Suite No. 3 in D major — J.S. Bach
7. "Peer Gynt" Suite No. 1 opus 46
 The Hall of the Mountain King — Edvard Grieg

"............farcical and truncated" — Daily Telegraph
"............approaches the cosmic ..." — Michael Watts, Melody Maker
"............no frivolous excreta" — Paul David Lewis
Music & Musicians Monthly

"............Sinfonia is on the road to
 success" — Paul Mitchell, Portsmouth News
"............2001 as you've never heard it" — Frendz No. 9

Information and FREE copies of William Tell Overture record from:

The Portsmouth Sinfonia,
20, Shaftesbury Road,
Southsea, Portsmouth,
Hants.
Please send 5p stamp for postage

October, 1971.

a hiking club out with pinhole cameras attached to their bodies, then she printed the results and stuck them to the walls of a museum devoted to the industrial heritage of the Ariège Valley, Les Forges de Pyrènes. In the same space, I placed on the floor a sixty-four sheet calligraphic "account" of one of my mountain walks.

Michael's contribution, again in the same space, was *Walking*, a piece of his Scratch music from 1969, in which an undefined number of participants are given cards with instructions: "Choose a point in the room and walk toward it, choose a speed to walk at and keep to it, when you have finished this walk choose a new direction and a new speed." I have never really gone along with the slogan, 'Anything can be art and anybody can do it.' I think it's a Sixties thing. On the one hand, it can't be refuted; on the other [hand], it does not take into account that even those who—since Duchamp—have taken the art world itself as their medium, [insist that] the medium has to be mastered. One can end up with something strong and profound, or something weak and trivial. It all depends on the quality. Twombly's paintings are affecting because they seem to conjure strength and depth out of "failure" and "mistakes." There are those who love the paintings and others who think they show nothing but incompetence. The question at the end of your last paragraph above calls for two—perhaps contradictory—answers, in terms of my current work. Well, yes, I do hold to the idea, [along] with the philosopher Maurice Merleau-Ponty, that painting must be somatic, so I continue to love the work of Pollock. [But] I [also] stay inspired by the thoughts and works of my friends in the musical avant garde of all those years ago. A work begins with setting up conditions that enable something to happen; what happens depends on the quality of the artistic thought that goes into the set-up.

> What is striking about the Sinfonia is its chaos. Despite the cacophony, the musicians/non-musicians are still able to make the piece sound recognizable. The metaphoric statement that prevails is twofold: on one hand, the amateur or non-specialist is a surrogate for the professional/specialist, making a statement against prevailing schools of art making; on the other, at best, the music that is produced has been billed as from "the world's worst orchestra," and at worst, a statement that perhaps some forms of music are best left to the professionals and specialists. What are your thoughts on the role of the amateur in art? Is it possible to become a professional when it comes to forms of music like the Sinfonia?

I find that it is always the quality of artistic thought that matters in the end. The designations "amateur" and "professional" are notoriously slippery. A close friend has worked all his life as a civil servant, yet his works are in some important museums around Europe. I'm giving him a show in my Mercus Barn project. Cardew, in spite of being, in my opinion, the greatest English composer of the last century, worked all his tragically short life in a bookshop to support his family. He never made any money. I have been, as I see it, a 'professional' painter since my teens. My commitment to the art is total; my works are in several of the great museums, including three in the Tate. Last year I had a show at Mummery Schnelle, London. It was the "Show of the Week" in *Time Out* and got a four-star review. Not even a scrap of paper was sold. The gallery went bust. Luckily, I can live on my pension.

(Correspondence, 2017–18)

1 Paul Du Noyer, *Deaf School: The Non-Stop Pop Art Punk Rock Party* (Liverpool University Press, 2013).

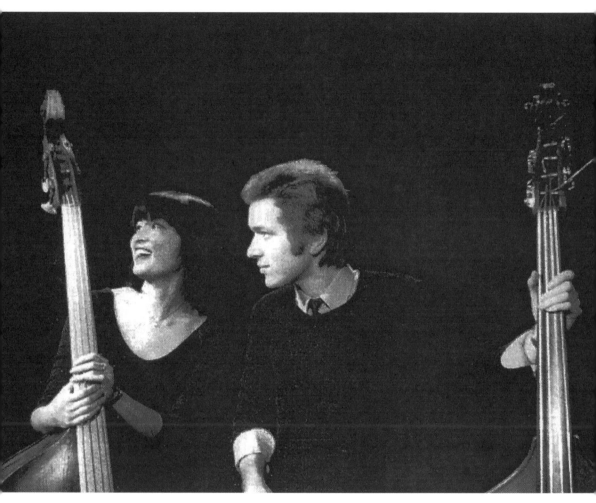

Meg and Ian Southwood, c. 1974. Courtesy of Ian and Meg Southwood.

IAN SOUTHWOOD

Double Bass

As you know, the Sinfonia started at Portsmouth Art School in 1970. The driving force (apart from the inspiration of Portsmouth tutor, Gavin Bryars) primarily consisted of second-year students Robin Mortimore, James Lampard, and Ivan Hume-Carter—also third year-student John Farley, who became the Sinfonia conductor.

In 1970, I was a third-year student, but a good friend of Ivan, Robin, James, and John. I was not involved in the first Sinfonia performance at the college talent competition, *Opportunity Knocks*. I was just graduating from Portsmouth and moving on to do a postgraduate painting course at Chelsea College of Art, though while there, I did organize a Portsmouth Sinfonia concert.

In the summer of 1971, Robin, Ivan, and James graduated, left Portsmouth, and moved to London. This meant that from then on, the main organizers and managers of the Sinfonia were London-based. As far as I know and can remember, from that time, until the final concert in Paris in 1980, I played in the orchestra at all the Sinfonia concerts.

The 1980 Paris concert was a rather special version of the Sinfonia. We were receiving sponsorship funds from the British Council and Radio France, but because of the cost restraints, only about six or seven members—a kind of "central committee"—of the London-based version

of the Sinfonia travelled to Paris, and we recruited an orchestra there. It was probably the most musically accomplished manifestation of the Portsmouth Sinfonia. Previously, the usual personnel who turned up to play in the Sinfonia were fine-art people rather than music people. A few days before we arrived, we had managed to put the word that we were looking for players around the music fraternity of Paris. We got lots of response from very enthusiastic musicians from all kinds of backgrounds—rock, jazz, and classical (including quite a few professional musicians)—so, to me at least, the orchestra seemed to have a much more assured (and louder) sound I think. But it still was the Portsmouth Sinfonia—the performance of each piece would still falter, stagger on, then after a few more bars get back together again. I think that despite all these competent French musicians being there, it proved that you don't need many unsure players to rock the boat.

I was also involved with Ivan, Robin, James, and David Saunders in the Ross and Cromarty Orchestra, and later, the Majorca Orchestra. They were kind of spin-off groups from the Sinfonia (but played their own compositions). The Ross and Cromarty Orchestra played at the Edinburgh Festival in 1971, followed by a tour of Scotland. Following the really cold, very wet, and grey Scottish tour, we changed the name to the Majorca Orchestra.

The Sinfonia's *Classic Rock Classics* LP, recorded in 1979, was a direct response to *Classic Rock* by the London Symphony Orchestra, which was released in 1978. We thought that the LSO's *Classic Rock* was really bad, but we thought we could probably do something worse. To be honest, it was probably just an opportunity to have some fun. We recorded it at a studio in central London in a couple of days, with just a small group from the Sinfonia regulars. As far as I can remember, there were only about twelve of us—I remember Robin, James, and Steve Beresford. I think Gavin was there—I played bass and Michael Nyman played euphonium and piano (notably on the intro to "Bridge over Troubled Water"). At the time of the recording, James was teaching art at a school in Putney, in London. He recruited a couple of fifteen- or sixteen-year-old girls from the school, plus the mother of one of them to be the Sinfonettes—they sang "Leader of the Pack."

By the way, there are two different versions of the album cover for

Opposite: **(Top)** The Ross and Cromarty Orchestra at the beginning of their Highland tour, September 1972. Photographer unknown. Courtesy of Suzette Worden. **(Bottom)** The Ross and Cromarty Orchestra performing for a group of schoolchildren, c. 1973. Photographer unknown. Courtesy of Suzette Worden.

Classic Rock Classics. The original UK one is the picture of the white-gloved hand holding a baton, with flowers, a candelabra, and red curtains behind, with a hint of Liberace about it. The other cover—destined for release outside the UK (I think)—showed a black-and-white photo of part of the orchestra on a floating platform in the River Thames (near Hampton Court) with some swimmers (in scuba divers' wetsuits) in the water's foreground, in front of the raft, with their hands over their ears. I am in this photo—on the right-hand side—the one holding the bass. On the *Popular Classics* LP, I am holding a double bass—on the left side—on the end of the back row.

When the Sinfonia was first formed in 1970, it was just for a one-time event—the *Opportunity Knocks* concert at the College of Art. It continued, and grew, simply because people really liked it, resulting in the Sinfonia receiving many invitations to play concerts at various venues (mainly colleges and universities). The ideas that inspired its creation primarily came from Bryars—his influence, his music interests, and [concepts]. I think there was also probably a general political attitude underlying the Sinfonia—strongly reflecting the viewpoint of at least some of the members of the group. The Sinfonia materialized not long after the student protests and sit-ins at various art schools in the UK (in the spring and summer of 1968), the May 1968 Paris student riots, and frequent anti-Vietnam War protests in the US and Europe around that time. The Sinfonia, with its anti-elitist, anti-exclusive, and anti-establishment (kind of punk) attitude seemed to some extent to echo and respond to events of that period.

Ivan Hume-Carter—an important Sinfonia founder member—was particularly committed to a Maoist political outlook. In fact, the Ross and Cromarty Orchestra—which was a small orchestra of about eight musicians plus a mezzo-soprano and a tenor (Michael Parsons) was mainly Ivan's creation—inspired by and celebrating his Scottish ancestry, and also some (slightly tenuous) links he saw between Scotland and China. As far as I can remember, these links had to do with bagpipes and the similar appearances of yaks and highland cattle. A brief line from one of the songs that he wrote, and which was performed by the RCO, sticks in my mind: "The highland deer runs, so it cannot be caught. Not so, are the ideas, found in Mao Zedong's thought."

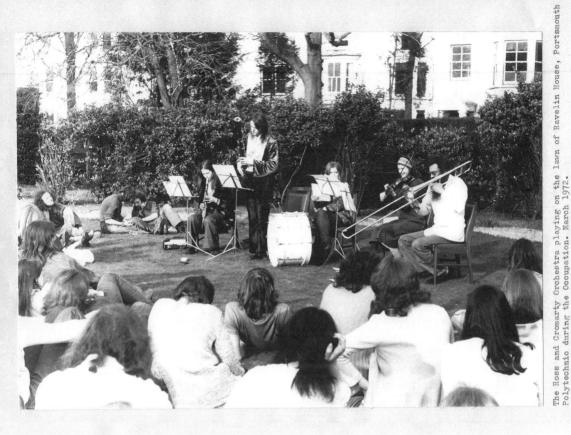

The Ross and Cromarty Orchestra playing on the lawn of Ravelin House, Portsmouth Polytechnic during the Occupation. March 1972.

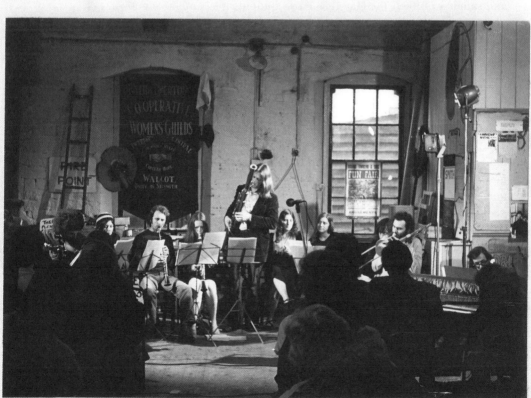

The Ross and Cromarty Orchestra at the Bath 'Other Festival'. Spring 1972.

228 Elmhurst Mansions,
Elmhurst st.
Clapham S.W.4.
622-7945.
5/9/74.

Dear Music-lovers,

I have great pleasure in announcing the start of
the Majorca Orchestra evening class at the Clapham and Balham Adult
Education Institute. The class provides a good atmosphere for begin-
ers (with orchestral instruments), and accomplished musicians to
gain greater knowledge into the beautiful mysteries of music.
At the classes we play simple chamber music composed by members of
the class and arrangements of light-weight Victorian compositions
by Ezra Read and Crawshaw Crabtree to name but two.

Last year the class proved so successful that we were invite-
ed to perform at a Grand Variety Concert in aid of the Mayor of
Lambeth's appeal for the help the aged fund. At this concert we were
privileged to appear on the same bill as The Clapham Old Peoples
Choir, Sidney Powseys Accordions and a Demonstration of Keep-fit for
Retired People. Modesty prevents me from mentioning that few other
new music groups perform with such exhalted company.

If you are interested in joining the class please contact
me at the above address or just come along to the class and see
what goes on.

 Best wishes,
 James Lampard.

 Enrolment; Thurs. 19 Sept. 6.30-9p.m.
 At 6 Edgeley Rd. Clapham,
 Fee £2.15p for year or 75p terminal.
 First class; Thurs. 26 Sept. 7p.m.-9 & continuing every Thurs.
 At Priory Park Sch. Aristotle Rd. Clapham S.W.4.

He was also an admirer of Scottish poet William McGonagall's work, and he set several of his poems to music. Unfortunately, during the RCO's tour of Scotland, Ivan threw a very serious tantrum following creative and political differences with the other members of the orchestra. He accused us all of being bourgeois reactionaries. He left the tour and went back to London. As far as I know, no one from the Sinfonia has had any contact with him since his tantrum in 1971.

It was shortly after this event that we changed the name of the orchestra to the Majorca Orchestra. The MO continued the same idea as the RCO—a small orchestra of about ten members, playing pieces composed by the members. These compositions were inherently very simple and naïve. We always composed and played these pieces to the best of our rather limited and varied musical abilities. While at the Edinburgh Festival we had met artist Barry Flanagan and dance choreographer Richard Alston. This led to the RCO collaborating with them at the festival to create a music and dance piece for Richard's dance group, Strider. The Edinburgh performance involved the RCO, accompanying Barry shoveling sand, while Strider performed dance patterns based on Tai Chi. Later, back in London, the Majorca Orchestra continued the collaboration with Strider. There were performances in Cardiff, and at the Place Theatre and the Institute of Contemporary Arts in London.

In the Sinfonia, I chose to attempt to play the double bass because, as a teenager, before going to college, I had played bass guitar in various pop/rock bands. Since the open string notes are the same on the double bass as on the electric bass, I thought this would help quite a lot when trying to play the double bass. Whenever taking part in a concert as a member of the Sinfonia, I always tried my best to play the correct notes in the right order. I remember a great sense of achievement the first time I ever got to the last note of *The Waltz of the Flowers* at the same time as most of the rest of the orchestra. I think I was always secretly a little disappointed that, however hard we tried, we never sounded like the Royal Philharmonic.

Sometime in 1972, a record company—Transatlantic—approached the Sinfonia, suggesting that the Sinfonia should be recorded. Initially the response to this invitation was fairly negative, as the idea of making a record of any particular concert or performance would seem to

contradict the basic concept of the Portsmouth Sinfonia. Every time the Sinfonia played, the result was unpredictable, with a variety of musicians and abilities making different mistakes. The record company persisted—they put forward the view that it was really important to document and record the very special musical phenomena that the Portsmouth Sinfonia represented. Eventually after some discussion it was agreed to record an LP of the popular classics. It was recorded in 1973.

At this point we were introduced to Martin Lewis from Transatlantic Records. His role was to manage and promote the Sinfonia and publicize the LP. He is an extremely talented publicist—still very busy—living and working in Los Angeles since about 1980. From the moment that Martin became involved with the Sinfonia, he changed Sinfonia concerts from fairly low-profile, fairly serious (political even—but, of course, always funny) performances, which took place mainly at art schools, colleges, and avant-garde/experimental events/festivals, to fodder for the front page of every UK newspaper—both quality papers and tabloids. He also managed to get the Sinfonia featured on many radio and TV shows. Obviously, the angle that he promoted to the media was centered on the comedy aspect—"the world's worst orchestra." In addition to the publicity created by Martin, with all his talent for manipulating the press, the fact that Brian Eno, at that time with chart-topping rock band Roxy Music, was also a member of the Sinfonia created a lot of interest, particularly from the music press. Eno's last ever appearance as part of Roxy Music was at a concert in York in 1973. Roxy was the main act and the Sinfonia was the supporting act. Brian insisted on playing with the Sinfonia before the Roxy Music set—apparently, this seriously annoyed the management of Roxy Music. He left Roxy shortly after this event.

Hallelujah: The Portsmouth Sinfonia at the Royal Albert Hall was a recording of the May 1974 concert to celebrate the release of *The Portsmouth Sinfonia Plays the Popular Classics*. It presented an opportunity to experiment with a very large (but inexperienced) choir singing the *Hallelujah Chorus*, and to accompany a professional pianist—Sally Binding—playing Tchaikovsky's *Piano Concerto No. 1* in B-flat Minor. (In fact, we transposed it to A-minor to make it a bit easier for the orchestra.)

Martin Lewis was the initiator and arranger of the Royal Albert Hall concert, and as far as I can remember, the prime mover behind *Classic Rock Classics* and *Classical Muddly*. His influence on the Sinfonia and promotion of the Sinfonia undoubtedly focused exclusively on the inherent comedic potential. His record label—Springtime—was responsible for producing and releasing *Classical Muddly*, as well as contributions from the Sinfonia on a CD presenting the best of British comedy.

I'm not too sure about Jeff Steele's theory about the heavy emphasis on Systems thinking at Portsmouth as very relevant. My own work at the time was not concerned with or involved with systems—at that time I guess my work would probably be pigeon-holed as Pop-influenced (I liked the work of Richard Hamilton, Lichtenstein, Warhol, Allen Jones, Hockney, etc.). Steele would stroll around the studios at the art college to talk to students about their work. He would come to my area, where I was working on fairly large paintings based on images sourced from furniture catalogues. He used to tell me that he would try to take off his dogmatic hat in order to be able to say something positive to me. He really did not think much of my work or figurative painting in general.

I think I found the Sinfonia to be of intense interest on so many levels, apart from the appeal of the subversive elements, both musically and politically—the really hilarious unpredictable accidents that always happened and its inclusive attitude to anybody who wanted to join the orchestra. It provided an educational opportunity, a focus to learn to play music, and the opportunity to perform in public concerts with other similarly minded people.

(Correspondence, 2017–18)

Following: Portsmouth Sinfonia at the York Arts Festival in Museum Gardens on July 8, 1973. Photograph © Doug Smith.

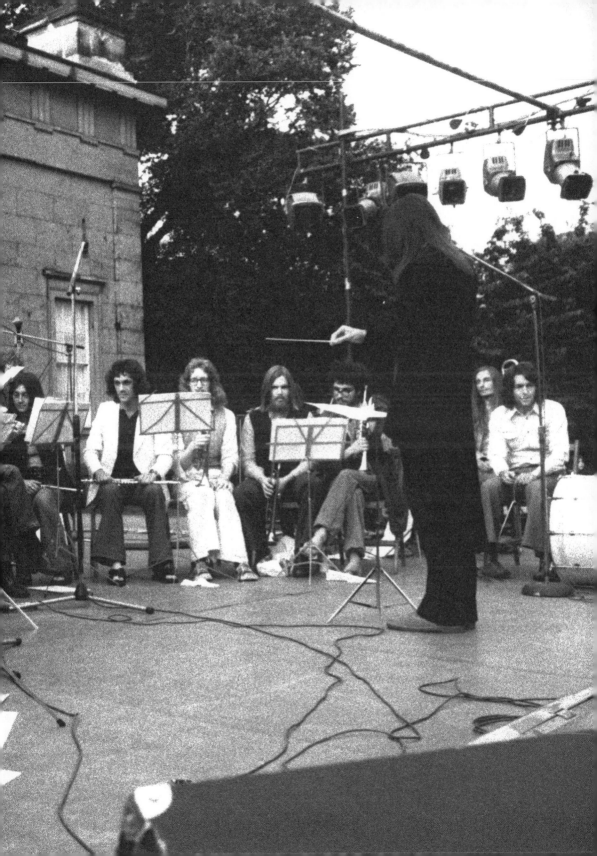

The Rare and Beautiful Music of

J. S. Bach. John Farley. Richard Strauss

Portsmouth Sinfonia

Portsmouth Sinfonia plays the popular classics on Transatlantic TRA 275

MARTIN LEWIS

Manager and Publicist

At the time I first encountered them, the Portsmouth Sinfonia had been going for just over three years. I was not a part of their foundation or their early days, but I ended up playing quite a sizeable role in their story.

As a prologue to my recollections, I'd like to mention something that my dear friend, the late Peter Cook, once said in response to an interviewer: "Peter Cook, without you and your contribution to British comedy, there would have been no Monty Python. You're probably the funniest Englishman since Charlie Chaplin. How do you feel about that?" Peter Cook replied simply, "Well, this is no time for false modesty." In that same vein, I'm going to say that, at my advanced age, this is not the time for false modesty! I did have a major impact on the Portsmouth Sinfonia, and they on me.

The fates happened to decree that our paths should cross. I use an analogy and I don't use it lightly: in a sense, I became the Brian Epstein of the Portsmouth Sinfonia. Not that they were looking for one. They were extremely happy and successful in their small pond, and they were doing well, achieving a good amount on their own. However, there was no concentrated effort to promote them beyond a tiny fraction of the general listening public. That was quite normal for a quasi-classical or new music ensemble in that era (and also for a lot of pop artists). Until

you got a manager, you just rolled along, got gigs when and where you could. Had I not encountered the Portsmouth Sinfonia, and they me, they would have continued being successful in a small sphere of the avant garde, and with college students looking to enjoy something unusual.

Martin Lewis, 1974. Courtesy of Martin Lewis.

In early 1973, I went to work for a small independent record company in London called Transatlantic Records. It was with Transatlantic that the Portsmouth Sinfonia would sign, shortly after I arrived there. Transatlantic was Britain's first real independent record company. It had started by importing blues and jazz records from America—and then it expanded by presenting new recordings of British folk music. It was not a mainstream pop or rock company. It handled UK distribution of Nonesuch Records, which was the classical music label of Elektra Records. Nonesuch had become very successful presenting unusual repertoire such as early/medieval music and composers such as Erik Satie and Scott Joplin. They weren't covering the mainstream classical canon of Beethoven, Bach, Mozart, et al. Transatlantic had become attuned to classical music that was a little off-the-beaten track.

The company was run on a shoestring, and consequently, its founder, Nat Joseph, operated on his instincts—employing hand-picked youngsters, who he gambled might achieve more than experienced, seasoned staff whom he couldn't afford. It was in early 1973, that I, at the ripe old age of twenty, became Special Projects Manager at Transatlantic. This was a new position in the company that Nat allowed me to create and define. I would have an overarching holistic role in every aspect—including management, publicity, and marketing—of a very few select artists and projects. My salary was bare-bones, so Nat figured he had nothing to lose. And if his instincts about my abilities were correct, plenty to gain. It turned out to be a win-win for both of us.

Transatlantic had a knack for finding good new artists, but the company didn't have big marketing budgets or much flair with which to promote them. So there was an appealing challenge for me: I was out to make a huge difference and a name for myself, armed with all the knowledge, expertise, and brimming self-confidence you have when you're twenty! I had two big advantages. I'd recently been mentored at another record company by the brilliant Derek Taylor (former publicist for the Beatles), and—all false modesty aside—I had a natural talent for such work.

BEFORE THE SINFONIA

The first two projects I worked on at Transatlantic were huge successes and gave me the experience and confidence that I then applied to the Sinfonia project. I took a group called Gryphon, who played a hybrid of traditional English folk crossed with medieval music, and I repositioned them as an acoustic prog-rock band. I came up with innovative ways to present them to the public and they became media darlings within months. Then I took on Joshua Rifkin, an American music professor who interpreted the piano rags of Scott Joplin in the way that Joplin had wanted—as Chopin-style classical pieces rather than as honky-tonk piano tunes. I was able to turn Rifkin into a household name in less than a year.

The trick for me was to identify what made these artists unique and then find an entertaining way to pitch them to the media. To my surprise, I was the only person in the UK music business operating in this way. I had discovered a small but valuable niche. So, by the time I was introduced to the Sinfonia, I had already developed a modus operandi and I was on a winning streak. Members of the UK media were now very open to anything I would present them.

"THE RARE AND BEAUTIFUL MUSIC . . ."

One day in July 1973, a Transatlantic staff member named Laurence Aston played me a tape of the Sinfonia. He was thinking of signing them to the label. He was not unaware that the Sinfonia induced laughter in people, but he was primarily interested in them because they were becoming part of the minimalist movement.[1] Three seconds into hearing the tape I was on the floor howling with laughter. I immediately sensed

TRANSATLANTIC RECORDS Ltd

<u>PROGRAMME FOR MERMAID THEATRE</u> SUNDAY 10th MARCH

ALSO SPRACH ZARATHUSTRA RICHARD STRAUSS

BLUE DANUBE WALTZ JOHANN STRAUSS

SUGAR PLUM FAIRY from Nutcracker Suite TCHAIKOVSKY
DANCEOF THE FLOWERS FROM Nutcracker Suite

FARANDOLE FROM L'ARLESIENNE SUITE BIZET

AIR FROM SUITE NO. 3 D MAJOR J.S.BACH

"JUPITER" FROM PLANET SUITE HOLST

<u>INTERVAL</u>

FIFTH SYMPHONY C minor opus 67 BEETHOVEN

"INTERMEZZO" FROM KARELIA SUITE JEAN SIBELIUS

OVERTURE "1812" TCHAIKOVSKY

MORNING fromPeer Gynt Suite Edvard Grieg

IN THE HALL OF THE MOUNTAIN KING
 from Peer Gynt Suite

WILLIAM TELL OVERTURE ROSSINI

86 Marylebone High Street London W1M 4AY
01-486 4353/6 01-935 1389 01-935 1380
Cables Xtra London W1

Directors Nathan Joseph S.Joseph.

massive potential outside the niche artsy sphere that Laurence had in mind. I determined that I would take this project under my wing—with the express aim of presenting the Sinfonia to the broadest audience.

I went to see them rehearse in a small hall in London on a Saturday afternoon in late July 1973. They were rehearsing because they were about to record their first album. I listened and I was captivated. It was clear that they were not intentionally playing badly. It was not that Victor Borge–confected humor, which is predicated on a succession of deliberate mistakes. Here, the errors, when they occurred, were clearly unintended. They were going to happen, but you didn't know *where or when*. I wasn't *au fait* with the language of the avant garde, but I understood visceral reaction. I immediately knew exactly how to present them to the outside world.

I decided that it was imperative that there be a major London concert to launch their first album. I was not interested in a show taking place in a college. It had to be in a beautiful concert hall or theater. It had to look classy. There needed to be a clear juxtaposition between the sound and the surroundings. In March 1974, we chose a London venue called the Mermaid Theatre, run by the very respected actor/manager, Sir Bernard Miles. It had only six-hundred seats, but it was a gorgeous, plush auditorium.

I evolved a twin-prong approach in presenting the Sinfonia. The official press releases about their albums and concerts would refer in straight poker-face language to "the rare and beautiful music of the Portsmouth Sinfonia," but when I was talking informally to the tabloid media, I would describe them as, "The World's Worst Orchestra!" When I went to the tabloids with that angle, it was irresistible. Who goes out and says, "I've got the worst in the world"?! Everybody's always saying they have the best. My pitch was catnip to the media.

PHOTOS

I had found it quite easy to get photographs of the group Gryphon in the national newspapers, because they played unusual-looking instruments, such as krummhorns. I would say, "medieval rock band," and I managed to get photographers and journalists to regularly show up for media

photo opportunities. With the British press, their big thing, second to celebrity, is novelty. A bunch of twenty-year-olds in a "medieval rock band" was a quirky thing.

With the Portsmouth Sinfonia, I decided on a similar approach. The Sinfonia had a good figurehead in their conductor, John Farley, who was good-looking in an offbeat way. He had long hair, a long frock coat, was quite thin and handsome, with a very winsome smile. He looked like a bohemian romantic from the early-nineteenth century. Franz Liszt crossed with Dave Davies of The Kinks!

I summoned the press photo corps to come and take photographs outside the Mermaid Theatre. They showed up en masse because I was saying that the Sinfonia was the "world's worst orchestra." There were about 15-20 musicians, with their instruments arranged in a semi-circle. John became the natural focal point. The photographers could say to their picture editors, "Hey, we got a photograph of the guy that conducts the world's worst orchestra!" Bingo! Suddenly, we were getting photographs in all the British tabloids and serious national papers.

A few weeks later I wanted to get another photo of them in the national papers and I needed a fresh angle. London buses in that era had an operator who sold tickets called a conductor. I had John—clutching his baton—stand in the middle of the road with a double-decker London bus fast approaching him. The caption read: "The only thing he's capable of conducting is a Number 28 bus!" The media lapped it all up.

To place this in some further context, Britain in 1974 was in the middle of a massive economic depression. There was rationed electricity supply and offices, factories, businesses, and retailers were ordered to work only a three-day week. The national mood was very gloomy. There wasn't quite revolution in the air, but there was a very bitter, nasty mood in the nation. And suddenly along comes the Portsmouth Sinfonia and they put a smile on everyone's face. The British have always loved eccentrics and in that spring, the Portsmouth Sinfonia captured the hearts of the general population.

Trade advertisement for Transatlantic Records, c. 1974. Courtesy of Martin Lewis.

BEETHOVEN'S BAKER

I was going to the USA to do some interviews about the Sinfonia on my own, and Robin told me a fascinating story. I had asked him, "Where did this come from, people wanting symphony orchestras to be so slick but people not really caring about hearing occasional bum notes from a rock band?" He said, "Well, back in the day, that's how it was. Before he lost his hearing, Beethoven didn't have a symphony orchestra at his command. The first performances of his music would be by the local baker, the plumber, and just people he knew. In other words, pals from his locality. Whoever had an instrument would play and the performances would have an imperfect quality because that's just what they were. They weren't slick."

I thought, "Wow, that is fascinating. They were, I guess, punk musicians in their own way." So I went through a whole series of interviews in America and I talked about it, about how in a sense the Sinfonia was just following a tradition of what had happened in Beethoven's time. When I got back from America. I said to Robin, "That went really well, people were fascinated to learn that." He said, "What?" I said, "That thing you told me about Beethoven initially using just his mates who didn't know how to play." Robin laughed heartily. "Oh, that thing I told you was just a joke, I just made that up!" But Robin had been so convincing when he told me that I convinced everybody to whom I recounted it. People would say "Yes, I've heard that before." So it became one of those "Emperor's New Clothes" things.

CRITICS

We were starting to get bite-back from serious classical critics. There was a famous writer and classical critic, Meirion Bowen, who wrote an article in the *Guardian,* that was aggressively against the Portsmouth Sinfonia, attacking Transatlantic and me personally, for our roles in desecrating classical music.[2] In the end, the *Guardian* printed a groveling apology to all of us.[3] In his fury about the Sinfonia, he clearly overstepped the line. These were the critics for whom classical music was *their* music, and something as uncouth as young people, or those with a sense of humor, having fun with it was heresy. The more I encountered that attitude the more I was determined to stir it up!

On one occasion we were on [radio and television personality] Richard Baker's panel radio show with Bernard Miles. Baker loved presenting classical music programs and played a track off the Sinfonia album, saying to Miles, "This is a cacophony, isn't it? It's dreadful." Miles, quite his senior and in his early seventies at the time, said, "No, no it's wonderful! Now *everyone* can play." That was in 1974, and he totally got it, this wise old man—it was about letting music-making be accessible to everyone, rescuing classical music from those I termed the tuxedo-Nazis. It was punk before punk. It was the joy of just *making* music, divorced from the pressures and expectation of perfection.

TELEVISION

In Britain, there was a TV magazine program called *Nationwide*. It was about an hour long, usually a little bit of news and then a plethora of light-hearted stories. I pitched them the Portsmouth Sinfonia. Normally they'd be very wary of booking an orchestra—as they would have to pay huge union fees—but together we found a way around it. The Sinfonia appeared on that program and it was a game-changer. Suddenly, instead of just being written about in the papers or being heard on the radio, there was John Farley, conducting twenty or twenty-five musicians, performing live in a TV studio.

Your average rock artist would never deign to appear on those kinds of cheesy magazine shows, playing for the family watching TV as they're having their evening meal. But I sensed it would be golden for us. At that time, Britain only had three TV channels. If you were on the biggest channel at supper time, you'd have been seen by ten- or twelve-million people. Subsequently, John would be on the London Tube and people would be coming up to him, recognizing him (Farley-Mania!). We'd never had that before, even after photos had appeared in many newspapers.

PURE SINFONIA

Robin, John, and I became a very tight inner circle, attending media interviews together and socializing. And any time something went wrong during Sinfonia-related events we'd say, "That's so Sinfonia!," or, "That's pure Sinfonia!"

There was a new London talk-radio station that launched around the same time as the Mermaid concert called LBC-London Broadcasting Company. It was so amateur hour, compared to the BBC. We went there and they were just dreadful: cues were off, the host got the names incorrect, and they played the records at the wrong speed. We turned to each other and said: "Sinfonia! Pure Sinfonia!" And that became a shorthand way of saying that something was terrible or bad in a funny way.

There were two acts representing British music at the 1974 CBS Records corporate convention in the USA: a children's novelty musical puppet act called the Wombles—and us! The Wombles were like the Smurfs, but without the artistic and intellectual gravitas, and were for a short period in 1970s Britain, as famous as Winnie the Pooh. The Wombles were run by a husband and wife team, Mike and Elizabeth Batt, who were right in front of us in the customs line at the Los Angeles airport, with all of their costumes of furry singing animals. The customs officers became convinced that the puppeteers were smuggling drugs. We spent an hour and a half behind these people as they opened up all their costumes. The customs officers were slicing open Great Uncle Bulgaria, a beloved badger-like creature, looking for drugs. Robin and I turned to each other and said, "Pure Sinfonia!"

PRISON AND SALLY BINDING

After the Royal Albert Hall performance, we went to prison! We gave a concert at Wandsworth Prison, one of the grimmer prisons in South London. I had previously arranged for other musical artists I worked with to give concerts at that prison. I don't know if treating prisoners to musical concerts lowered rates of recidivism, but my belief was that it was a decent, humanitarian thing to do. The prisoners had really enjoyed the concerts I'd previously presented. So I offered the prison a concert by the Sinfonia.

Sally Binding came into the Sinfonia orbit when she wrote a letter to the orchestra offering to play piano for our concerts. She was an aspiring concert pianist in search of an orchestra, blissfully unaware of our reputation. In social terms, she was what is called in Britain a "Sloane Ranger"—a very upper-middle-class, young Princess Diana–type. She

came from an upper-crust family, but she wasn't stuck-up at all, and had a great sense of fun. We would affectionately tease her about being so posh and she would just laugh. We rehearsed very hard to integrate her role as pianist for the Albert Hall concert, and the audience instantly took to her. They adored her.

On the day of our concert at Wandsworth Prison, there was no sign of Sally. The prison had gone to the great trouble of getting a grand piano for her per our request. So we had our grand piano but no grand pianist! We played the concert, which the prisoners enjoyed, but dropped the piano concerto from the set list.

We were worried that something terrible had happened to Sally. That night we discovered that she had mistakenly shown up at another very famous prison in London called Wormwood Scrubs, where several of Britain's most notorious spies had been incarcerated. Can you imagine this delightful upper-class society gal knocking on the heavy oak doors of Wormwood Scrubs? A burly prison guard opens the door and he hears—in very refined dulcet tones—"I'm here to play the Tchaikovsky Piano Concerto." She'd gone to the wrong prison! In Sally's defense, both prison names started with a "W." Pure Sinfonia!

CLASSIC ROCK CLASSICS

Everything then went fairly quiet on the Sinfonia front. We'd played the Royal Albert Hall, and we'd played in a major prison. What more could we do? It was about 1978 that companies such as K-Tel and Ronco became very successful in Britain, releasing compilation albums of recent hits by multiple artists. One of the companies was fishing around for new product ideas, and it came up with a cunning notion: record an album of symphonic versions of classic rock songs. Suddenly we have K-Tel presenting the London Symphony Orchestra playing the Beatles, the Rolling Stones, and others. It was called *Classic Rock*, and it was a brilliant marketing exercise—a famous brand-name orchestra playing the favorite rock songs of baby boomers. It was very slick, but musically it was distinctly bland, a cynical product carefully confected to cash in. It sold very well because it exploited the culture-vulture nature of middle-class baby boomers.

Following: Members of the Portsmouth Sinfonia arriving for their concert at Wandsworth Prison, London on February 2, 1975. (L-R) Imogen Morley, Jill Adams, Philip Wood, Linda Adams, Christaine Sasportas, Rachel Maloney, Stephen Luscombe, Nigel Coombes, Robin Mortimore, Gary Gunby. Credit: Keystone Press/Alamy Stock Photo.

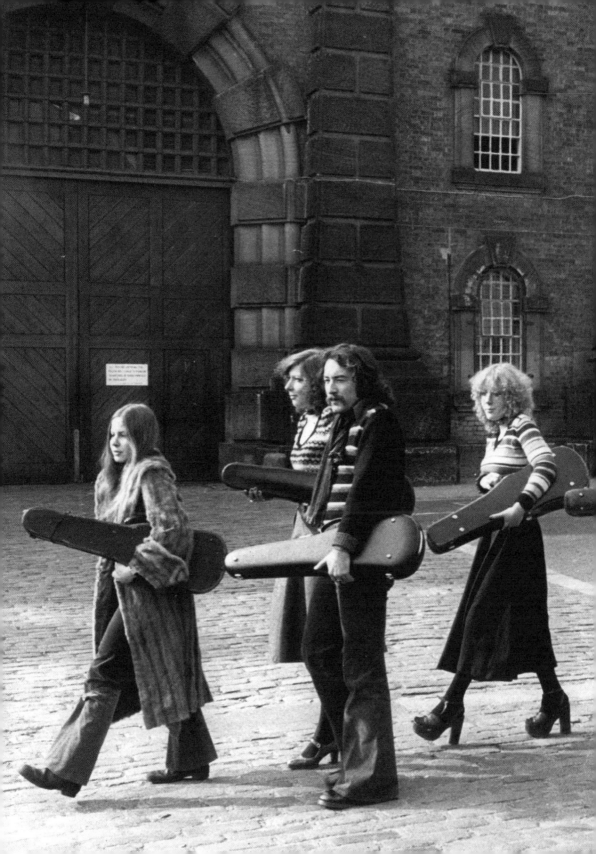

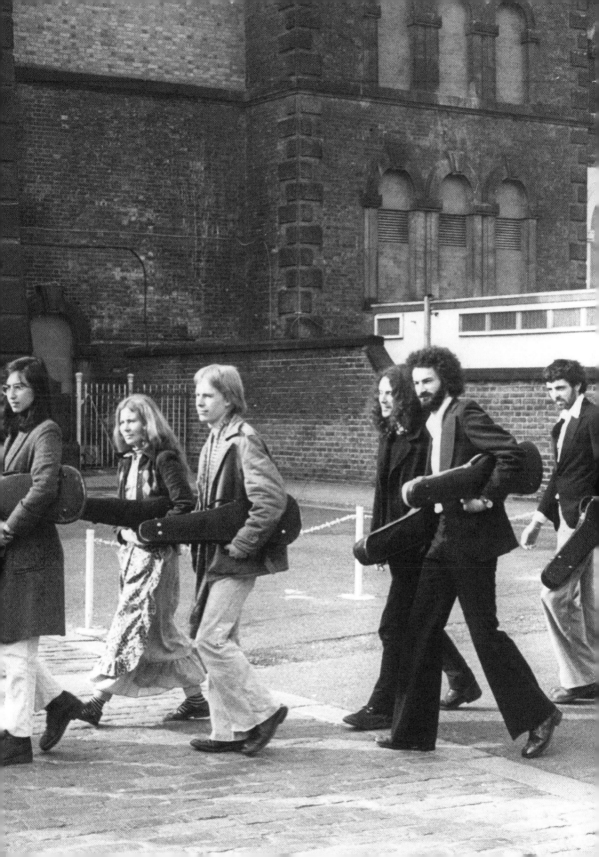

At that point the Sinfonia had pretty much retired—we were certainly on indefinite hiatus. But I called up Robin, and said, "We've got to take the piss out of this." We decided that the Sinfonia should make its own version of the rather schlocky *Classic Rock* album. Together Robin and I decided what music to record. We covered the obvious: "A Day In The Life," "Nights in White Satin," "A Whiter Shade of Pale." And then we intentionally did some kitsch tunes, such as "Glad All Over" by the Dave Clark Five, and "My Boy Lollipop," a late-fifties American pop song that became a hit again in 1964 for a girl singer called Millie. So our album was about two-thirds of real classic rock, in the sense of respected songs, and the rest were kitsch—guilty pop pleasures of the 1960s and '70s. The very fact that we were dolling up some slight pop tunes amidst the real classic songs was one of our ways of satirizing the London Symphony Orchestra album. The album title, *Twenty Classic Rock Classics*, was my spoof on the way the word "classic" had been hi-jacked and over-used in music marketing.

As part of the promotion for the album, I decided to contact the composers and original performers of all the songs we'd recorded and get quotes from them about our endeavors. I had replies from several of those to whom I reached out: Pete Townshend told me our version of "Pinball Wizard" was second only to The Who's! I wanted to get a comment from Elvis Presley, who quite inconveniently, had died two years earlier. So I contacted a rather well-known psychic based in Las Vegas called Sylvia C. Browne, who claimed to have an open line to Elvis, and sent her our recording of "Heartbreak Hotel." A couple of weeks later I received a very serious letter saying that she'd played it for Elvis, and he was worried that if it were played loudly it might give people epilepsy. We were very impressed by this. Of course, I fed all these comments and quotes to the press: "Elvis Warns about the Portsmouth Sinfonia!," and so on.

At the time, I was becoming more aware of the music of Charles Ives. I was starting to learn about dissonance. So when I listened back to our recording of "A Whiter Shade of Pale" late at night, I thought, "This is really beautiful in an unexpected, strange way." I don't find our recording of that track especially amusing. I find it eerily strange, like a surreal dream sequence in a movie. The dissonance of it was actually appealing to me aesthetically.

PLAYING WITH THE SINFONIA

I begged to have a cameo on the *Twenty Classic Rock Classics* album. I said, "I know what I can do: on the Simon and Garfunkel original of 'Bridge Over Troubled Water,' there's a big percussive sound after the last time we hear the words, 'Like a bridge over troubled water (boom!)' Maybe I can do something like that." I always thought that the (boom!) sound on that recording was timpani, but I later discovered that on the original record, it came from Simon and Garfunkel kicking a large metal echo plate to get that audio effect.

It was agreed that I would recreate this sound on the Sinfonia version by using cymbals, and I decided that I would record this loud percussive effect as an over-dub. I would be on my own in the studio. The engineer would play me back the recorded track, and I would add my cymbal clash. I decided that I would hit those cymbals so hard that I would make the loudest sound ever heard by mankind! It should be noted that I'd never played cymbals in my life, but I thought, "How hard could it be to play the cymbals?"

I decided not to rehearse, because to do so would take away the momentum. It had to be special. I said, "Brace yourselves, everybody. You better put your fingers in your ears. This is going to be the loudest thing you've ever heard in your life." And then when it happened, all you could hear was the sound of a very genteel click. In my natural incompetence, I had simply clashed the two cymbals into each other in a way that produced minimal sound. I looked up aghast. I looked into the control room and I couldn't see anybody. So I ran out of the studio into the control room and I find all of them rolling on the floor in uncontrollable laughter. I had made this my big moment, and I'd screwed up monumentally. I begged and begged to be able to re-do it. And I was told, "No, Martin. That was pure Sinfonia. You had your moment. You desperately wanted to be on the record and you fucked it up royally! It's perfect!"

So that's why you hear what sounds like a couple of saucepan lids gently touching instead of the biggest bang of all time.

Following: Conductor John Farley with members of the Portsmouth Sinfonia in front of the Royal Albert Hall on May 28, 1974. Photograph © Doug Smith.

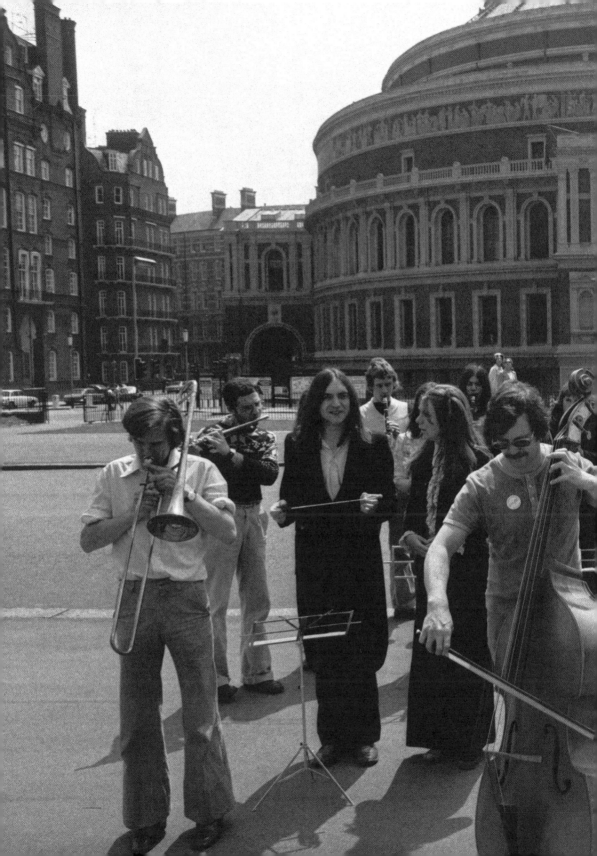

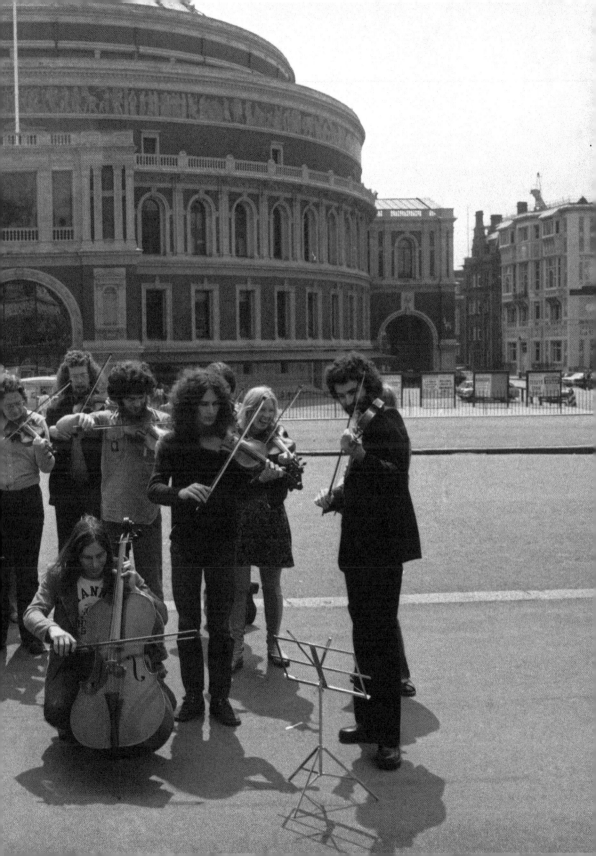

CLASSICAL MUDDLY

In 1981–83, there was a craze for medley records. It started with a recording by session players (dubbed *Stars on 45*) of various Beatles compositions strung together as a disco-styled medley. It continued with numerous other medleys—some by copycat performers, some by skillful editing of the original tracks by artists such as the Bee Gees, the Beach Boys, and many more.

This led to the ultimate degradation of our culture! The Royal Philharmonic Orchestra released a single called "Hooked on Classics," a medley of familiar melody lines from popular classical works. It was even worse than my description of it! So I called Robin, and said, "Let's do our own version." My plan was to take some short extracts from all of our recorded "canon," stitch them together, and overlay that with percussion played by me, the world's worst disco handclap machine operator (all modesty aside, I think I really own that title).

This is where my lack of rhythm came in really handy. My best idea was having the medley go from a series of classical melodies—all in 4/4 time— suddenly into the "Blue Danube Waltz," which of course, is a waltz in 3/4 time. I called it *Classical Muddly*, but in hindsight I should have called it *Classical Massacre*. We put the *Hallelujah Chorus* from Handel's *Messiah* on the B-side, the way one does. It was a chart hit in the UK.

As part of my promotion of the single, I organized a publicity stunt, in which I issued a challenge to the Royal Philharmonic Orchestra. The statement was something like this: "For the last ten years, we have been very proud of being known as the 'World's Worst Orchestra.' We've just heard your record, *Hooked on Classics*, and we're upset that you're clearly trying to steal our title from us! We demand a musical duel to settle this thing." I have to say that the people running the Royal Philharmonic were wonderful sports about it. They thought it was very funny and played along with it.

The UK copyright law at that time ordained that a musical work entered into the public domain at the point that the composer of the work had been dead for seventy years, becoming what Monty Python called a "decomposing composer." All of the extracts of music in our medley

were in the public domain, as one would expect, given that most of the composers of classical works were from the preceding 150 to 300 years. Alas, Richard Strauss didn't die until 1949, so in 1981, his works were still in copyright. We had a disco handclap going on top of all the musical extracts, including Richard Strauss's *Also Sprach Zarathustra*. That gave the publishers of Richard Strauss the opportunity to say "That's a new arrangement, so it needs our pro-active permission to be released!" They sent a threatening legal letter to BBC Radio saying they were about to enjoin the record for copyright infringement. It was a clever scare tactic, and they succeeded in intimidating BBC Radio from giving us further airplay. We had to re-press the record with the handclap removed from the thirty seconds of Strauss. By the time this was done, we'd lost our chart momentum, and all it cost the publishers was just one legal letter. Now *Also Sprach Zarathustra* is out of copyright. I think we'll make them regret maligning and crossing us back then! "The Curse of the Sinfonia" is rather formidable. . . .

THE WORLD'S WORST ORCHESTRA

Everybody who played in the Sinfonia knew that the ensemble could sound awful, but they weren't *trying* to sound awful. They were the happy accident that kept giving. The joy of the Sinfonia was the juxtaposition between what you knew in your head the music ought to be and what you actually heard with your ears. To a great degree, we increased the probability of the juxtaposition occurring by playing only pieces that were widely known. It wouldn't have created such an impact if the audiences had been unfamiliar with the melodies.

I think there was a glorious naiveté about the Sinfonia. Yes, they understood that their collective incompetence would probably make people laugh, but there was considerable restraint. It was considered very bad form for a player to intentionally play badly. That would be contrived, artificial humor and it was imperative that we be far above that. Fortunately, it was exceptionally rare that any player gave into temptation. Such a person would not stay a member long. The orchestra members spanned the full spectrum of musical competence from people of professional orchestra standard to people who literally didn't know which end of a violin to blow. That rich mixture was at the heart of the Sinfonia experience.

The Sinfonia brought the world considerable joy. I don't think there is anything more joyous or infectious than natural, spontaneous laughter, and the Sinfonia always had the gift of triggering that. People hearing them for the first time invariably react the same way. I think it's partly because decades of conditioning has led us to think that performance of classical music is supposed to be pristine and perfect. But perfection is not the end game. If you can play beautifully, great, well done. You've rehearsed stringently and diligently. You've reached a point where you can repeat your performance perfectly. But surely the joy of music must be the making of it in the first place? If you keep making mistakes and don't achieve slick orchestral standards, that should not stop you playing music.

In the classical music world, it's all about the rehearsal; it's not really about the final performance. All the slickness, the perfection, the high gloss, comes from the hours and hours of rehearsal, which on one level, is admirable. But, ultimately, that's the equivalent of people passing exams by memory of facts, rather than by actual knowledge. Performances of classical music have become slick rendition rather than emotional expression.

I'm very glad to have played a small part in this wonderful adventure, along with Gavin, Robin, John, James, Ian, Brian, and all the other people who were the bedrock of it. The Sinfonia and I were lucky and blessed to have found each other. Over the forty-five years of my career that have followed my first work with the Sinfonia, I've had the privilege and joy of working as a producer and/or marketing strategist with many of the world's leading comedic and musical talents. Taking into consideration all the people I've worked with and all the projects I've done—ranging from Monty Python to Paul McCartney—I don't think I ever had more fun, or made more people laugh and be happy, than in my work with the Portsmouth Sinfonia. When I finally shuffle off my mortal coil—in seventy or eighty years' time—it will be with a huge smile on my face, and I think that will be in great part because of my time with the Portsmouth Sinfonia.

(Correspondence, 2019)

1 The "minimalist movement" that Lewis refers to here is slightly distinct from the American arts movement and music style. "Minimalism," in the context of the Sinfonia's milieu, had to do with the works revealing their construction, i.e., their "system." The "English Systems Group," spearheaded by Sinfonia alums David Saunders and Jeffrey Steele at Portsmouth, developed work that was characterized by limited elements. As Saunders and Steele mention in their respective contributions to this book, the Sinfonia, with their caveat for membership, theoretically fall under this type of systemizing art making. Further reading: Michael Parsons, "Systems in Art and Music," *The Musical Times* 117.1604. (Oct. 1976), p. 815–18; and Virginia Anderson, "Systems and Other Minimalism in Britain," in Keith Potter, Kyle Gann, and Pwyll ap Siôn, eds., *The Ashgate Research Companion to Minimalist and Postminimalist Music* (Farham, Surrey: Ashgate Publishing), p. 80–106.

2 Meirion Bowen, "The malady lingers on," *Guardian* (Wednesday, May 1, 1974), p. 16. Bowen's abridged statements are as follows:

> "When it comes to avant garde music phenomena . . . the first question the record companies tend to ask is 'Does this act—or do these performers—have a saleable gimmick?' They are indeed entitled to do so; but should they not heed the consequences should they not balance this against other non-commercial factors? The expertise in advertising and press relations by Martin Lewis of Transatlantic (himself a frustrated composer) has of late been exercised upon promoting the Portsmouth Sinfonia. With what pride and enthusiasm does he inform us that this is an orchestra of between 30 and 50 'musicians' whose aim is to 'reinterpret the popular classics' but (wait for it) 'most of the musicians can neither read music nor play their instruments . . . I do believe Transatlantic Records perform a disservice to contemporary music when they single out for special treatment a group like Portsmouth Sinfonia; not because I personally or anyone else happens to think it's a load of rubbish; but because there is an element of fraud in presenting it as the latest exotic arrival in the fun palace of commercially recorded music . . . Even if I didn't think the Sinfonia a one-minute joke and a two-hour yawn, I should find this whole affair tinged with immorality."

3 Over a year later, the *Guardian* published an apology addressed to Transatlantic Records (Thursday, August 28, 1975), p. 8.

> "On May 1, 1974 we published an article on art patronage in the music world in which reference was made to Transatlantic Records Limited and its promotional director Martin Lewis. It is now accepted that the facts upon which the article was based did not justify the severity of the criticisms which were made, in particular, the attack on the integrity of Transatlantic Records Limited, Mr. Lewis, and, by implication, its managing director Nathan Joseph. The Guardian wishes to apologise to Transatlantic Records Limited, Mr. Joseph, and Mr. Lewis for this."

LIVE AT THE ROYAL ALBERT HALL (1974)

"All people who have a passion and spirit for music, especially playing music, would surely find difficulty in declining an offer to perform with an orchestra. Likewise each orchestra that seeks an audience would find it a hundred times more difficult to resist the delightful spell the Royal Albert Hall casts with its invitation.

This brief note of introduction welcomes you to a recording made on the 28th May 1974. It was a date that was destined to become firmly lodged in the Sinfonia's memory, for not only was the Sinfonia, with four new pieces in its repertoire, to be embraced by the father of halls, but, for the first time ever, a choir and a piano concerto were to be included in the programme. The choir was to sing the *Hallelujah Chorus* and was originally expected to consist of 100 singers, however on the day of the concert it was found to exceed 350. So vast an undertaking, together with the Sinfonia membership at an all time high of 82, caused certain communication confusions which were eventually solved by the services of a special choir conductor, Mr. Michael Parsons, who approached this test of strength with a flawless and classic quality.

The evening was to prove true to its promise. A blissful stirring was evident throughout. Only a few were to suffer musical indigestion and had to leave, but for those who stayed a whole feast of surprises lay in wait; Mr. Michael Bond's impeccable announcements, an enchanting interpretation of Tchaikovsky by Miss Sally Binding, a truly moving *1812 Overture*, a grand and magnificent choir."

Liner Notes from *Hallelujah: Live at the Royal Albert Hall* LP (1974).

Pages 112–127: Stills from *Hallelujah!: The Portsmouth Sinfonia at the Royal Albert Hall*, a film of the May 28, 1974 concert directed by Rex Pyke. Courtesy of Martin Lewis and PortsmouthSinfonia.com.
Pages 128–131: Sheet music for the *Hallelujah Chorus* (Handel), arranged by James Lampard, 1974. Courtesy of Suzette Worden.

Royal Albert Hall

GEN. MANAGER A.J. CHARLTON

PORTSMOUTH SINFONIA

PLAYS THE POPULAR CLASSICS

The programme will include

ROSSINI ... WILLIAM TELL OVERTURE

JOHANN STRAUSS .. BLUE DANUBE WALTZ

BEETHOVEN .. SYMPHONY No.5 in C minor

TCHAIKOVSKY NUTCRACKER SUITE (Selections)

GREIG ... PEER GYNT SUITE (Selections)

J.S. BACH AIR FROM SUITE No.3 in D major

SCHUBERT .. MARCHE MILITAIRE

HANDEL 'HALLELUJAH' CHORUS FROM THE MESSIAH

TCHAIKOVSKY ... 1812 OVERTURE

TCHAIKOVSKY PIANO CONCERTO NO.1 in B♭ minor

Conductor: John Farley soloist : SALLY BINDING

TUESDAY 28TH MAY AT 7·30 PM

TICKETS £1·65, £1·40, £1·10, 80p
FROM BOX OFFICE TEL: 589 8212 and usual agents

MANAGEMENT — DEREK BLOCK PROMOTIONS & TRANSATLANTIC RECORDS
Album: 'Portsmouth Sinfonia Plays The Popular Classics' TRA 275 Single: 'William Tell Overture' 'Blue Danube Waltz' BIG 515
Both available now on Transatlantic Records

THEATRE GRAPHICS 01-437 3926

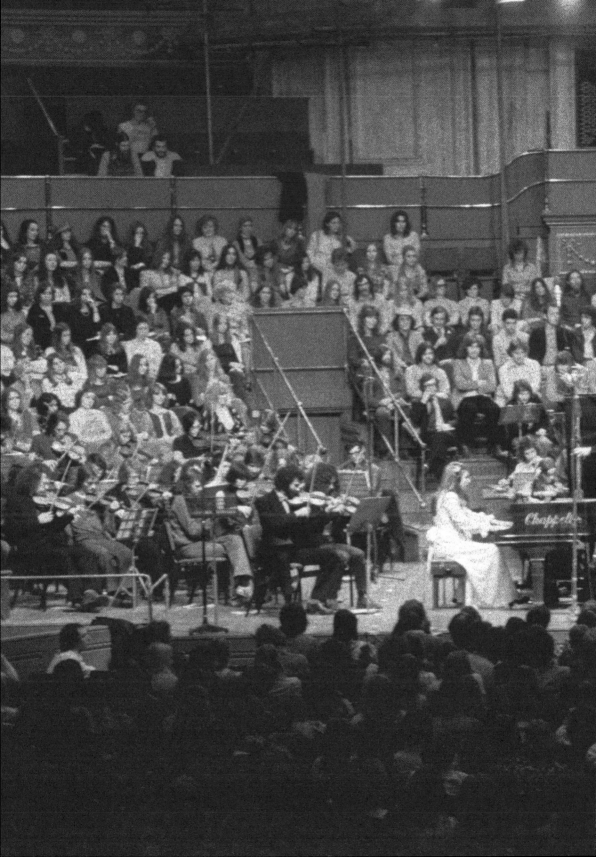

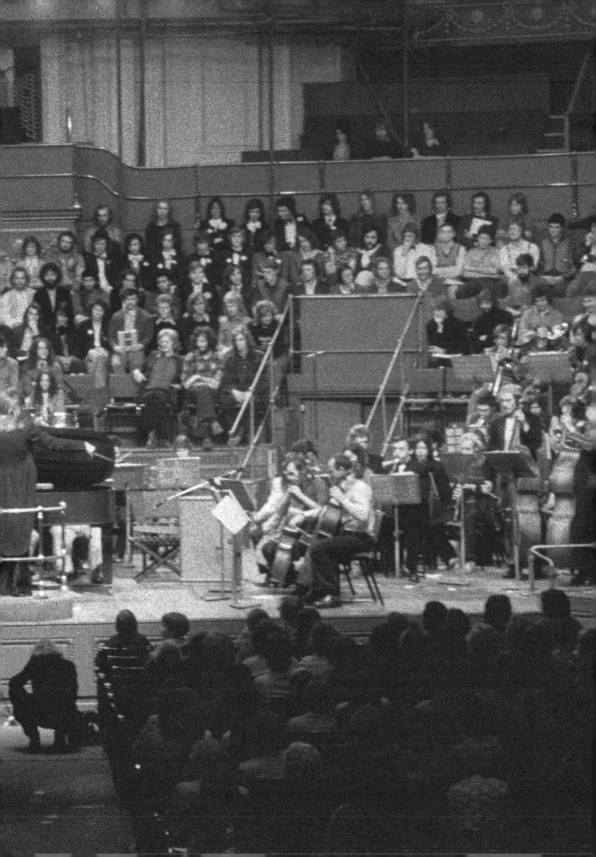

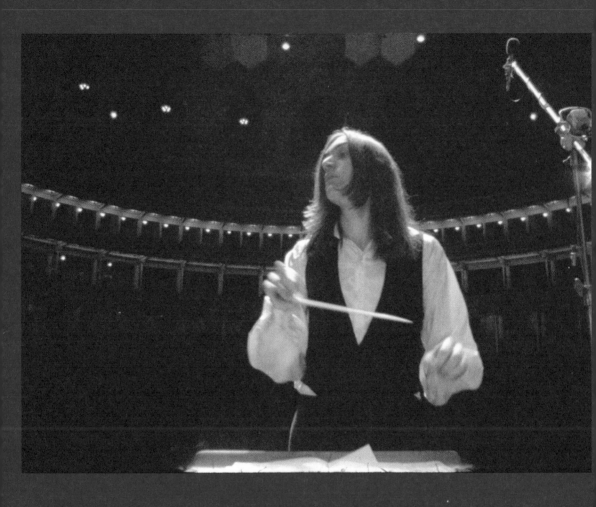

Above: John Farley. **Opposite:** (L-R) Brian Young, Angus Fraser, Peter Clutterbuck.

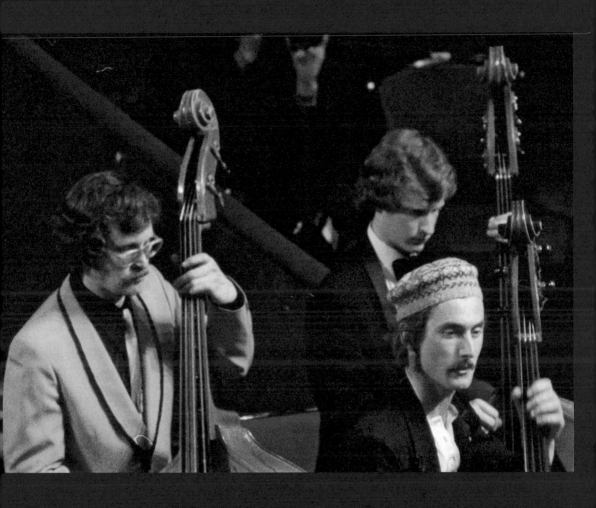

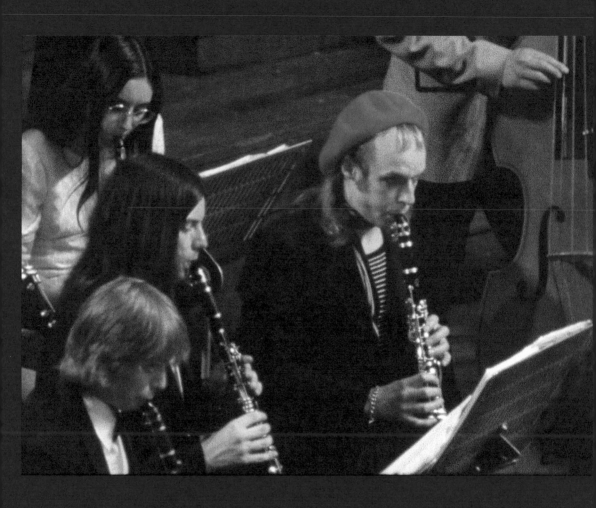

Above: (L-R) Simon Turner, Andrew Tomsett, Brian Eno. **Opposite: (L-R)** Gary Rickard, Gavin Bryars.

Above: (R) Michael Archer. **Opposite: (L-R)** Printz Holman, Simon Dale.

Above: (L-R) Robin Mortimore, Nigel Coombes. Opposite: Brian Eno.

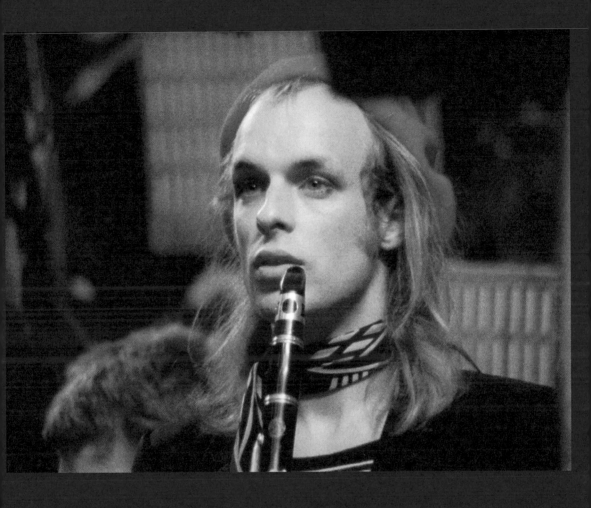

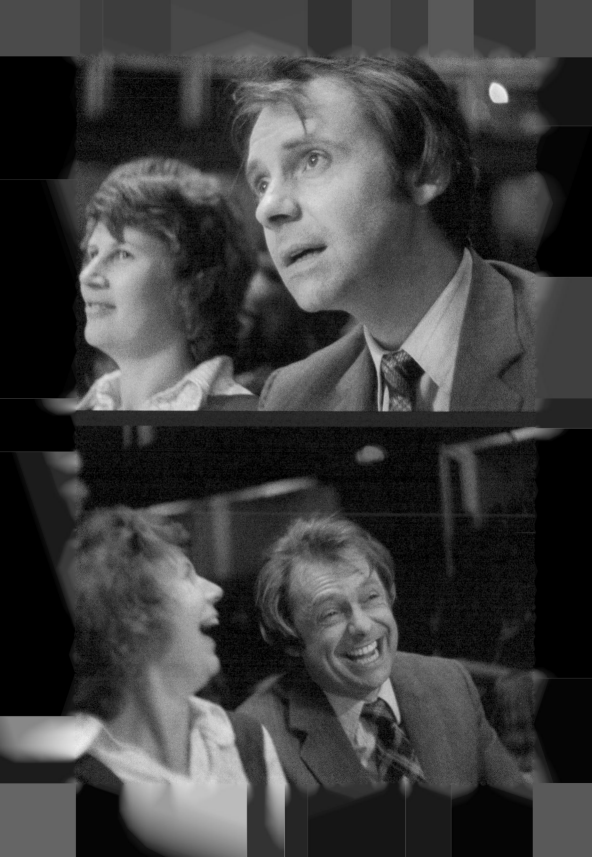

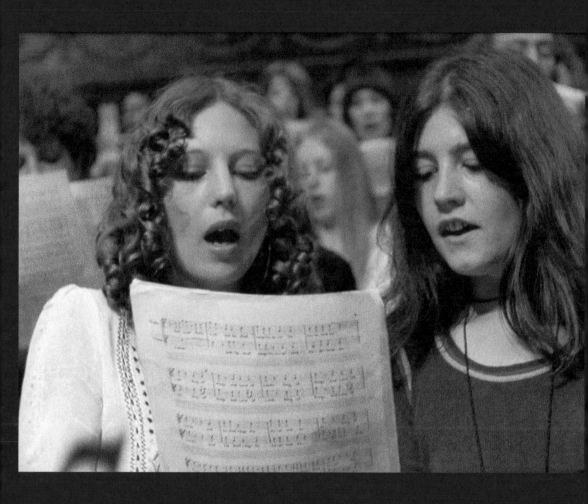

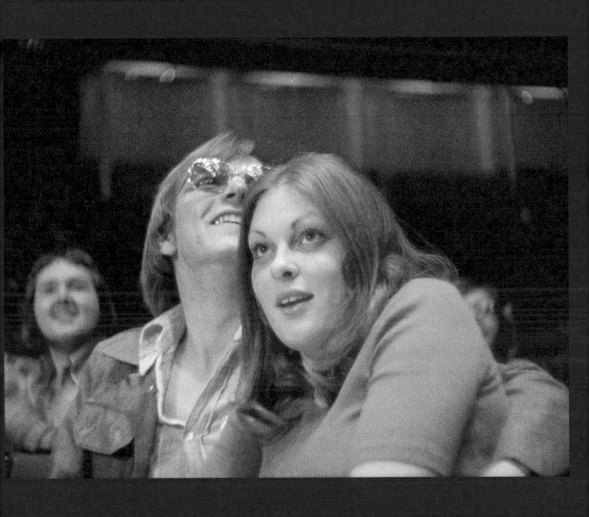

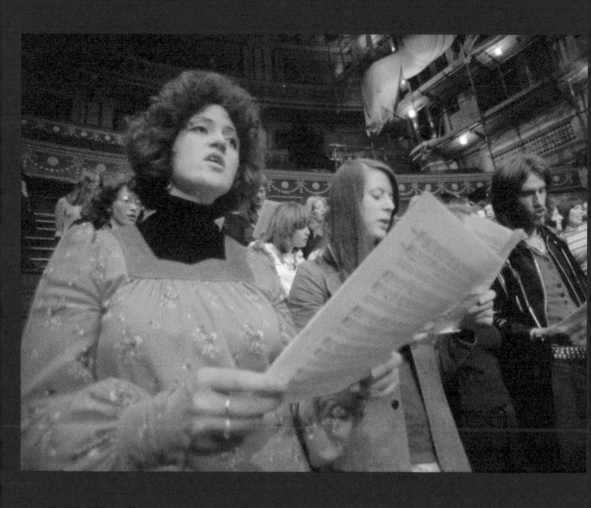

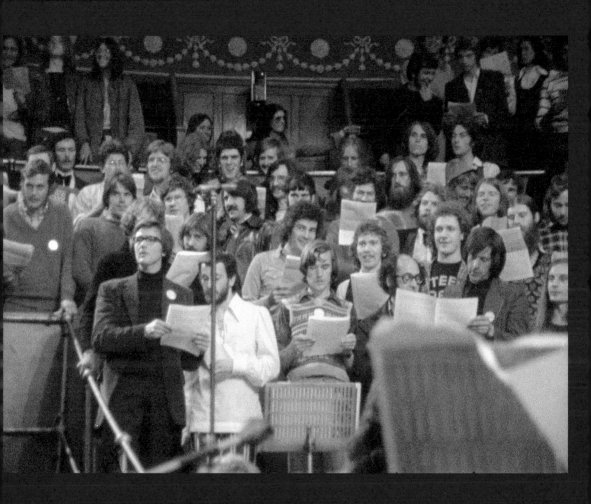

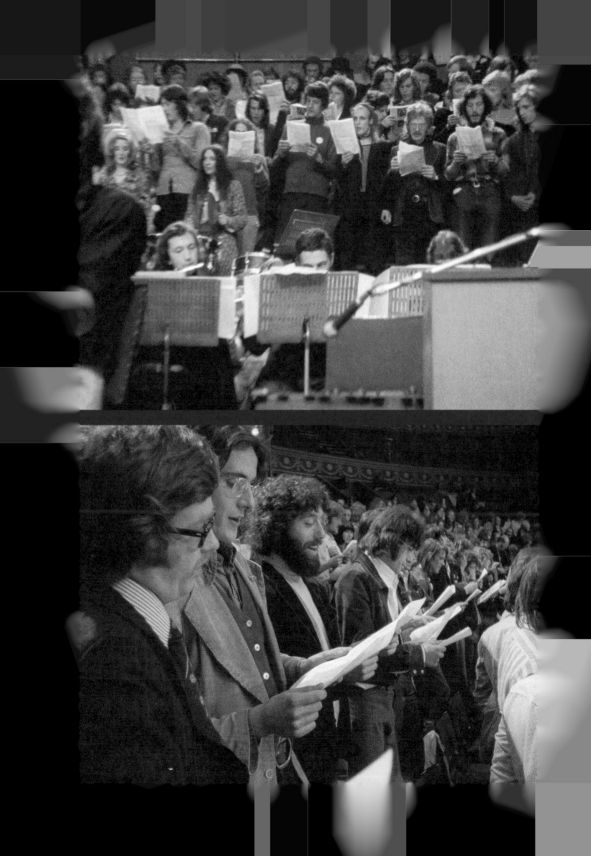

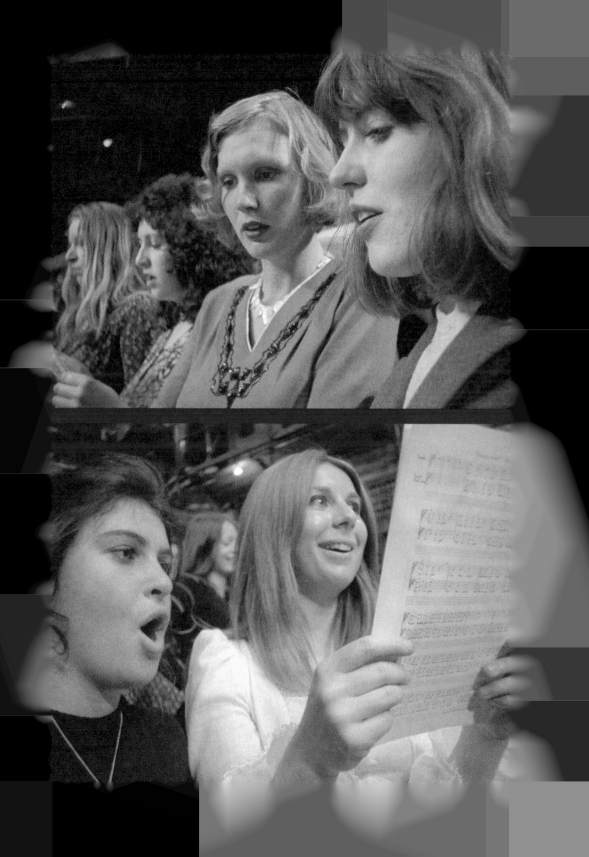

Treble
Tenor 8ve lower

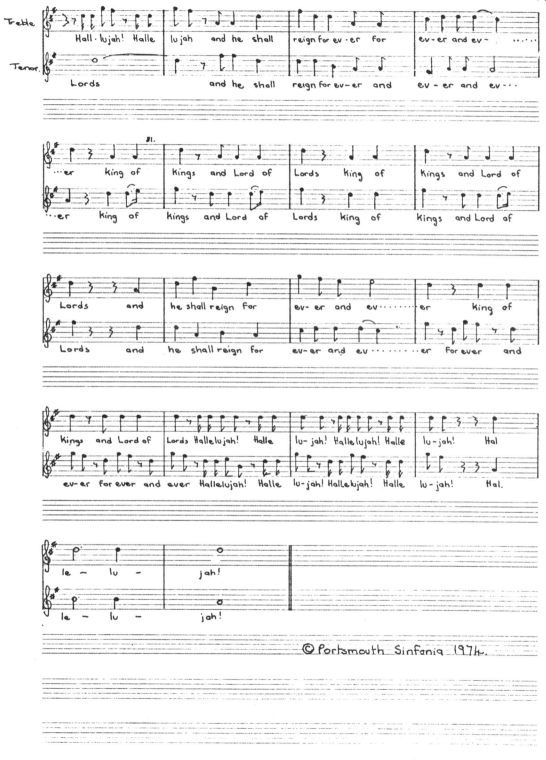

TRANSATLANTIC RECORDS Ltd

P O R T S M O U T H S I N F O N I A C O N C E R T

ROYAL ALBERT HALL

TUESDAY 28TH MAY 1974

B A C K S T A G E

P A S S - I P E R S O N

P L E A S E A D M I T B E A R E R T H R O U G H

A R T I S T E S E N T R A N C E A N D I N T O

B A C K S T A G E A R E A

86 Marylebone High Street London W1M 4AY
01-486 4353/6 01-935 1389 01-935 1380
Cables Xtra London W1

Directors: Nathan Joseph. S.Joseph.

DEREK BLOCK
IN ASSOCIATION WITH
TRANSATLANTIC RECORDS
PRESENTS

The
Rare and Beautiful Music
of

Portsmouth Sinfonia

CONDUCTOR : JOHN FARLEY

AT THE
ROYAL ALBERT HALL
GENERAL MANAGER : A.J. CHARLTON
TUESDAY 28TH MAY, 1974

7.30 pm

ANNOUNCEMENTS : MR. MICHAEL BOND

SOUVENIR
PROGRAMME
10p

Also Sprach Zarathustra

Richard Strauss

Richard Strauss

Blue Danube Waltz, Op. 314

Johann Strauss

Johann Strauss

From The Nutcracker Suite, Op. 71a

"March"
"Dance of the Sugar Plum Fairy"
"Waltz of the Flowers"

Peter Tchaikovsky

"Farandole" - L'Arlesienne Suite No. 2

Georges Bizet

Georges Bizet

"Air" from Suite No. 3 in D Major

Johann Sebastian Bach

"Jupiter" from The Planets, Op. 32

Gustav Holst

J. S. Bach

Marche Militaire in D Major

Franz Schubert

Piano Concerto No.1 in B♭ minor, Op.23 Peter Tchaikovsky

Soloist: Miss Sally Binding

Fifth Symphony in C minor, Op.67

Ludwig van Beethoven

Peter Tchaikovsky

Intermezzo from the Karelia Suite, Op.11 Jean Sibelius

Overture "1812"

Peter Tchaikovsky

Ludwig van Beethoven

From Peer Gynt Suite No.1

"Morning"

"In the Hall of the Mountain King"

Edvard Grieg

Edvard Greig

From the Messiah Part II

"Hallelujah Chorus" George Handel

with the Portsmouth Sinfonia Chorus

William Tell Overture

Gioacchino Rossini

Gioacchino Rossini

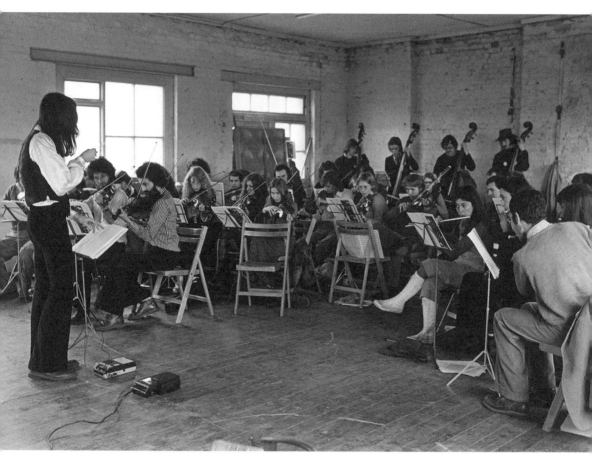

Portsmouth Sinfonia rehearsal. Camden Town, London, 1974. © Rod Taylor/Shutterstock.

COLLABORATIVE WORK AT PORTSMOUTH

Jeffrey Steele
Studio International (Nov/Dec 1976)

> ...This is not music for the ear alone.[1]
> —James Lampard

The establishment of productive working relationships with all other fields of human activity has always been one of the principle aims of constructivist art, since its inception in the years following the socialist revolution in Russia in 1917. When I took up the appointment as head of the Department of Fine Art at Portsmouth College of Art in May 1968, after almost a decade of commitment to painting in the constructivist tradition, it was with the definite hope of developing further the experimental work in music in a fine art context which Keith Richardson-Jones, David Saunders, and I had already begun at Newport College of Art. I will briefly mention some of the factors which formed the ingredients of the primordial soup out of which the primitive organisms [whom] became Portsmouth Music developed in the years which followed.

At Portsmouth College of Art, there was a generally favourable climate, as well as positive support for the development of this work from the principal, John Powell, and Maurice Dennis, the lecturer in charge of complementary studies. There was the possibility to appoint David Saunders to the part-time painting staff and the appointment of a part-time lecturer in Music. Ron Geesin took this position during the autumn of 1968 and Gavin Bryars from [in] the beginning of 1969. The year 1968 is, of course, synonymous with revolutionary activities by students in almost every country in the world. This revolution, or quasi-revolution,

contained a fundamental contradiction between a genuinely progressive trend towards conscious political change and a mystifying tendency towards anarchy and a regressive philosophical idealism. The critical attitude of students which prevailed at that time, often amounting to total rejection of all established academic and educational criteria, disappeared with astonishing speed and completeness within two years—probably because the importance of this contradiction was then insufficiently recognized. The students who joined the fine art course at Portsmouth in September 1968 had, in general, a well-developed suspicion of the forces controlling their own education, a positive motivation to construct an alternative, and a strong sense of the need to do this in a collective way, rather than as a number of young artist-individuals.

The musical avant garde of the late 1960s contained a complex network of contradictions, of which the major antagonism was between various officially approved descendants of the tradition of [Arnold] Schönberg and [Anton] Webern and the American-based school led by John Cage. Both of these traditions had firm historical links with contemporary developments in painting, and the conflict could roughly be said to centre on questions concerning the value and significance of structure in a work of art or music and the attendant proclivities, on both sides, for the results to degenerate into academicism or mysticism. Since Gavin Bryars had worked directly with Cage at the University of Illinois, and I was interested in experiments in the systematic programming of colour, light, and sound, such as those of Ludwig Hirschfeld-Mack at the Bauhaus, both tendencies were well represented at Portsmouth.

I think it is the dialectical resolution of these two contradictions in the context of provincial isolation and naiveté which gave Portsmouth music of that time its seductive quality. Of course such a resolution could only be temporary, localized and idiosyncratic, given the larger world context of ideological and political struggle. The emphasis was on the harmonious apparent resolution of what was, and properly remains, a fundamentally antagonistic conflict. The unfolding of the various stages produced a series of completely unexpected visual, acoustic, and social situations.

PORTSMOUTH POLYTECHNIC
DEPARTMENT OF FINE ART

THEORETICAL STUDIES SECTION

SUMMER TERM 1973

TUES	9.30 a.m.	20th Century British and American Poetry - Alex Potts I-14 (starts 8th May)	2.00 p.m.	Medieval Art - Alex Potts I-14 (starts 8th May)
	11.15 a.m.	Spanish Painters - Flora Dutton I-14	4.30 p.m.	History of Socialism since 1800 - Adrian Rifkin I-15 (alternate Wednesdays starting 9th May)
WED	9.30 a.m.	Political Implications of aesthetic change since 1890 - Adrian Rifkin/ Maurice Dennis Library.	2.00 p.m	Revision class for Political Implications course - Adrian Rifkin/Maurice Dennis I-16
THURS	11.00 a.m.	Musical Analysis - Michael Parsons I-13	1.30 p m	Philosophy and the idea of Progress - Maurice Dennis I-16
			2.00 p.m.	American Painting and Sculpture, 1940 onwards - Flora Dutton - Painting Studio
			3.00 p.m.	History of American Cinema - James Allen Lecture Theatre
			6.00 p.m.	Performance Class - Michael Parsons Lecture Theatre
FRI	9.30 a.m.	Music Seminar - Michael Parsons I-13	2.00 p.m.	Performance Class - Michael Parsons Lecture Theatre
			2.00 p.m.	Seminar on Ireland - Michael Doig and others I-16

ADMINISTRATIVE PROBLEMS

Before discussing the development of the music and art, I shall write briefly about some of the problems it produced at the administrative level. While the majority of fine art lecturers at Portsmouth initially welcomed the new developments, the fact that a dozen or so students wished to give their whole time to musical/performance/conceptual activities and do virtually no traditionally-oriented studio painting or sculpture caused fundamental differences of opinion within the Fine Art Department. Several lecturers who had perhaps envisaged music a peripheral presence were unprepared to accept its integration at the kernel of the system. Because I could not pretend to have an unbiased oversight of this disagreement, and had no means of resolving it, I stood down as head of [the] department in September 1969, when the department officially moved out of the Portsmouth College of Art and into the Portsmouth Polytechnic. From my point of view this meant that I was less burdened with administrative work and could take a more active part in creative work, research, teaching, and debate. The disagreements about the academic status of music and performance in the Fine Art Department were never formally resolved, but Gavin Bryars was appointed full-time lecturer in music, also in September 1969, and all the students concerned obtained satisfactory final examinations results.

Similar disagreements occurred about the status of conceptual art, art and language, performance art, etc., in various fine art departments at that time. These conflicts were all, in some measure, about the general principle of diversification. A group of specialists in mathematics, biology, psychology, and communications engineering had overcome the administrative barriers between their various disciplines, and the consequent interpenetration of their fields of study resulted in the new science of cybernetics. There was a general hope for something comparable to happen, perhaps along the lines of the Black Mountain College experiment, among the progressive artists in the late 1960s.

At the beginning of 1969 it might have appeared that there was a main opposition between principles of order and [the] system as represented by authority, on the one hand, and disruption, chaos, and freedom, on the other, as represented by students and the Cage-inspired avant garde. But, in practice, the main contradiction had a different orientation.

Hierarchical social structures in crisis conditions generate entropy and disruption within themselves as part of a process of homeostasis. The real opposing tendency is towards a flexible "network" structure. Unlike most painters, whose training and experience encourage them to see themselves as individual creators in hierarchical interrelationship, musicians and composers of very diverse opinions and temperaments are accustomed to working together effectively. Moreover a study of the work of those who were to become involved with music in Portsmouth as students, teachers, or visitors shows that they all possess[ed] an interest in the precise interaction of various forms of structured information, so that, in the event, the common interest in the multiplicity of situations resulting from this flexibly disciplined approach was reinforced by a common rejection of both excessively dogmatic and excessively libertarian tendencies.

CHARACTERISTICS OF PORTSMOUTH MUSIC

Although the various artists and musicians who taught regularly or occasionally at Portsmouth obviously affected the students' outlook very profoundly, it is important to understand that almost all the initiatives came from the students themselves. They saw that the necessity for a highly trained collaborative organisation logically preceded the acquisition of musical theory or instrumental skills. Realising that a musical performance is primarily a social event whose success depends on the implied psychological relationships between three groups of people designated composers, performers, and audience, they learned to work directly on these relationships by the timing and placing of events. Their first concerts consisted in sublimely assured presentations of rudimentary and banal material—aping, miming, posing, juxtaposing, and superimposing electronic sounds with impressive visual displays of instruments, which they only later learned to play. Despite the paucity of content, these early concerts were successful because the collaborative, conceptual, and organizational base[s] had already been established.

An essential difference between music and painting is that there is no way of recording or preserving the qualitative aspect of particular musical performances which exist in, and cannot be detached from, time. Because photographs and tape-recording give an essentially illusory and misleading account of reality, the students tended to resist

any attempt to legitimate their activities by such false documentation, just as they derided the notion that their texts and scores had any legitimating value as fine art or graphic design, in the manner of certain works by Cornelius Cardew, [Karlheinz] Stockhausen, or Earle Brown. Starting from this basis the students began to acquire technical knowledge and ability in composition, arrangement, and performance. They learned partly from practice, by trial and error, by questioning, and from cheap instrumental tuition books, but they inverted the explicitly stated premise found in most of these books that long study and practice must precede any worthwhile achievement.[2] It was more as though music was intended to fill an existing need rather than approached from the outside. Each fundamental aspect of music—tempo, rhythm, duration; the possibility of variable pitch, terminology, and notation; dynamics, modulation, etc.—was immediately set to work and combined with what was already known as a source of new compositions. This rather spontaneous learning process was supported by formal teaching such as the lecture series, *System and the Artist*, which I presented throughout 1970 and 1971. The theme was suggested by Noel Forster, who reorganised the former Art History and Complementary Studies [Departments] into a more integrated theoretical studies section of the Fine Art Department in autumn 1969.

Visitors like Cornelius Cardew, Michael Chant, Chris Hobbs, John Tilbury, [and] John White, rather than give classes or concerts, often preferred to work with the students at an equal level on performances of their own or the students' compositions. Only Morton Feldman elected to maintain a certain distance between himself and the students, giving a formal lecture and assuring us that he would never contemplate introducing music into the New York Studio School, [where] he was at that time Dean. That, on the contrary, his main objective there was to quieten everything down.

The connection between musical responses and the basic human process of learning was further emphasised by the founding of the Scratch Orchestra by Cardew, Michael Parsons, and Howard Skempton in London in 1969, by a performance of Cardew's *Schooltime Compositions* at the Portsmouth Guildhall in June 1970, and by the arrival of Ian Hays, who transferred to Portsmouth from another college in order to do music and stayed for less than a year. Hays was a student but comported

himself as a teacher, giving lectures and tutorials which were at the same time musical performances of a highly cathartic nature.

The development in the London-based avant garde, away from pieces with a heavily conceptualized emphasis in which aleatory, whimsical, or randomized events played a major part, towards a re-evaluation of traditional Western melodic and harmonic structures, was signaled by John Tilbury's incorporation of a straight rendering of *Bells Across the Meadow* by Albert Ketelby into one of his Rome concerts. The practice in Portsmouth of using material from beginners' instrumental teaching manuals integrated perfectly with this trend, but the special quality of Portsmouth music at this time owed its existence to a piece of theoretical legerdemain which, in the end, proved unequal to the everyday strains placed upon it.

The widely propagated views of John Cage, to the effect that all sounds have an equal value and that those ambient sounds entering into a musical performance by chance or as a result of ad hoc technical devices are a musically more interesting aspect of composition than syntactic structures produced by human intellect, legitimated types of musical activities in which participation was considered to be entirely independent of consciousness.

This premise, which was somewhat misleadingly associated with Werner Heisenberg's principle of mathematical indeterminacy, allowed experimental composers a vast new range of conceptual possibilities. Its paradoxical implications were elaborated by La Monte Young, in works such as *X for Henry Flynt*. The Portsmouth students in their fashion, and perhaps prompted by La Monte Young's notation, "Practice and perform any piece as well as possible," stood this principle, too, on its head and made it apply dialectically to errors and shortcomings in a basically classical enterprise. Noel Forster gave a lecture (June 1970) on the error factor in his own painting—"The painting as a measure of its own performance." Gradually the whole concept of "error" was eliminated and that of "deviation" substituted. A system was considered realizable by virtue of deviations from it, and while no effort was spared to minimize such deviations from the "ideal" structure, the structural quality of the deviations themselves became an integral part of the system. Negative factors could now be transferred into the positive

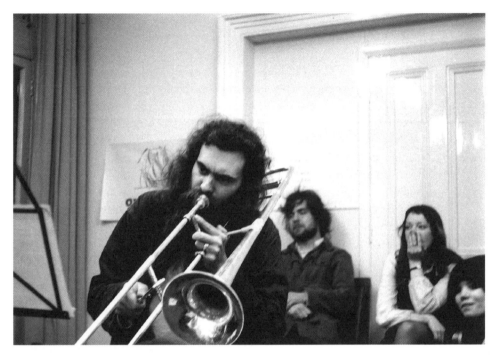

The Ross and Cromarty Orchestra, c. 1973. Photographers unknown. **(Top)** Jeffrey Steele in foreground. **(Bottom, L-R)** Suzette Worden, James Lampard, and unidentified performers. Both images courtesy of Suzette Worden.

column. Successfully realized intentions received silent approval but failure was deemed magisterial. John White compared Portsmouth music to the Promenade Theatre Orchestra: "Our music is confident, precise and crude but Portsmouth music is soft, faltering, and correct."

But, an important caveat: it sometimes happened that somebody joined a performance and hearing a high proportion of false, delayed, premature, or accidental notes, felt entitled to relax and add their improvised contributions to the apparent disorder or event to make deliberately grotesque or inappropriate sounds. There were various means of indicating that this sort of thing was, in fact, the only inadmissible material.

The characteristics I have so far mentioned fall into five categories:

1. Emphasis on collaborative group work and presentation.
2. Equal importance of visual, acoustic, and conceptual aspects of performance.
3. Dedication to the acquisition of elementary techniques of classical music-making.
4. Establishment of working relations with artists and composers.
5. Acceptability of all sounds and actions made with serious intentions.

They applied generally throughout the whole period which I am describing to works by students belonging to different-year-groups, different sections, and with varying degrees of commitment. A sixth characteristic should be added, which is that full use was made of the college painting, printmaking, sculpture, and film studios, as well as the collaboration of lecturers, technicians, and administrative staff. For example, it was agreed that Terry Riley's composition *In C* would be played for a given duration each Thursday lunchtime for a number of weeks, by the same performers, using the same instruments. The performance(s) was (were) [sic] filmed from a fixed point against a white background.

POLITICIZATION

The inherently authoritarian structure of the international avant garde, its reliance on fundamentally occult philo-sophical justification, its

confusion of conscious with un-conscious perception, its total disregard of the real working circumstances of the majority of people—these aspects of avant-garde art negate its pretensions to revolutionary significance. The preposterous nature of John Cage's theories, now so transparently obvious, only percolated slowly through our consciousness then. Suspicion was first aroused when George Brecht visited the department in November 1970. His repudiation, under John Cage's influence, of his own scholarly paper, "Chance—Imagery" (1957), and his unrelieved emphasis on the spontaneous creativity of a small group of privileged individuals, alienated a section of the audience. Successive events exposed serious fissures in the ideological foundations on which Portsmouth music rested.

Gavin Bryars left to take a senior lectureship at Leicester Polytechnic's Department of Fine Art in September 1970. Michael Parsons was appointed on a permanent part-time basis to continue his work in the Fine Art Department and immediately began to pursue very demanding enquiries into the fundamental attitudes to[wards] music, studio, and theoretical work, and general education in the department. At the same time, a more consciously political approach to questions concerning the relations between art, ideology, and social structures developed. Towards the end of 1971, John Tilbury read a paper which presented the first specifically Marxist critique of the role of avant-garde music in a class society.

In a rough way we had worked out for ourselves that capitalist relations of musical production are destructive in four connected ways, viz.:

1. They reinforce the hierarchical structure of society associating music with an ideology of ruthless competition.
2. They deprive society of creative music by substituting a profit-making form of limited-range electronic reproduction[s] of [the] acoustic residue from works designated as of superlative quality.
3. They devalue musical production and discourage the musical development of children by identifying music with the above-mentioned substitute.
4. The substitute music is itself a powerful vehicle for the propagation of anti-conscious ideology.

Opposite: Scratch Orchestra song sheet, c. 1970–71. Courtesy of Suzette Worden.

The Internationale

Arise ye prisoners of starvation,
Arise ye wretched of the earth,
For justice thunders condemnation,
A better world's in birth.
No more traditions chains shall bind us,
Arise ye slaves no more in thrall,
The earth shall rise on new foundations,
We have been nought we shall be all

Chorus: Tis the final conflict, let each stand in his place,
 The Internationale shall be the human race.
 Tis the final conflict, let each stand in his place,
 The Internationale shall be the human race

We want no condescending saviours
To rule us from their judgement hall,
We workers ask not for their favours,
Let us consult for all.
To make the thief disgorge his booty,
To free the spirit from its cell,
We must ourselves decide our duty,
We must decide and do it well.

Chorus

Toilers from shops and fields united,
The union of all who work,
The earth belongs to us the workers
No room for those who shirk.
How many on our flesh have fattened,
But if the bloody birds of prey
Shall vanish from the sky some morning
The golden sunlight will stay.

Chorus

Long Live Chairman Mao

Words freely adapted from the Chinese by C Cardew

The glorious sunrise gilding the east now
Spreads its dazzling rays,
Now blows the east wind rippling the red flags
Flowers in a limitless sea.
Respected and beloved above all
Our guide is Chairman Mao
You're the bright red sun in the hearts of
Revolution'ries everywhere.

Chorus: Long life to Chairman Mao
 Long life to Chairman Mao
 Long life to Chairman Mao, a long long life to him, hei,
 Long life to Chairman Mao.

Disperse the mists, away with those dark clouds
Now the sky is clear,
Full steam ahead the ship of the revolution
Steers its course to the west.
Respected and beloved above all
Our helmsman Chairman Mao
You ensure the correct direction for
Revolution'ries everywhere.

Chorus

Storming the heights the people throughout the
Globe rise up to be free,
The old dark world cannot last forever,
Exploitation will be no more.
Towards the light, towards happiness,
We turn now to Chairman Mao
You're the light that leads our advance t'wards
Communism in the whole world.

Chorus

John Tilbury showed how the avant garde, whom had previously considered themselves virtuously anti-establishment, was in reality an integral part of this repressive system. To concentrate a political attack, as Tilbury and later Cardew did, on their former friends of the American and European avant garde, perhaps betrayed an undialectical approach. It was also dangerously selective since it sought to deny the real creative force, refinement, and ability of artists like Cage, Stockhausen, and Brecht, while diverting attention from the infinitely greater problem of the ideological effects of mass-produced music, to which whole populations are daily subjected [to] at work, in school, and in their homes. Nevertheless, in so far as it concerned our own activities, Tilbury's analysis was seen to be accurate both in general and in detail, and the results of his exposure were, in my view, entirely beneficial.

Music became associated with political struggle, and in 1972, while ideological differences were disintegrating [in] London groups such as the Scratch Orchestra and the Promenade Theatre Orchestra, a much higher level of unity was noticeable at Portsmouth. Students who had previously been repelled by the ambivalent attitudes to jokes and humour and to the ironically pretentious "superstar" status of certain individuals, now found that the music had meaning and that they could contribute to it. Others who had, by now, officially completed their studies, returned to Portsmouth for frequent visits and worked to set up new groups directly stemming from the Portsmouth experiment.[3]

CURRENT DEVELOPMENTS

The Portsmouth Sinfonia, like a sore boil in which were concentrated all residual opportunist, Dadaist, and anarchist tendencies, achieved its climax in the [Royal] Albert Hall on 28 May 1974, and disappeared. The Majorca Orchestra, organized at the same time by the same team of people, notably Robin Mortimore, pursued a diametrically opposite course, giving several concerts in the Lucy Milton Gallery, where the music began to approach in sobriety, simplicity, and clarity, the exhibitions of works by Dutch and English constructivists to [whom] the gallery was committed. Indeed, on one such occasion James Lampard could announce: "The next piece the orchestra will play is *Mountain Air*, composed by our tenor horn player, David Saunders, whose exhibition this is."

C O N C E R T

Thursday 5 February 1976

5.00 p.m. Lecture Theatre

HOWARD SKEMPTON - Accordion
MICHAEL PARSONS and DAVE SMITH - Baritone Horns
MICHAEL PARSONS and HOWARD SKEMPTON - Drums

Three Canons from Glarean's Dodecachordon (16th Century)	- Josquin des Pres Gregor Meyer Jakob Obrecht
Wipe 1, Wipe 2, for drums	- Howard Skempton
Equale, for 2 horns	- Howard Skempton
Three pieces for accordion	- Howard Skempton
Four pieces for 2 horns	- Dave Smith
Constant and changing Pulses 1-4, for drums	- Michael Parsons
Two Canons from The Musical Offering	- J.S. Bach
King Porter Stomp (arranged for 2 horns)	- Ferdinand 'Jelly Roll' Morton

MAJORCA ORCHESTRA

The Majorca Orchestra is a chamber ensemble that plays compositions and arrangements by its members. The music is simple because of the limited capabilities of both performers and composers. All its members play with the Portsmouth Sinfonia or used to play with the Ross and Cromarty Orchestra. These groups attempt to make popular, music not dependent on technical ability and professional ease.

Robin Mortimore, John Farley, Sue Astle violins.

Brian Watterson, Ann Shrosbree, flutes.

James Lampard, glockenspiel and clarinet.

Ted Brum, flugelhorn. David Saunders, tenor horn.

Ian Southwood, double bass. Jenni Adams, percussion.

Pieces include:

Ross & Cromarty Waltz No. 5	(by Suzette Worden)
The Darkies	(by Ezra Read arr. Majorca Orchestra)
The Great March	Two Tune March
Sea Air in G	Maryland Tunes
The Caterpillar	Butterfly Waltz
A Sharp Waltz	Pizza Round
Pot-pourri one	Mediterranean Waltzes
March Air	Sonatina
Ode to a Toad	Amplexus Variations No. 1
Copris Lunaris	Waltz No. 1
Mountain Air;	Easter Holiday Tune
Theme and Variations	

for information contact:
Majorca Orchestra, 228 Elmhurst Mansions,
Elmhurst Street, London, S.W.4. Tel: 01-622-7945.

June, 1973.

Some previous engagements of the Orchestra.

The Slade, with a Graham Snow Theatre presentation
Music Information Centre, Royal Society of Musicians,
 with Gavin Bryars
Midland Group Gallery, Nottingham
The Place, with Strider Dance Troupe
Arnolfini Gallery, Bristol " " " "
Another Festival, Bath " " " "
Chapter, Cardiff " " " "
Clapham and Balham A.E.I. resident course

For further information, contact:

Majorca Orchestra, 228 Elmhurst Mansions,

Elmhurst Street, London, S.W.4. Tel: 01-622 7945.

THE MAJORCA ORCHESTRA

The Orchestra

Robin Mortimore, John Farley, violins.
Brian Watterson, Ann Shrosbree, Deborah Smith, flutes.
James Gregg oboe.
James Lampard clarinet and glockenspiel.
David Saunders tenor horn.
Ian Southwood double bass.
Jenni Adams percussion

The Majorca Orchestra is a chamber ensemble that plays simple
orchestral music composed and arranged by its members.
The simplicity of the music reflects the limited but continually
improving, capabilities of both performers and composers.
All the members also play with the Portsmouth Sinfonia. These
groups attempt to make popular, music not dependent on
technical ability or professional ease. With the Majorca
Orchestra, the freshness and excitement of the Sinfonia is
coupled with more sober qualities to produce a unique and
refreshing entertainment.

The Repertoire

Valse Emu

Mediterranean Waltzes

Pot-Pourri

Maryland Tunes

March Air

Sonatina

Waltzing Majorca

Umm Rhum Bhum

Sea Air

A Sharp Waltz

Pizza Round

Copris Lunaris

Ode To A Toad

Mountain Air

Anywhere In The Sunlight

The Great March

The Two Tune March

Caterpillar

Butterfly Waltz

The Procession

The Darkies by Ezra Read, arr. Majorca Orchestra

Sweet Memories " " " " " "

The Eden Valley Waltz by Crawshaw Crabtree, arr. J. Lampard

David Saunders is, however, an exception, and it would be wrong to exaggerate the degree of integration possible or desirable between constructivist art and music under prevailing circumstances. I personally feel an unbridgeable gulf between my own work, as an artist, and music, such as that [by] Steve Reich, which is usually cited as its nearest equivalent. My actual participation in musical activities at Portsmouth was more in the spirit of I. K. Bonset.[4] I decided late in 1973 that this was an unsatisfactory position and that the most fruitful direction for future collaborative work was, as I had originally thought, more towards the exchange of syntactic information and didactic situations arising out of this exchange. This view was confirmed by the work of musicians and composers with members of the Systems Group of artists.[5] The attempt to collaborate implies acceptance of a common view of art, music, and learning as fundamentally linked psychological processes, by which information becomes accessible to consciousness.

The systematic approach enables artists and composers to exchange technical concepts more freely. The resultant works are not, as is sometimes thought, concerned with equivalents or Baudelairean correspondences between musical sounds and colours, etc., but rather, situations in which known and perceived realities have the maximum possible congruence.[6] Work of this general kind, bringing current developments in systematic music and constructivist art into clear relationship, is now well established at Portsmouth and the Slade. Other modes of collaboration, with origins in the Portsmouth experiment, are taking place at Goldsmiths, Leicester, Liverpool, Nottingham, and other art colleges.

The period of fluid interaction between artists, musicians, composers, and students ended with the recognition of the idealist fallacy on which it was based. Recent generations of Portsmouth students, some of whose first works exhibited the characteristics described above, have since developed various combination[s] of theoretical, musical, and fine art production. Much of this work is of a higher qualitative level than the earlier experimental work, but the operative principle is to *combine*. The attempt at integration, as such, has been abandoned or deferred.

1 From a programme note by James Lampard introducing the "10 piano concert" in March 1971, [held in] the Exhibition Hall, College of Art, Hyde Park Road, Portsmouth.

2 One author of teaching manuals and a prolific and versatile composer of pieces for musicians of limited ability, was free from this puritanical approach. Michael Parsons initiated research into his work and formed a group—the Ezra Read Orchestra—exclusively for its performance.

3 The current range of this work was outlined by Michael Nyman in the review[s] section of *Studio International*, May/June 1976.

4 I. K. Bonset was the pseudonym adopted by Theo van Doesburg for his Dadaist activities.

5 The Systems Group of artists: See "Notes on the Context of 'Systems,'" Malcolm Hughes, *Studio International*, May 1972; and Correspondence, "Systems," *Studio International*, April 1974.

6 Cf. "Systems in Art and Music," Michael Parsons, *The Musical Times*, October 1976.

Following: The Portsmouth Sinfonia at the York Arts Festival in Museum Gardens on July 8, 1973. Photograph © Doug Smith.

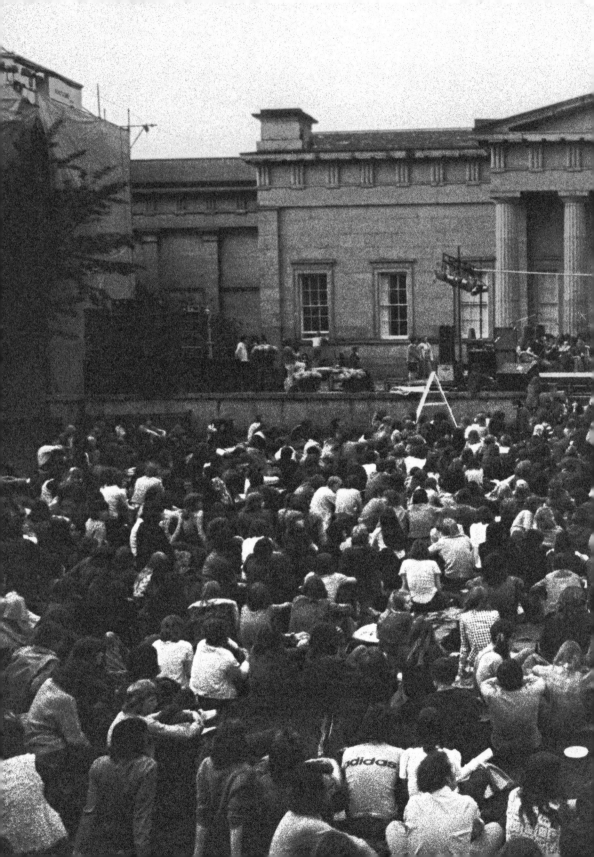

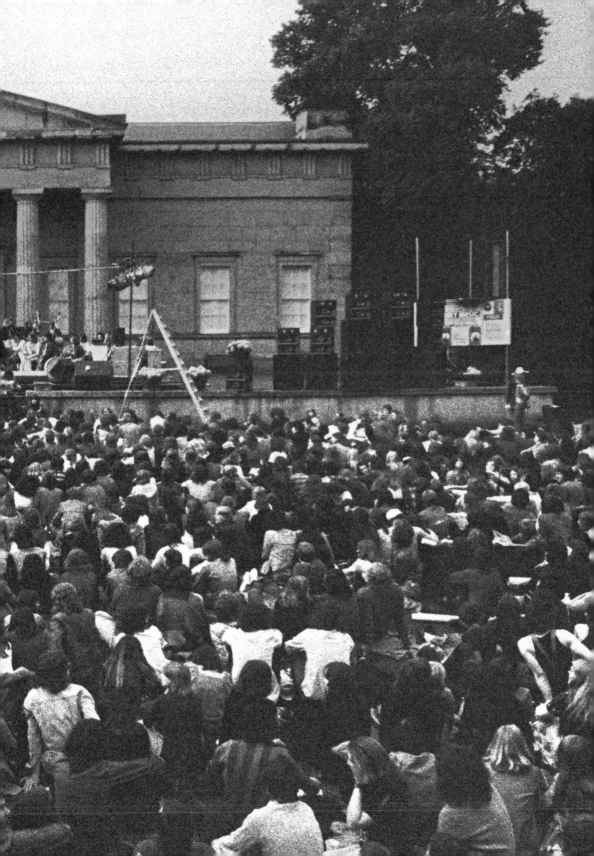

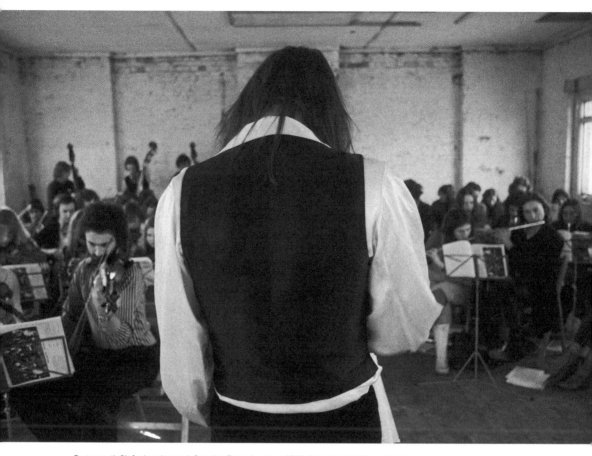

Portsmouth Sinfonia rehearsal. Camden Town, London, 1974. Photograph © Doug Smith.

THE WORLD'S WORST

Christopher M. Reeves

Experimental music is often engaging to listen to for its intellectual charge: Where did such sounds come from, and how or why did the performer make them?[1] Experimental music, like conceptual work more generally, also asks much of the listener, and is often not, by design, a conventionally pleasurable listen. This type of music is not passive, which is more generally how we encounter listening today, on account of the changing nature of our daily working lives and the algorithmic nature of attention, prompted by streaming services, i.e., music to jog to, music to wash your dishes to, work-out music, etc.[2] If one wants to go for a drive while listening to Annea Lockwood's *Glass Music*, one has to train themselves to find the undisturbed beauty in this type of music, to labor to find pleasure in it. Such an effort can prove fatiguing, or, depending on the intent of the composition, entirely counterproductive.

The Portsmouth Sinfonia, an experiment in creative musicianship, emboldened by the constraint that its members not be able to play their chosen instruments, is one such example of this tug of war between pleasure and intellect, the head and the heart. Like their experimental familiars, the Sinfonia's music is challenging, not necessarily by virtue of musical design but through the personification of an Oulipian ideal.[3] Oulipo, generally speaking, refers to a group of French writers, who created works limited by specific constraints—George Perec's *A Void*, perhaps the most notable example, is a novel written without using the

letter, "e." Oulipian writers often aimed to challenge their own learned behaviors and techniques, as well as writerly conventions in general, by employing restraints that might guide the creative process to heretofore unconsidered territories.[4] The Sinfonia, made up of as many trained and skilled musicians as not, would have sounded quite different, and perhaps unremarkable, were they playing the instruments they were proficient on. Despite their connection to vanguard practices in the arts, the Sinfonia did not aim to make music without precedent. Instead, they brought tenets of experimentalism into the realm of the familiar: circulating amongst the public of popular classics.

The Sinfonia's decision to play only segments of classical music that the general public knew well—often from television or movie themes—was a purposeful act of heresy, an intervention that wondered aloud if the canon were at all flexible, and if not, why?[5] By providing the listener a point of access, i.e., "I know this piece of music," the Sinfonia became a different type of experiment, one that masked the heady intellectualism of experimental music with the familiar, parading forth something inherently funny or joyful (always a difficult role for art, particularly art looking to forge new forms). The Sinfonia was an avant-garde confection, a rare example of not only party novelty but also experimental concerns—indeterminate performers playing, minor improvisations born from accidents, and the numerous variables that a collective of trained and untrained musicians brought upon working collaboration.

To this end, Martin Lewis, the Sinfonia's manager (a keen marketer for the often unruly roster on the now defunct independent label, Transatlantic Records) became a crucial part of the story, elevating the group from student experiment to large-scale cult ensemble. Recognizing that "an experiment in the variables of the untrained performer" wasn't much of a tagline, Lewis passed along to the press a judgement: "The World's Worst Orchestra." The line proved irresistible, but what makes it remarkable is that it simultaneously plays down any pretense of experimentation, while emphasizing the general inaccessibility that marks most experimental music making.

By beating the audience to the punch, the tagline of "World's Worst" allowed the Sinfonia to feel like they were in on it, a good-humored experience that suggested there might not be much of a difference

The Portsmouth Sinfonia

between an avant-garde orchestra hall and a sketch comedy one-liner. On the other hand, the risk that could, and inevitably did, mark such a premise was that the Sinfonia became entirely novelty, and their legacy a kind of joke orchestra—more Monty Python than Moondog (particularly in the United States where they had little to no presence).[6] This transition from intellectual deconstruction to punchline symphony is a trajectory in art that has little precedent, and points to a more general tendency in the arts throughout the 1970s, in the move from commenting or critiquing dominant culture, to becoming subordinate to it. In this brief essay, I attempt to look at this shift, outlining the major encounters that pushed the Sinfonia's trajectory, with the aim of readdressing just what might be found in revisiting "The World's Worst Orchestra"—potentials, losses, jokes, and all.

PORTSMOUTH COLLEGE OF ART AND THE SCRATCH ORCHESTRA

A sea change in the British arts education system in the 1960s was put forth to catch up to contemporary trends and innovations in the arts. Pioneered through pedagogical shifts in curricula, British art schools during this time are marked by competing tendencies of both old world romanticism—the private, hermetic craftsperson, honing their skills—and also burgeoning conceptual and social approaches, which attempted to put the notion of "art" up against contemporary processes of hybridizing and deconstruction, structuralism and systems, protest and critique.

The student body of Portsmouth School of Art, c. 1969–72, represented a fine metric of this latter tendency—and although not the hyphen/hybrid/hodgepodge anything-goes-ism that became Leeds College of Art, activity at Portsmouth was a robust site for experimentation, particularly in terms of musical activity.[7] Gavin Bryars, hired at Portsmouth in 1969 was, despite a brief tenure, undoubtedly a major contributing factor to this tendency. Bryars, a composer and musician attracted to conceptual and fantastic scoring and instrumentation, brought both a uniquely British take on the type of musical experiments done in the US, and also a rich, sometimes Dadaist-inspired, sense of play and humor to Portsmouth College.[8] In 1970, Portsmouth faculty Maurice Dennis concocted an end-of-term student/faculty showcase

inspired by (and named after) the British viewer-vote-in talent show *Opportunity Knocks* (a precursor to *The Gong Show*).[9] Airing weekly, and hosted by Hughie Green, *Opportunity Knocks* featured a motley collection of various "talents" each week—plate spinners, singing dogs, and the requisite naïve musical performer. Assembling student activities of all stripes, *Opportunity Knocks* was essentially an art student variety show, and would mark the first performance of the Portsmouth Sinfonia, a one-off orchestral ensemble made up of students who were largely incapable of playing their musical instruments. Unlike other non-professional or deskilled orchestras of the time, the Sinfonia eschewed originals for a canonical piece of classical music, *The William Tell Overture*.[9] As Bryars recalls of *Opportunity Knocks*, "There were people doing ventriloquist acts, comedians, a rock group. The thirteen people of the Sinfonia were also the Pontypridd Male Voice Choir. We just put down our instruments and sang, 'The Lord is My Shepherd.' Four of us were also the Boradin Quartet and six of us were Pyrotechnic Pyramid from the Pyrenees. Basically, three of us knelt down, two knelt across the three of us, and one stood up—we just went 'ta-da' and that was it."[10]

The general sense of goofing off in Bryars's description can lead one to believe that the Sinfonia was merely a fun exercise, a parodic provocation in line with the nature of the event (if not the times). Yet, the Sinfonia was modeled upon a more highbrow arts precedent— the Scratch Orchestra, a roving ensemble of trained and untrained musicians formed by composers and musicians Cornelius Cardew, Michael Parsons, and Howard Skempton. Initiated in 1969 by Cardew (Parsons and Skempton would come on-board soon after) as a means to both address his desire to work with musically untrained performers and also to perform part of his opus, *The Great Learning*—a text and standard notation-based work with the stated goal, "To illustrate illustrious virtue; to renovate the people; and to rest in the highest excellence"—the Scratch Orchestra held a generally similar sentiment towards musical virtuosity as the Sinfonia. Cardew's "Scratch Orchestra Draft Constitution" was a foundational document, which not only helped to steer activity, but provided suggested areas of exploration: "Scratch Music," "Popular Classics," "Improvisation Rites," "Compositions," and "Research Projects." Of particular relevance to the Sinfonia is the "Popular Classics" section, which reads:

Only such works that are familiar to several members are eligible for this category. Particles of the selected works will be gathered in Appendix 1. A particle could be: a page of a score, a page or more of the part for one instrument or voice, a page of an arrangement, a thematic analysis, a gramophone record, etc. The technique of performance is as follows: a qualified member plays the given particle, while the remaining players join in as best they can, playing along contributing whatever they can recall of the work in question, filling the gaps of memory with improvised variational material. As is appropriate to the classics, avoid losing touch with the reading player (who may terminate the piece at his discretion), and strive to act concertedly rather than independently. These works should be programmed under their original titles.[11]

"Popular Classics" included canonical works, such as those by Beethoven or Tchaikovsky, as well as pieces by contemporary composers such as Terry Riley or John Cage.[12]

The sprawling nature of the Scratch makes a set ideology behind the "Popular Classics" difficult to pin down, but from a general critical point of view, the aim seems not necessarily a demolition of the canon (although there were certainly anarchists within the group who called for such a move) but an attempt to democratize it. The historian Virginia Anderson identifies a suspicious and ironic view of the musical canon and its accompanying idolatry as one of the traits typical of British experiments in music making, writing, "The Scratch Orchestra . . . treated high art, neglected art, and so-called low art with equal admiration and equal humor, quite differently from the 'secondary aesthetic practices' . . . in the use of popular music by the historical avant-garde."[13]

This tendency was on full display at the Sinfonia's second public performance at London's Purcell Room for *Beethoven Today* (September 25, 1970), a concert celebrating the bicentennial birthday of the composer. At this "program of reinterpretations and arrangements," musician John White played selections from Beethoven's piano sonatas on bass tuba, accompanied by tape preparations from the *Eroica* symphony from Bryars and Christopher Hobbs, along with a chamber reduction of the Pastoral symphony, while the Sinfonia and the Scratch both shared faux conductors, with John Farley conducting the former's version of *Symphony No. 5* and Skempton conducting the latter's rendition of *Ode to Joy*.[14]

In a pre-emptive review of the concert, the *Observer* remarked that the works performed were "aimed at entertainment rather than erudition," and while it would be misleading to dismiss these interpretations as lacking any sort of proficiency, there was indeed a palpable sense of play with these versions.[15] The *Observer*, knee-jerking in its pre-emptive judgement, nonetheless raised a key question for the British contingent of experiments in music making, particularly those that played with the canon: How serious were we supposed to take this type of new music?

It is within this question that the Sinfonia found a sandbox, muddying up the distinctions between seriousness and goofing off, intellectual exercises and pithy one-liners. This space, hairy as it might have been, was where certain members of the Sinfonia also distinguished themselves from the Scratch. "The Sinfonia came about partly as a reaction against Cardew," Robin Mortimore told *Melody Maker*'s Steve Lake in 1974. "He had the classical training and his audience was very elitist. But he wasn't achieving anything. We listened, thought, 'Well, why don't we have a go, it can't be all that difficult.' Y'know if Benjamin Britten and Sir Adrian Boult can do it, why can't we?"[16] The Scratch Orchestra was, like the Sinfonia, an exercise in performer accessibility, a minor quest to enlighten the masses to the possibilities, potentials, and joy of creating music regardless of its aesthetic (and sometimes conceptual) merits. Yet, contained in their adventurousness was the risk of self-indulgence, a tendency to "degenerate into a hippie free-for-all," as Mortimore put it in the same article.

The Sinfonia's premise was far less anarchic, and, for a gathered audience, relatively simpler to understand: here was a group of performers trying their hardest to play classical music to haphazard and often humorous results. In a write-up on the Sinfonia's *Beethoven Today* performance in *The Source: Music of the Avant Garde*, a staff writer notes that the audience was:

> ... gripped by the experience of recognizing, or not recognizing, the familiar material played by instrumentalists who were not (in any old meaning of the word) skilled, and by the obvious seriousness and commitment which marked the appearance of the performers. Never before, perhaps, had Beethoven's music been greeted with such serious and voluntary laughter; in the pleasure and spontaneity of its response, the audience recognized the simple validity of the Sinfonia interpretation.[17]

Following: Pages from a promotional booklet produced by the Portsmouth Sinfonia, featuring a photograph of the ensemble at "Beethoven Today," c. 1971, inscribed by Ivan Hume-Carter and James Lampard. Courtesy of Suzette Worden.

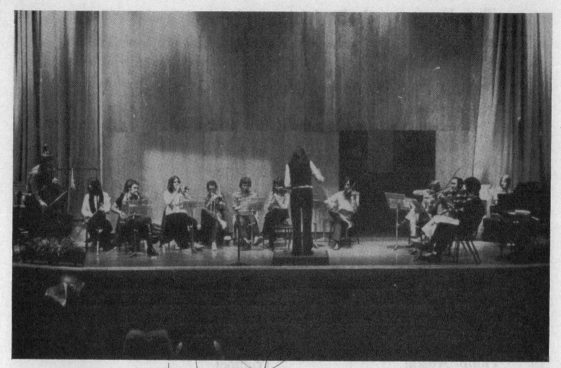

A. Speller

Purcell Room, Sept. 1970

The Portsmouth Sinfonia

It is now a year since the formation of the Portsmouth
Sinfonia, and our first performance of The William Tell Overture.
We are celebrating our anniversary year with a series
of concerts, showing how the much abused and in reality
neglected music of Rossini, Beethoven, Tchaikovsky and
Bach, has been brought back to life with pure intentions
and sense of jollity.
We would like to play for you.
We have reached out to audiences of "classical" concerts,
i.e. The Royal Festival Hall, university festivals, "pop"
music concerts, an art school refectory and await the
opportunity to reach the music lovers you know.

The "simple validity" mentioned is a key distinction between the Sinfonia and the Scratch in their respective approaches towards the potential of the non-musical performer and the negation of a passive spectator or audience (the story goes that at *Beethoven Today*, Michael Nyman, so impressed by the Sinfonia, hopped onstage and started to play a vacant instrument).

By the time of Mortimore's comments on Cardew's inability "to achieve anything" with the Scratch, Cardew felt the same, realizing that a stated goal of "renovating people" in the context of experimentation or avant-garde musical ideas was limited in scope and possibility. Far from turning populist or engaging with pop music, he disavowed experimentation and "new music" altogether, a move that culminated with the seething polemic, *Stockhausen Serves Imperialism*, published in 1974 (the same year that the Sinfonia released their first LP, *Plays the Popular Classics*). The Scratch Orchestra had fallen victim to this ideological turn by 1972, with Cardew writing in a book of Scratch collections, *Scratch Music*: "Scratch Music fulfilled a particular need at a particular time, at a particular stage in the development of the Scratch Orchestra. Such a need may be felt by other groups passing through a similar stage either now or in the future, and some or all of the basic notions of *Scratch Music* may again be useful, but for now, as far as the Scratch Orchestra is concerned, Scratch Music is dead."[18]

Cardew's obituary for the Scratch, predicated on both a slow political radicalization of factions of the group (the Scratch would eventually be redubbed an almost-parodic sounding Red Flame Proletariat Orchestra, at the end of its life) and also his own drive to move towards true revolutionary interaction with people (he dedicated the rest of his life to the cause of the Maoist doctrine of the Marxist-Leninist Communist Party of England) might be felt as the final word on the group.

Yet, Cardew's sentiments, that the tenets of Scratch Music may resonate in other groups, is certainly valuable in considering the Sinfonia. Tony Saint of the *Telegraph* referred to the Sinfonia as "a Scratch Orchestra" in a retrospective piece from 2004, giving credence to the idea that there was *the* Scratch Orchestra—but also that there could be other Scratch Orchestras, who might take tenets or ideas from the working processes of the group. While the Sinfonia's mandate of untrained-over-trained

was not an explicit aim for Cardew or the Scratch, it nonetheless is their persistent legacy.[19] One aim for the Scratch was to decenter and reconsider approaches to the popular classics as a kind of generative strategy, an ideal the Sinfonia shared. A final, crucial difference was that the Sinfonia's brand of deskilled—trained musicians and a few non-musicians playing canonized popular classical music poorly—was intended to be received through immediate recognition, directing the audience to pleasure through an all-too-seldom utilized facet in the arts: humor.[20]

A MUSICAL JOKE?

The question of whether the Sinfonia is a parody act is a complicated one. Parody exists as a mode indebted to foregrounding elements of the past, simultaneously commenting upon and participating in a given (typically) structure. In the Sinfonia's case, the "target" is obviously an orchestra in the Western musical tradition, including its virtuosic makeup and valorizing and propagating select works of music (canon). An orchestra of this kind, say the Royal Philharmonic or the London Symphony Orchestra, inseparably encodes politics and ideologies. Rather than simply deconstruct or reinvent, as did their other new music brethren, the Sinfonia could be seen, keeping in line with Anderson's sentiments on a British tendency to be sympathetic to musical canons, using parody as a gentler form of critique, one that writes back to their target while building upon its conventions.

"[Parody] is an intentional dialogized hybrid," Mikhail Bakhtin writes, "Within it, languages and styles actively and mutually illuminate one another."[21] As a visual example of Bakhtin's notion of parody, we can look at the front cover of the Sinfonia's first LP, *Plays the Popular Classics*, which bears all the hallmarks of a conventional classical music sleeve.[22] On a black stage, in front of a black background, thirty-three Sinfonia players sit or stand expressionless with their instruments (ten members who appear on the album are not present), the name of the group and album titled imposed above them in cursive script. Despite this seemingly inauspicious photograph, there are a few tells on this LP cover that might give a sense that all is not what it seems: the bellbottoms and facial hair—most orchestras aren't typically pictured in such casual clothing and are seldom so hirsute; the appearance of

JOHN FARLEY, conductor

Hear Portsmouth Sinfonia play The Popular Classics on Transatlantic TRA 275

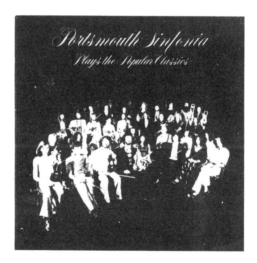

Brian Eno, relatively famous in England by this time from his tenure in Roxy Music; and the fact that the photograph itself is extremely blurry, a likely accident that nonetheless summarizes visually the foggy classical musical that could be heard on the vinyl inside the sleeve.

What the cover of *Popular Classics* does is use the visual codes of classical music LPs and discreetly changes them. Unlike the cover designs produced for someone like John Cage or Karlheinz Stockhausen, which often used formless visuals to represent their respective sonic experimentation (usually psychedelic or minimalist abstraction), *Popular Classics* makes legible visually the "art" at hand, i.e., an orchestra.[23] To this end, the Sinfonia works much more legibly as parody than experiment. However, as Linda Hutcheon notes in her book, the straightforwardly titled *Theory of Parody*, "tension between conservative representation and revolutionary difference is a common denominator [of parody]," and to this end the experiment of the Sinfonia is not only important, but crucial to the parodic aspect.[24] As concert attendees begin to file into the Sinfonia's 1974 Royal Albert Hall concert, filmmaker Rex Pyke was on hand to gather pre-performance reactions. On a reconnaissance mission, Lewis, in a "Transatlantic Records" t-shirt and blazer, asked people filing in if they had heard of the Sinfonia, and while many claimed familiarity, just as many seemed to be attending on the media promoted promise to hear so many works of classical music in one concert. Sinfonia flautist Clive Langer recalled later that "a lot of people came to the Albert Hall expecting a trained orchestra . . . so people were leaving the entire time. People were misled . . . in a cruel way, it was quite funny."[25] For the uninitiated, the parody of the Sinfonia could easily get lost in translation: playing one of the most esteemed concert halls in England represented straightforwardly in a standard press advertisement.[26]

The tension between the Sinfonia as a parody orchestra or an actual orchestra or an experiment in orchestral playing is what ultimately led to a myriad of receptions of the group. *Rolling Stone* awarded *Popular Classics* "Comedy Album of the Year," and also a one-star review, citing the album as "perhaps the worst record ever made; best dismissed as an intellectual joke."[27] Meanwhile, Bryars stresses that the Sinfonia was "not a sendup. We're not sending up the pieces we are playing. It's not a musical joke . . . deliberately created for people in the know, in-jokes

for professionals."[28] Add to this Nyman's inclusion of the Sinfonia in his canon-building tome, *Experimental Music: Cage and Beyond*:

> Considering the Orchestra's intention simply to play the music they know … it might seem odd to find the Sinfonia in a book on experimental music. Not, however, if one remembers [Howard] Skempton's term 'uncontrollable variables.' These variables are located not in the arrangements of the pieces, which may be truncated to preserve the most well-known bits, or re-orchestrated yet otherwise remain faithful to the originals, but in the players themselves. The uncontrollable factor arises out of the variable abilities of the members. Some are untrained and others less musically innocent may not be specially expert on their instruments. As with so much experimental music, one hears a wide discrepancy between intention and effect.[29]

It becomes a metaphysical or even existential question then, whether the Sinfonia is an actual orchestra. Such pontifications might go along the lines of whether a classical orchestra must be defined by capable players, right notes, pitch, rhythm, etc., or if it merely need be a collective body working its best to express a piece of music. Revising the terms of a conventional classical orchestra by putting committed dilettantism front and center is, whether trying one's best to represent or setting out to purposefully deskill the canon, a disruption that wonders aloud about the control of meaning, and thus, access. This has always been the idea behind experimentation—visual, musical, poetic, etc.—to consider things otherwise, and what sets the Sinfonia apart from their contemporaries is their hybridity: an experiment against pat virtuosity that lent itself well to parodic comment, and more often than not was wholly sincere. The Sinfonia makes a case for the sincerity of goofing off, the hilarity of experimentation, and the politics of a lampoon. Most effectively perhaps, they make a case for the joy of inclusion.

The Royal Albert Hall concert ended with Part II of Handel's *Messiah*, the *Hallelujah Chorus*. The audience—estimated around 850 people—was asked to join the Sinfonia choir. If throughout the concert the audience was prone to bursts of laughter at the Sinfonia's mangling the classics, this big finale that invited the audience into the chaos elicited pure glee. Nearly every audience member filmed during this segment of the concert in Pyke's film is smiling, singing proudly and loudly as possible. Of course, to play *Messiah* at the Royal Albert Hall had some

historical precedent—the Royal Choral Society, a choir of amateurs, had established an annual Good Friday performance of Handel's piece in 1878. Thus, while the Sinfonia's covert musical vanguardism was audience accessible, and their humorous intent-ions debatable, their sentiments on bourgeois culture seemed readily apparent, proving that joy and critique can exist alongside one another without pessimism, cynicism, or the extremes of irony.

THE WORST ORCHESTRA IN THE WORLD

Lewis's tagline most certainly elevated their status in the media, bringing them recognition outside of a small nomadic tribe of art students and musical sojourners. However, the music was always the Sinfonia's and the judgement of "worst" is always ours. Their branding, cannily playing up the comedic aspect, makes the "simple validity" of their premise more palatable generally, but in doing so masks somewhat the possibilities of thoughtfulness in their conceit, seemingly less about collective catharsis and edification through shared fallibility, and simply a spectacle.

By the time the Sinfonia appeared on the Jack Palance-hosted *Ripley's Believe it Or Not?* television series in 1982 (playing a clip from a live performance from the 1970s), this move towards full novelty act seemed concrete. It's difficult to surmise if this transition impeded any later attempts by critics or writers to consider their work seriously, but writing on the Sinfonia since their 1980 back-to-basics popular classics concert in Paris has been sparse to non-existent.[30] Was it that the branding, "the world's worst," made their failure generic, or a mode of success in its own right, thus relegating the act of failing obsolete? Failure without learning is, after all, proud incompetence, a condition all too prevalent in our contemporary moment to be of much interest outside mild intellectual curiosity.

Today, proud incompetence has become the flavor of the world—no doubt on account of the increasing prevalence of automatism—and "trying one's best" has proven an able shorthand for willful or dangerous (particularly in governance) ignorance. It would be patently ridiculous to single out the Sinfonia as a catalyst for this, but their example has certainly been followed into unchartered

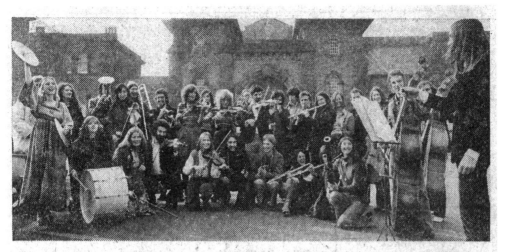

The entire Portsmouth Ensemble . . . their proud boast: 'We're the worst'

The Portsmouth Sinfonia outside of Wandsworth Prison, 1975. Courtesy of Suzette Worden. Credit and permission: Larry Ellis/ Daily Express/Express Syndication.

territories, perverted for the sake of various grasps at power. It becomes important to reassess the legacy of the art of the 1960s and '70s in order to extradite them from their easy link as a harbinger of these contemporary insidious tendencies. A group like the Portsmouth Sinfonia is certainly postmodern—provisional, fragmentary, flexible, forcefully ironic—and thus carries the baggage that all of these postmodern attributes have wrought.

Their conceit was not simply, as I hope I have expressed, a distanced critique or a celebration of one's freedom to choose to remain incapable. The Sinfonia believed, importantly, in a collective power to transform, setting an example not just of incapability, but tenacity in numbers that articulated resistance. The Sinfonia's political legibility was minimal, but what they represented, at their best, is something that is often promised in vain through communicative technology today: a connection. The Sinfonia players struggled together during *William Tell* and this difficulty was witnessed and emphasized (and laughed with) by the audience: what the Sinfonia allowed for, or even demanded to some extent in their premise, was that those listening understand what it might be like to be someone else, to sympathize, empathize, or find joy with them. To say it another way, of utmost importance was the positive

value of participation. While operating on a different class of goals than their more musically adventurous contemporaries—many of whom they played alongside—the Sinfonia offered up an experiment in experience by giving their listeners an immediate in. Few of the best orchestras offer up such concessions.

1 Although used for the sake of clarity in this essay, I hesitate to use the term "experimental" on account of both a.) the generalized set of attributes and aesthetics that normalizes an experiment to a recognizable category today; and b.) engaging alongside systemic orders of power that proactively worked to keep experiments in music by non-white-Anglo men subterranean. "Non-idiomatic" is entirely imperfect, if not a bit pretentious, but could be a good placeholder until someone can come up with a better way to describe the rich and varied activity of this time period that doesn't simply designate the entire strata of this work to either "The John Cage School" or "found in Michael Nyman's *Experimental Music* book."

2 In this regard Brian Eno was quite ahead of the curve with *Music for Airports*. Space prohibits expounding this further, but *Music for Airports* is not exactly Muzak, per se—it invites us to consider the material nature of sound, how it is listened to, the conditions of where, etc. This is quite different from a Spotify-generated driving playlist. I discuss this further in *How to Listen to a Record* (Something Other Press, 2018).

3 In 1971–73, the Sinfonia played many concerts that shared bills with some of the cream of the crop in the "new music" world, as well as more experimentally inclined rock groups: Derek Bailey, Carolee Schneeman, Roxy Music, Henry Cow, AMM, Alvin Lucier, several members of Fluxus, John Cage, and Pauline Oliveros, just to name a handful. Through sheer conceit, and a willingness to perform, the Sinfonia's avant-garde bona-fides were relatively in place. This was further exacerbated by the presence of Brian Eno, who began to perform with the group sometime around 1972.

4 "There probably was [a connection between the Sinfonia and the ideas of the Oulipo]," Gavin Bryars explained to *The Quietus*'s Robert Barry in 2012. "Though that was a couple of years before I became involved with the College of Pataphysics. But then, on the other hand, as pataphysicians will tell you, everyone is a pataphysician—they're simply not aware of their pataphysical nature" (<https://thequietus.com/articles/08491-gavin-bryars-interview>). However, during a 2012 BBC Four radio interview with Joylon Jenkins, Bryars disputes that there was ever a restraint saying that Sinfonia members must not know how to play their chosen instruments: "That's a rather scurrilous rumor put about by the BBC, I think. From time to time, there were people who did join the orchestra who were professionals on their instruments. I remember at one point there was a trumpeter called Ted (Brum), who was a professional trumpeter, and he played with us at the Roundhouse when we played in 1972. We thought he was going to show us up and it would be really very embarrassing. But of course, Ted, like a good musician, was someone concerned with following the score and following the conductor. In both cases, there were huge gaps in conveying the information. So, Ted . . . would fluff his note like everybody else." (<http://www.bbc.co.uk/programmes/b013fj17>). Bryars is, as this book testifies, one of the only individuals involved in the Sinfonia who claims that they did not go by a caveat for joining the group. Here, Bryars is putting an emphasis not on the membership restrictions placed on the performer, but in the system of notation and conducting (John Farley, chosen because he looked the most like a conductor). This is an added dimension to what Michael Nyman finds experimental in the Sinfonia, despite their usage of

canonical classical music. One exception was Sally Binding, who was an exceptional pianist and played, albeit significantly transposed, on Tchaikovsky's *Piano Concerto*, from B-minor to A-minor. Lastly, Ted Brum regularly played trumpet with the Sinfonia, but according to the program for the Roundhouse concert—part of the enormous *ICES-72* festival—he is not on the roster. Either the roster is incomplete or Bryars is thinking of a different event.

5 Rossini's *The William Tell Overture* was familiar to many of the group as the theme to *The Lone Ranger*. Gavin Bryars notes that, "Everything the Sinfonia did they'd taken from popular sources—the [Richard] Strauss piece [*Also Sprach Zarathustra*] was the theme to [Stanley Kubrick's] *2001: A Space Odyssey*, which is also where our version of [Johann] Strauss's *Blue Danube* came from. We strung the two together. I don't think most people in the Sinfonia realized they were two different Strausses actually." (David Sheppard, *On Some Faraway Beach: The Life and Times of Brian Eno* [London: Orion Books, 2009], p.156)

6 This was not for lack of trying. The Sinfonia were signed to Columbia Records in the US by longtime label head Goddard Lieberson, who had overseen the signing of Bob Dylan and Bruce Springsteen. Lieberson died just a few weeks before Sinfonia delegates arrived at Columbia HQ, and with him went any label interest or support for the group. Lewis called the American release of *Popular Classics* a "piss drop in the ocean. It could never have any success because there was no one who understood it" (personal correspondence).

7 See: James Charnley, *Creative License: From Leeds College of Art to Leeds Polytechnic, 1963–1973* (London: Lutterworth Press, 2014); and Jeffrey Steele, "Collaborative Work at Portsmouth" (*Studio International* 192.988, Nov/Dec 1976), in this book, p. 135.

8 *The Visual Anthology of the Experimental Music Catalogue* (1973) contains several examples of more whimsical scores by Bryars: *Marvelous Aphorisms Are Scattered Richly Throughout These Pages* (Winter 1969) calls for a variety of sound-making devices to be obscured by one's clothing and includes two photographs of Bryars in long overcoat, a concealed sound apparatus flasher; *Golders (As) Green By Eps(Ups) Om('N') Downs* (September 1970) is a score that calls for a helicopter to bump cooling towers with a large dangling metal ball for percussion.

9 Portsmouth College of Art groups the Majorca Orchestra and the Ross and Cromarty Orchestra were similarly made up of students who were unable to play their chosen instruments well.

10 Bryars in Sheppard, p. 65.

11 Cornelius Cardew, "A Scratch Orchestra Draft Constitution." *The Musical Times*, Vol. 110, No. 1516: 125th Anniversary Issue (June 1969), p. 617–19.

12 Their Queen Elizabeth Hall concert in November of 1970 featured both Strauss's *Blue Danube* and Riley's *In C* (as well as Mahler, Tchaikovsky, and the UK's Eurovision entry in 1969, "Boom Bang-a-Bang" by Lulu, a song famously parodied by Monty Python). Queen Elizabeth Hall program courtesy of the private archives of Richard Ascough.

13 Virginia Anderson, "British Experimental Music After Nyman," in Benjamin Piekut, ed., *Tomorrow is The Question* (Ann Arbor: University of Michigan Press, 2014), p. 159–79.

14 **The Maestro at the Bar, or, The Image of the Composer:**

On the television show *Seinfeld,* the character Bob Cobb, conductor of "The Policeman's Benevolence Orchestra," insists on being called, by friends and lovers alike, "Maestro." We are meant to infer that Cobb's mania is a product of his conducting a lower-end orchestra, either a marker of insecurity or a symptom of entirely unearned confidence. While on a date, the character Elaine makes the mistake of calling him by his given name:

Maestro:
You know, I'm sorry I didn't mention it earlier, but actually I prefer to be called Maestro.

Elaine:
Excuse me?

Maestro:
Well, you know, I am a conductor.

Elaine:
Yeah, so?

Maestro:
Oh, I suppose it's okay for Leonard Bernstein to be called Maestro because he conducted the New York Philharmonic. So he gets to be called Maestro and I don't.

Elaine:
Well, I mean don't you think that he was probably called Maestro while he was conducting, not in social situations? I mean his friends probably just called him Lenny.

Maestro:
I happen to know for a fact that he was called Maestro in social situations. I once saw him at a bar and someone came up to him and said, "Hello Maestro, how about a beer?" O.K. So that's a fact.

How does Bob Cobb think of Leonard Bernstein? What could it mean that, even in intimate social gatherings (note that "beer" is a more affable symbol of leisure than "wine," or even, "drink") Bernstein was referred to by his profession? While the accuracy of Cobb's story is arguable (1), what we can glean from Cobb's inferiority complex is not only a coveting of respect (the joke being that Bernstein is one of the most revered conductors in history) but his inability to distinguish between personal and professional life, something Elaine on the other hand, is wholly able to do. Yet, Cobb's demand is not entirely uncommon, particular in the realm of authority figures—"Mr. President," "Boss," "Officer," to name a few possible examples whose titles are synecdoche for their subjectivity. Asking, "Why don't we call all orchestra conductors 'Maestro'?," opens up an inquiry that touches on the authority of orchestra conductors and how we perceive them.

On Quora, a "questions and answers website," a (notably anonymous) question was posed: "Why is there a conductor in an orchestra? Don't the musicians know the music?" Jimmy Levi, "probably a music major?," answers:

> Have you ever run a rehearsal? I ran a few string quartet rehearsals—it's hard. You have to manage your rehearsal time to make sure you cover all the passages you need to. Hell, it's difficult getting 4 people in a room together, let alone 100. The conductor of an orchestra does all this—planning and running rehearsals. Running rehearsals involves communicating musical ideas to the musicians efficiently, so conductors must be master communicators. My rehearsal was a piece of cake compared to what a conductor actually does. I wrote the piece I was rehearsing, so I knew exactly how I wanted each passage performed. A conductor has to spend hours and hours studying the music to try and figure out how to perform someone else's music. If the musicians did score-study instead, then you would have to reconcile 100 different opinions about how the piece should be performed. Performance of music has 3-4 layers. It begins with the composer, then the score, then (where applicable) the conductor, then finally the musician. The conductor isn't a necessary middleman in small chamber ensembles. An orchestra has far too many parts to be leaderless. (2)

What Jimmy Levi, "probably a music major?," gets at, is a longstanding truism of the conductor, which we can trace all the way back to 1913 in Lavignac and Laurencie's *Encyclopedia of Music*: "In summary, the orchestra leader must possess the qualities of a leader of men, an always difficult talk that is more particularly delicate in the case of artists." (3)

Artists, as we are all aware, are a difficult lot—bohemian, demanding visionaries who, without a proper supervisor, will spin into pure chaos. This is why we look to the bourgeois, who take the form of curators, collectors, tastemakers, critics, and

institutional directors, to tame and temper these wooly personalities. As Lavignac and Laurencie suggest, this is no different, despite the perhaps immediate reticence to associate a chamber orchestra player with bohemia, when it comes to the makeup of an orchestra. Jacques Attali, in his seminal book, *Noise: The Political Economy of Music*, makes this point crystal clear: "The ruling class—whether bourgeois industrial or bureaucratic elite—identifies with the orchestra leader, the creator of the order needed to avoid chaos in production. It has eyes only for him. He is the image it wishes to communicate to others and bestow upon itself." (4)

As a thought experiment, think for a moment about the image of a conductor. Our immediate thought might go to signs: the baton or the tuxedo. We might also think about their expressions or movements: serious, poised, arms outstretched, rapidly moving, hair (if they have any) disheveled and moving wildly. Of course, the conductor must also act in accordance with what a conductor's labor has been historically. Let us consider this conductor for an orchestra. Their movement is quick and forward, a little too precise, a little too rapid. They conduct the orchestra with a step a little too quick. They bend forward a little too eagerly, their eyes express an interest a little too solicitous for the audience assembled. Finally, they bow for the finale, an inflexible stiffness like that of some kind of automaton while holding their baton with the recklessness of a tight-rope-walker by putting it in a perpetually unstable, perpetually broken equilibrium which they perpetually re-establish by a light movement of the arm and hand. All this behavior seems to us a game. They apply themselves to chaining their movements as if they were mechanisms, the one regulating the other; their gestures and even their voices seem to be mechanisms; they give themselves the quickness and pitiless rapidity of things. They are playing, they are amusing themselves. But what are they playing? We need not watch long before we can explain it: they are playing at being a conductor in an orchestra. There is nothing there to surprise us. The game is a kind of marking out and investigation. The child

plays with his body in order to explore it, to take inventory of it; the conductor of the orchestra plays with their condition in order to realize it.

In 1970, Portsmouth College of Art student John Farley, was chosen to be the conductor of the Portsmouth Sinfonia. Bryars remarks, "(Farley) was chosen because he looked most like a conductor. He studied all the photos . . . he had long black flowing hair. He looked terrific. He was completely incompetent as a musician. . . . He wouldn't know a beat if he saw one . . . in a sense he's rather like a mime artist." If a conductor acts the way they act because they must explain their role as a conductor—i.e., it would not make sense for the conductor to bring us a pizza during this concert (unless of course the score called for it), and if they are simply fulfilling a social function (acting a certain way), and therefore denying their own autonomy (their choice to be a conductor), what can be said about Farley, who steps up to the rostrum to conduct an orchestra, having studied what a conductor looks like, but not how to be a conductor? What Farley does, ultimately, is critique the notion of surrendering subjectivity to professionalism on its own terms. He is no more a conductor as I am Jean-Paul Sartre, whom I plagiarized (with a few tense and pronoun changes) in the previous paragraph. (5)

A constant in twenty-first century life is this inability to distinguish our own freedom from our performed labor. Unlike Sartre, however, an awareness of one's performativity, one's exquisite precariousness, can lead to other possibilities. Farley's (or any of the number of individuals from the mid-twentieth century onwards who recalibrated the idea of "conductor" or "orchestra" either conceptually, or just by their marginalization from its tenets) gesture reflects an undesirable image of something desired, not necessarily as a critique of that position (Farley truly tries to be the best conductor he can possibly be), but to comment on how the social function is mediated by those in power (the same way that citing Sartre might show the signs of an intellectually curious writer working in the European tradition, just as writing

his ideas down verbatim and publishing them as one's own are not). The role of conductor may not have dramatically changed on account of Farley's mimicry, but it nonetheless opens up a line of analysis and inquiry: What could it mean to be a conductor who can't conduct, and how might that, like any good art, possibly subvert the expectations of the ruling classes and show other possibilities? In a later episode of *Seinfeld*, Cobb returns, showing an "old conductor's trick I learned from Leonard Bernstein" of not wearing his pants before a performance. (Note, Cobb does not ever call Bernstein 'Maestro' himself). Hanging the pants from a clothes-hanger beforehand keeps a "perfect crease." So distracted is Cobb by (yet again) this conductor mimicry, that he fails to notice his crooked baton (used as pool cue for a close quarters pool game earlier in the episode). He attempts to press onward, raising the baton, and the small orchestra dutifully follows (playing the music convincingly). Yet, this symbol, non-coincidentally flaccid, becomes too much for the Maestro, and he exasperatedly gives up. So obsessed is he, with the image of performativity—in title, clothing, baton—that he cannot fulfill any number of functions without them. As a metaphor for our own contemporary situation, in which we continually reevaluate the various forms of our performed labor, we must remember not to lose sight of the image of this labor, not to valorize it (and thus the systems behind it), but to remember what it is a stand-in for.

(1) Frank Strauss recounts, "On numerous backstage visits, I was always told that I should address Lenny as Maestro, which I dutifully did." As this quote suggests, "Lenny" might have been just as intimate a nomenclature (<http://bernstein.carnegiehall.org/leonardbernstein/memorybank.aspx>).

(2) <https://www.quora.com/Why-is-there-a-conductor-in-an-orchestra-Dont-the-musicians-know-the-music>.

(3) Lavignac and Laurencie quoted in Jacques Attali, *Noise: The Political Economy of Music* (Minneapolis: University of Minneapolis Press, 1977.)

(4) Ibid.

(5) The previous paragraph was a reworked version of the story of the water in the "Bad Faith" segment of Sartre's *Being and Nothingness*. The original text:

"Let us consider the waiter in the café. His movement is quick and forward, a little too precise, a little too rapid. He comes toward the patrons with a step a little too quick. He bends forward a little too eagerly; his voice, his eyes express an interest a little too solicitous for the order of the customer. Finally, there he returns, trying to imitate in his walk the inflexible stiffness of some kind of automaton while carrying his tray with the recklessness of a tight-rope-walker by putting in in a perpetually unstable, perpetually broken equilibrium which he perpetually re-establishes by a light movement of the arm and hand. All his behavior seems to us a game. He applies himself to chaining his movements as if they were mechanisms, the one regulating the other; his gestures and even his voice seem to be mechanisms; he gives himself the quickness and pitiless rapidity of things. He is playing, he is amusing himself. But what is he playing? We need not watch long before we can explain it: he is playing at being a waiter in a café. There is nothing there to surprise us. The game is a kind of marking out and investigation. The child plays with his body in order to explore it, to take inventory of it; the waiter in the café plays with his condition in order to realize it." (*Essays in Existentialism*, New York: Kensington Press, 1965; p. 167).

Further, what sets Farley apart from a conductor Sartre explicates himself: "It is not that I do not wish to be this person or that I want this person to be different. But rather there is no common measure between his being and mine." Farley, we could argue, wants the conductor to be different. As a further editorial, Sartre's classism in this particular essay is quite astounding.

15 "Music: Beethoven Today," *Observer* (Sunday, September 20, 1970). *The Pastoral Symphony*, for example, was a meticulous exercise in playing out of

concert, with Howard Skempton noting that the performance was characterized "by the simultaneous use of different tempi." In the *Beethoven Today* program notes. Bryars notes on the Sinfonia's performance are as follows:

"Counsel me, cold, wise one! I long to give Gallenberg his conge and marry the wonderfully, ugly, beautiful Beethoven, if—if only it did not involve lowering myself socially." She began too fast, became disconcerted when Beethoven gruffly called out, "Tempo!," she overtook him only by the butler's timely action. From that time on he looked at Therese with different eyes. The engagement had to be kept a secret, the letter begins, "my angel, my all myself," "Yes, I have decided to toss abroad so long, until I can fly to your arms and call myself at home with you, and let my soul, enveloped in your love, wander through the kingdom of spirits." The ribbon fading with passing years, the paper growing yellow, but still showing the words: "L'Immortelle a son Immortelle—Luigi." She made a white silken pillow of the flowers; and when death came at last, she was laid at rest, her hand cushioned on the mementos of the man she had loved . . .The Portsmouth Sinfonia plays Luigi van Beethoven in the spirit of the memory of Therese, a noblewoman who spurned the lover of the Master, because of her social obligations."

The text Bryars references is from Gustav Kobbé's *The Loves of Great Composers* (1905), "Luigi van Beethoven," being a pen name/code name to Therese, his secret lover. Following this, Bryars advertises the sale of the Sinfonia's 7" of *The William Tell Overture* for the price of "three five penny stamps to cover postage and packaging." *Beethoven Today* program courtesy of the private archives of Richard Ascough.

16 Steve Lake, "Slightly Out of Tune," *Melody Maker* (March 16, 1974), p. 8.

17 *The Source: Music of the Avant Garde No. 10*, ed. Alvin Lucier (Sacramento: Performer/Composer Editions, 1971), p. 78.

18 Cornelius Cardew, ed., *Scratch Music* (Cambridge, MA: MIT Press, 1974), p. 12.

19 Ivan Hume-Carter (cornet and bassoon) opens the mandate up even further, stating that the only thing required for membership was "[A] passion for music. . . . We have a very serious attitude to it, these composers' work is played over and over without feeling, they would be appalled if they knew about all the unnecessary performances. During the first performance of Beethoven' Ninth some of the musicians had only been playing two days. Mozart's piano concertos were actually designed for free interpretation by the players. There's this whole Western tradition of the 'virtuoso.' In other cultures, it's the spirit that counts. In the Gaelic highlands the only entertainment was the ceilidhs, where everyone in the village attended just like rock 'n' roll used to be. It wasn't just Elvis, there were loads of people doing it. Just art isn't Bridget Riley and Andy Warhol and so on. All the time there are the unfamous working away—they're the foundation of it." In David Gale, "Symphonic Socialism," *Time Out*, Issue 29 (August 4-10, 1972).

20 I do not want to suggest that the Scratch Orchestra was a humorless affair, far from it. Many of their performances, proposals, improvisation rites, and scores are marked by dryly funny instructions, as well as an almost childlike sense of play and whimsy. Their attachment to the often very serious compositions of Cardew, however, as well as their preference for chaotic and obtuse live performances, granted little access for public audiences to engage in just what that humor was. The Sinfonia, to say it simply, was a more focused premise, but in that regard, entirely more limited in terms of innovation when compared to the Scratch, particularly in their mostly limited skillset. On this point, Scratch member and pianist John Tilbury, in his biography of Cardew, *A Life Unfinished*, makes this distinction that the Sinfonia "introduced variations through sheer unabashed incompetence; not as was the case with the Scratch Orchestra's anarchic design." John Tilbury, *Cornelius Cardew: A Life Unfinished* (London: Copula, 2008), p. 418.

21 Mikhail Bakhtin, *The Dialogic Imagination* (Austin: University of Texas Press, 1981), p. 76.

22 Early copies of *Plays the Popular Classics* came emblazoned with a circular sticker of Eno's face that read: "Produced by Eno: Roxy Music." Eno "produced" in the sense that he helped secure studio time, although his exact role here is contentious, but he was mostly just an occasional player in the group. David Sheppard remarks that Eno was present for the *Beethoven Today* concert, but I can find no evidence of this (he is not pictured in any photographs from the event, nor is he listed as personnel). It is more likely that Eno began playing with the group regularly, as Robin Mortimore mentions in this book, following their performance at *Ices-72* on August 26, 1972. (He claims membership to the Sinfonia in an October 14, 1972, Roxy Music profile in *Melody Maker.*) Further, Sinfonia clarinetist Suzette Worden recalls that, "Eno would have become involved after the initial idea and concept had been thought of and experimented with, so I don't see him having been an instigator of the early formation of the character of the orchestra." (Email correspondence, 2019). Although Lewis downplays Eno's involvement with the group somewhat (while proudly using a photograph of Eno with Sinfonia conductor John Farley for press releases against Eno's then-managers' wishes), it's rather clear that Eno was a good point of marketing for the group. The Sinfonia appears in Alphons Sinniger's 1973 promotional film, *ENO*, and Eno would often mention the group in rock press interviews and play tracks from *Popular Classics* on radio appearances. Sinniger's film is available to rent: <https://vimeo.com/ondemand/enovbyalfisinniger>; Eno playing and talking Sinfonia on a 1974 radio interview in Windsor, Canada: <https://www.youtube.com/watch?v=uP4F4IKE7Qc>; Eno sticker from the Sinfonia: <https://thechemistryset.tumblr.com-post/171773250913/produced-by-eno-sticker-portsmouth-sinfonia-plays>.

23 A few examples of experimental music LP covers with this type of design include Richard Mantel's bricolage art for *New Electronic Music from the Leaders of the Avant Garde* (Columbia, 1967); Ron Koro's op-art portrait of Cage for *Music for Keyboard, 1935–1948* (Columbia, 1970); the pop-infused portrait of Stockhausen by Horst Baumann for *Complete Piano Music* (CBS, 1967); the biomorphic abstraction on the cover of *Panorama Electronique* (Mercury, 1968); Gunther Stiller's minimalist designs for Wergo Records LPs of Christian Wolff (*For Piano I, For Pianist*, Burdocks, 1972) and Josef Anton Riedel (1972). Thanks to Jon Lorenz for sharing these examples with me from his collection.

24 Linda Hutcheon, *A Theory of Parody: The Teachings of Twentieth Century Art Forms* (Urbana: University of Illinois Press, 2000), p. xii.

25 <http://www.bbc.co.uk/programmes/b013fj17>. In the same interview, Mortimore pushes back on the notion of the group as an ensemble predicated on trickery: "The humor was purely accidental, because sometimes pieces weren't funny at all. For example, when we did a slow tempo piece like when we did Bach's *Suite in D Major* . . . no one ever laughed at that because it was a slow approximation of a piece of Bach. I think also, maybe, what made people laugh was their expectation. There was just a magical moment at the Royal Albert Hall in the piano concerto when, even to a vaguely trained ear it just sounded absolutely right . . . for two bars and one and a half bars it sounded great, but then it became the Portsmouth Sinfonia again."

26 Advertisement for the Portsmouth Sinfonia at Royal Albert Hall in the *Observer* (Sunday, May 19, 1974).

27 Frank Rose, review of *Portsmouth Sinfonia Play the Popular Classics* in the *Rolling Stone Record Guide* (1974).

28 <http://www.bbc.co.uk/programmes/b013fj17>.

29 Michael Nyman, *Experimental Music: Cage and Beyond* (Cambridge: Cambridge University Press, 1999), p. 161.

30 See: Francesca Brittan, "Cultures of Musical Failure" in Sara Crangle and Peter Nicholls, eds., *On Bathos: Literature, Art, Music* (London: Bloomsbury, 2010), p. 112–31; and Cecilia Sun, "Brian Eno, Non-Musicianship, and the Experimental Tradition," in Sean Albiez and David Pattie, eds., *Brian Eno: Oblique Music* (London: Bloomsbury, 2016), p. 29–48.

MUSIC NOW
(1972)

Music Now was a nonprofit concert series founded and
operated by Victor Schonfield that produced over eighty
concerts from 1968 to 1976. *Music Now* concerts included
performances by the British free improvisation groups AMM
and Scratch Orchestra; international performers, including
the Japanese ensemble Taj Mahal Travellers, John Cage,
and David Tudor; and the British debut of Sun Ra and the
Intergalatic Research Arkestra.

The Sinfonia performed as part of *Music Now* with Gavin
Bryars, John Tilbury, and Derek Bailey at the Queen
Elizabeth Hall on December 11, 1972. This concert marked
the premiere of Gavin Bryars's *The Sinking of the Titanic*, now
regarded as a classic work of British minimalist composition.

Music Now presents

with financial assistance from the Arts Council of Great Britain

Monday 11 December 1972, 7.45 p.m.

Greater London Council
Queen Elizabeth Hall
Director : John Denison, CBE

Derek Bailey and **John Tilbury** (guitars)
Gavin Bryars *The Squirrel and the Rickety-Rackety Bridge*

Music Now Ensemble directed by **Gavin Bryars**
Gavin Bryars *The Sinking of the Titanic* (1st performance)

Portsmouth Sinfonia conductor **John R. Farley**
a selection of Popular Classics

film premiere : **Gavin Bryars** — **Steve Dwoskin** *Jesus Blood Never Failed Me Yet*
with accompaniment by **Music Now Ensemble**

amplification by **Bob Woolford Sound**

* * * * * *

Programme 10p.

Gavin Bryars *The Squirrel and the Rickety-Rackety Bridge* (1971) for one player of 2 guitars
(duo version for four guitars by Derek Bailey and John Tilbury)
(Recording available on INCUS LP2 "Derek Bailey")

Gavin Bryars *The Sinking of the Titanic* (1970 onwards)
Music Now Ensemble directed by Gavin Bryars
John Nash and Michael Parsons — violins
Simon Dale — viola
Sandra Hill and Alan Brett — cellos
Michael Nyman — piano
John Tilbury, Christopher Hobbs, John White, Gavin Bryars

With the technical assistance of Keith Winter and the Physics Dept. of University College, Cardiff

— interval —

Portsmouth Sinfonia conductor John R. Farley
programme selected from

William Tell Overture	Rossini
Fifth Symphony in C minor opus 67	Beethoven
Nutcracker Suite :	
Dance of the Sugar-Plum Fairy	
Waltz of the Flowers.	Tchaikovsky
Overture 1812	Tchaikovsky
Selection from 2001 :	
Blue Danube Waltz	Johann Strauss
Also Sprach Zarathustra	Richard Strauss
Air From Suite No 3 in D major	J.S. Bach
Peer Gynt Suite:	
In the Hall of the Mountain King	Edvard Grieg

The orchestra includes: Jeremy Main, John Ryder, Robin Mortimore, Tamara Steel, Brian Eno, Michael
Nyman, Michael Parsons, Russell Coates, Pamela Niblett, Paul Beven, Gary Rickard, Linda Adams, Simon
Dale, Barry Flanagan, Peter Clutterbuck, Sue Astle, Anne Shrosbee, Deborah Smith, Gavin Bryars, James
Lampard, Suzette Worden, Gwen Fereday, Alex Potts, Adrian Rifkin, Barry Wills, Ted Brum, David Saunders,
Jeffrey Steele, Janet Fox, Maggie Wooton, Jennifer Adams, David Gale, Chris Turner, Nicky Holford, Imogen
Morley, Brian Young, Ian Southwood, Joy Wadsworth, Peter Best, Peter Swales

Gavin Bryars *Jesus' Blood Never Failed Me Yet*
Film by Steve Dwoskin based on an idea found in the work of Alan Power
Music Now Ensemble directed by Gavin Bryars
John Nash and Michael Parsons — violins
Simon Dale — viola
Sandra Hill and Alan Brett — cellos
Derek Bailey — guitar / John Tilbury — organ / John White — tuba
Christopher Hobbs — bassoon / Gavin Bryars — double bass

The pieces by Gavin Bryars and those of many other composers are published by
Experimental Music Catalogue, 208 Ladbroke Grove, London, W.10.

Please write for catalogue, enclosing 5p stamp.

Gavin Bryars Talks

Extracts from an Interview with Michael Nyman, October 1972

I always consider humour as being very central to anything I do how many other experimental musicians have my background? Most have been to music college, most are trained musicians of some kind, I'm not my background is not of academic music, it's of philosophy Musical training is geared to seeing your output in the light of music history. I've never been geared to that because I've never related myself to music history in that way. Now in some senses I have to because I am more aware of music history than I was before. Obviously I knew music history anyway because I studied music at University as well, and now I'm interested in a lot of other composers — like Satie for instance — so in that sense you inevitably see yourself in the light of music history, but not *composing* in the light of history, whereas I think a musical education does make you do that.

At the art school where I teach, students have this huge hang-up about working in the Life Room, because when they get in there as soon as they start making life drawings they have this huge wealth of art history weighing down on their backs. They know the drawings of Goya, Leonardo, Michaelangelo and as soon as they start making marks that's what they see, they don't see the work they're doing — they're not relating the lines they make to the model. At least that's what they're worried about, that's why they become very disenchanted with the Life Room. And it takes a long time before a student can actually work in the Life Room and work directly with lines derived from the model — and that's because they've got the wealth of art history leaning on them, in a conventional situation like that.

Whereas the kind of history I build on is working at Greaseborough, the cabaret world — cabaret in a working-men's club. This at a particular time when I had become disenchanted with jazz, when I was becoming more interested in the ideas of Cage and other composers. At that time humour was the one thing that held everything together for me. The craziness of that place — some of the acts were completely stunning. To put on some of those acts in the context of a contemporary music concert would be very close to the kind of content in the pieces I do, close to the humour of the Portsmouth Sinfonia. There were people who were doing things they simply weren't able to do, but they did them in front of an audience of 2000 and did them with huge panache — with glitter, lights, the band, everything geared to making it a glamorous production. But it simply wasn't there. You'd get an acrobatic act which consisted of two ex-Army P.T.I.'s still wearing the black pumps they got when they were discharged, one of them with a bad squint You'd get illusionist acts which would rely entirely on props, and there would be one night when all their props simply failed, nothing worked. You'd have a box, the box disappears, but you could still hear the radio playing

inside it: but you can't hear the radio because it's broken, or someone has pulled the mains plug out. And the audience would be totally mystified, wathing this inane thing going on.

I also worked with a number of big stars — which can be very enlightening, not only in that you see another way of life you can see them being very successful, doing what they do very well. Working with Johnnie Ray was a revelation. He had this audience of 2000 miners in tears, they were really crying. Singing things like "Mr. Cry" — his hearing aid as well, dropping his handkerchief to the women in the front row, just like the Sunday Palladium in 1955. I became very impressed with that sort of skill. A bit later I became interested in Tiny Tim; he had the same quality While the songs he sings may be maudlin, or may be old sentimental things, like those George M. Cohan and Rudy Vallee songs, and while he has an implicit humorousness in his presentation, in his way of life, in his way of singing, in the kind of things he sings — the songs themselves and the arrangements are extremely rich and very beautiful in a sensuous way. Similarly I think something like the Sinfonia is too — that while it has this surface daftness, it also is incredibly beautiful to hear

In the old days sounds weren't important. Any sound would go provided it fitted the rules. But now there are a lot of sounds I probably wouldn't use any more because I don't find them interesting. Things like using tonality now, and not only tonality but consonance What I think is very important about "Jesus' Blood" is that its easy to take on a popular level. It could go out on Radio 2 — maybe — if they'd put out 30 minutes of that. On one level it's an immediately likeable piece but on the other hand I think it's a very complex piece, rather like George Brecht's work. They have a surface simplicity because they use a minimum of elements — there's so little going on. But the kind of things that reverberate in "Jesus' Blood" — such as all sorts of movie references. The accompaniment reference would be the singer singing and the instruments slowly drifting in, in a Hollywood way. And the gradual built-up of instruments refers to the ending of Marine films where you get the slow crescendo of "John Brown's Body"......
That reference is not overt in "Jesus' Blood" but it's certainly present

The tramp sang "Jesus' Blood" out of genuine religious feeling and his hesitancy was in fact due to his dramatic sense — he was emphasising the lines he was singing absolutely sincerely.

* * * * * * * *

Portsmouth Sinfonia

The Sinfonia was formed one day in 1970 when Ivan Hume-Carter was painting one of the college pianos white. Robin Mortimore, Gary Rickard, Jimmy Lampard and I were talking with him when we had the idea of forming a symphony orchestra to take part in Maurice Dennis's "Opportunity Knocks" concert. I think I suggested the name — Ivan had suggested the Portsmouth Symphony Orchestra — because I'd always felt that names like "Sinfonia" and "Sinfonietta" sounded so puny.

We all spent some time finding orchestral instruments (no guitars and no harmonicas — which was to become a demand of Ivan's own music later) : I bought an old euphonium from a second-hand bicycle shop, Gary repaired a cello that had been about for some time, Ivan played cornet, Jimmy bought the saxophone that, apparently, he'd always dreamed of owning and, with about 10 others (Maurice, I remember, played flute) rehearsed for a couple of days. None of us could play our instruments and few could read music, so we bought those "Tune-a-day" books for our instruments which, as well as having fingering charts, also show where notes go on staves, what ledger lines are like, what minims are and so on. (In the concert several of us had these manuals alongside the score). The problem of what to play was fairly easily solved as none of the players had a "musical" background and so only knew "famous" and "popular" classics, and we decided on the "William Tell Overture" by Rossini (from the Lone Ranger T.V. series). Ivan bought a piano score of the piece and photocopied the three pages where the tunes occurred, and John Farley, who knew least about music but most about conducting from reading

part of a Penguin book called "Introducing Music", obtained a frock-coat and a baton. Apart from playing in the Sinfonia, four of the members, Gary (on bass), Ivan and Robin (violins) and myself (cello) also played as a string quartet (the "Borodin Quartet playing the Borodin Quartet") ; six of the members, Maurice, Andy Speller, myself, Gary, Robin and Chris Marriot were the "Pyrotechnic Pyramid from the Pyrenees" — an elegant balancing troupe who formed pyramids and did roly-polys ; Ivan, James, Gary and some others were a kind of rock band in which Ivan sang Elvis Presley and Eddie Cochran songs (using a microphone of the type that he had seen in photos from the mid-50's), and the whole of the Sinfonia, setting down their instruments, were the Pontypridd Male Voice Choir ("The Lord's my Shepherd").

The concert was played outdoors on a sunny afternoon in front of a large and sympathetic audience who were held entranced by ventriloquists, comedians and Malcolm Coker, a black student from Sierra Leone (billed as "Music from the Colonies") who played drums and sang "Wimoweh". The last item on the whole concert was the Sinfonia who played their just-recognisable version of "William Tell". The tape of that historic performance contains mostly loud euphonium and cornet plus laughter followed my amazement at the announcement — from Adrian Rifkin, the compere — that the Sinfonia were to play it again. By this time Ivan's lip could not produce much from the cornet and the piece could just about be recognised.

After that the Sinfonia made a recording of "William Tell" in the college film-studio and had a "Lyntone" pressing made of the piece as a single 45 r.p.m. record. These were sent all over the world to politicians, musicians, artists, relatives, sympathisers, sportsmen. The letter from the company who pressed the record is still a pleasure (illustrated).

After this, the Sinfonia was asked to play in the concert "Beethoven Today" at the Purcell Room by Michael Parsons (who took over from me at Portsmouth) and for this the Sinfonia prepared the Fifth Symphony. From then on it has added several other pieces to its repertoire, generally with tighter arrangements than the earliest pieces had, and has begun to attract more and more attention, not only from the listening and critical public, but also from the people who wished to play in the orchestra. Robin Mortimore, who has been the main force holding the orchestra together since many of the members left Portsmouth, tells of an occasion when the Sinfonia played at the Bath Festival (it was playing at the common "counter-festival"). An elderly couple, the man having a retired-military bearing, were at the concert, presumably expecting to hear the works listed in the programme. After a "William Tell" which lasted 1½ minutes the man appeared puzzled and, when the Sinfonia began playing Beethoven's Fifth, could stand no more. "Look here", he called, "Beethoven *couldn't* have written *that*!" When no-one suggested any other possibility he went on, "Will someone please tell me what is going on?" One of the audience said, "Use your ears, man". He replied "I'm using my legs!" and walked out. His wife stayed, however, and eventually he came back to hear Ivan Hume-Carter's Ross and Cromarty orchestra (since disbanded).

At the concert at Harmony Farm, a rock-festival in Sussex, the Sinfonia played last, well after midnight, due to an organisers' mix-up. When the audience saw all the amplification being removed from the stage after the penultimate group, they became restive, since they'd been assured that another group would close the show. When we filed on stage and began playing, a large group of Hell's Angels was in front of us and we all felt uneasy. Nevertheless, we played beautifully and the audience responded enthusiastically, so much so that afterwards a leather-jacketed Hell's Angel sidled over to me and said, "Were you playing with that lot?" Nervously I said, "Yes." He shook my hand and said, "It's the best thing I've heard since I came down off the pills!"

The Sinfonia goes from strength to strength, and the addition of new and more skilled musicians has not destroyed its characteristic gaucheness. Texan composer Jerry Hunt, who was one of the recipients of a Lyntone recording, heard the Sinfonia this summer at ICES festival. He observed that, while the Sinfonia is getting more polished in its performance, he still recognised the performance as being of the Sinfonia rather than a bad performance of Rossini. Its really a question of what gets polished — with the Sinfonia it's the filtering of the piece that is getting better, but the piece can never emerge intact, not while the original members remain. I'm happy to maintain my membership of the orchestra and to give them this "guest spot" in the concert.

Gavin Bryars

LYNTONE RECORDINGS LIMITED

15 Great Portland Street London · W1

Tel 01 - 636 2696 Cables Lyntone London

1066/rt/3424 10th June, 1970

Mr. G. Bryars.

Mr. ... Davey,
Department of Fine Art, A.J. : C.S.
Portsmouth Polytechnic,
Hyde Park Road,
Portsmouth.

Dear Mr. Davey,

 We are sending to you, under separate cover, a test pressing of the
"William Tell Overture" which you ordered from us on 2nd June 1970.

 Having had no advance warning of the somewhat novel interpretation
of Rossini's Creation we were bewildered by what we heard. We should
be most grateful if you would advise us by return that this is indeed
what you had recorded and what you want to be captured for posterity.

 Thanking you in anticipation.

 Yours sincerely,

 Paul S. Lynton
 Director

Associated Companies: Audio Plastics Ltd. Commercial Sound Ltd. University Educational Records Ltd.

Directors: P. S. Lynton, L. Lynton Factory: 46 Penton Street, London, N.1.

EXPERIMENTAL MUSIC CATALOGUE (1972)

Christopher Hobbs's *Experimental Music Catalogue*—founded in 1968 and still in operation in 2020—released several "anthologies" of experimental music in the early 1970s. These included: the "Scratch Anthology of Composition," featuring works by the Scratch Orchestra; the "Visual Anthology," filled with graphic scores, conceptual schemas, and mazes by Greg Bright, Gavin Bryars, and Michael Parsons; the "Verbal Anthology," which collected verbal scores by Robert Ashley, Phil Gebbett, Hugh Shrapnel, Hobbs, and Bryars; and many others.

These early *Experimental Music Catalogue* releases, which Hobbs and Bryars often assembled by hand, served as primers to the experimental music scene in England at the time. As the following pages from September 1972 attest, a "Portsmouth Anthology" was planned, and it was to include Robin Mortimore's score for *Very Circular Pieces* and Jeffrey Steele's "short essay on the nature of collaborative work," which became "Collaborative Work at Portsmouth"; both of these documents are included in this book. The "Portsmouth Anthology" ultimately did not come to fruition.

POLICY

The Catalogue (EMC) is run by an editorial board consisting of Gavin Bryars, Christopher Hobbs and Michael Nyman who handle the day to day running of the EMC, put ideas for policy to the composers and keep the composers informed about its progress.

The Catalogue is updated at intervals by the editors in consultation with the composers as to which of their pieces they a) wish to retain in the Catalogue, b) now wish to inclued and c) wish to remove. Pieces removed would be located in an archive in reproduction; these will be available for research but not for sale. In all cases composers may over-ride the editors and decide to destroy all old pieces.

The policy is to publish pieces by individual composers with the addition of anthologies of a) collected pieces by a single composer, b) pieces of a similar type and c) written books in limited editions.

All new composers will be checked to see if their pieces are not sellable by other publishers and that they fit the concept of renewable publication.

The address of the EMC is 208 Ladbroke Grove, London W.10. telephone (01-960 1996).

CONDITIONS OF SALE

Postage and Packing
1. Domestic orders: add 10p per item
2. European orders: add 20p per item
3. Rest of world: add 30p per item

All cheques, postal orders and money orders should be made payable to the Experimental Music Catalogue.

Cheques and money orders made out in currencies other than sterling should add the exchange equivalent of 25p per cheque/money order to cover English bank charges.

3. PORTSMOUTH ANTHOLOGY

The music in this anthology originates in the Fine Art Department of Portsmouth Polytechnic, whence groups composed of staff, students, former students, former staff, visitors and associates of the Department have gone out to perform in schools, hospitals, colleges, festivals and concert halls all over the country. While it would be difficult to describe the full range of the music, it would be true to say that the practical production of valuable music by people with very limited training is a common aim of all these activities. Some of the composers are represented elsewhere in the Catalogue (Ivan Hume-Carter, Michael Parsons) while other composers in the Catalogue who have been closely associated with Portsmouth are omitted from the Anthology (Christopher Hobbs, John White, Gavin Bryars, Cornelius Cardew and performer John Tilbury).This Anthology is representative of the current work of Portsmouth.

The term 'Ross and Cromarty Orchestra' needs explanation. The orchestra was formed by Ivan-Hume Carter to perform his 'Ross and Cromarty Waltz No.1' in 1971 and work by him and others have been added to the repertoire. The instrumentation is flexible, consisting of high, middle and low range orchestral instruments, piano and percussion. In some places there is a singing voice included. "Because of the simplicity of the music, it uses only what is richly essential, anyone with little or even no musical knowledge could participate in performance of any piece played by the orchestra.....The Ross and Cromarty Orchestra sees it's role as exemplary and encourages the performance by others, either individually or collectively, of its pieces or pieces similar to those used by the orchestra" (Ivan Hume-Carter 1971)

Ivan Hume-Carter
+Ross and Cromarty Waltzes 1-5 +Marilyn's Birthday Tune
 +Ross and Cromarty Fling +The Highland Railway Symphonic
 Movement
- all the above for the Ross and Cromarty ensemble.
+The Foolish old Man who removed the Mountains
-miniature opera (see Section 1 for description)

PORTSMOUTH ANTHOLOGY (cont.)

Sue Astle
+Easter Holiday Tune +Flower Songs (1. Wallflower 2. Jasmin)
- all for Ross and Cromarty Ensemble

Suzette Ann Worden
+Ross and Cromarty Waltz No.5 - for Ross and Cromarty ensemble
+Pentatonic Scale Piece - for piano. Uses printout from computer
 using permutations.

Mike Gunter
+Piano Piece (30') - mathematical permuations using a system
 which also generated films, paintings, etc.

Pamela Niblett
+String Quartet in D major (20') - single movement tonal piece
 based on scale patterns.

Robin Mortimore
+Very Circular Pieces - a series of related pieces from a
 collection exploring various facets of a musical
 situation. Each piece consists of a notation based
 on a circle, a title and a performers note.

Michael Parsons
+Theme and Variations for Solo Violin - a highland tune with
 several variations, simply written.

Jeffrey Steele
+Short essay on the nature of the 'Portsmouth' work (Portsmouth
 Sinfonia, Ross and Cromarty Orchestra and Visual Research
 ensemble).

£2

COLLECTED
CORRESPONDENCE
(1972-75)

The Portsmouth Sinfonia 15th May 1972

Sorry no rehearsal due to finance shortage
Robin and James no longer live at Gipsy Hill. Sinfonia can be contacted
at 460 0333 in London until futher notice or Ivan in Portsmouth

Notes about the scores. Some of the stave lines have not printed –
suggest you them in in pencil. Generally pieces are arranged for B flat
instruments on top line – others 2nd line – bass and timpani 3rd line

Arrangements for Bath Concert
Portsmouth Sinfonia play evening on Sat 27th May
Ross & Cromarty Orchestra on Sun 28th May
we can stay at the Cleveland Hotel on Sat night (bring sleeping gear)
also we shall be fed by the festival free kitchen
We are only getting £30 for this concert so travelling arrangements are;
1. a van from Portsmouth leaving early Sat morning, see Ivan or Jeremy
2. a van from London leaving early Sat morning driven by James
– ring Robin at 460 0333 for details
No expenses available for train fares sorry
Also note Concert Tues 22nd June Goldsmiths (to be confirmed)
 Concert Fri 30th June Architects Assoc. (to be confirmed)
 Concert Sun 2nd July I.C.A. definite.
The Sinfonia needs music stands
Scores printed by Copyrun London SW 1 money loaned by J.Steele.

Summer Engagements with the Majorca Orchestra

Friday 15th.June FREE	7.00pm	Concert at The Music Information Centre 10, Stratford Place, off Oxford Street. Gavin Bryars "Sinking of the Titanic" & the music of the Majorca Orchestra.
Tuesday 19th June	9.00pm	Concert at Fluxus Exhibition, Nottingham for details ring 01-622-7945
Tuesday 31st July	evening	"Another Festival" Friends Meeting House Bath. arranged by Bath Artsworkshop. Performing with STRIDER Dance Group.
Wednesday 1st August	evening	Arnolfini Gallery, Shed 'W' Canons Road, Bristol Docks. Performing with STRIDER Dance Group.

Portsmouth Sinfonia, 228 Elmhurst Mansions, Elmhurst Street,
 London S.W. 4 6HH tel. 01 622 7945
13.7.73

 Many thanks to everyone who made the 7th/8th July weekend so
enjoyable, even if one York Evening Press journalist did not like
it much !

It is hoped that with two more sessions we shall have a good enough
selection for the record. Details for theses;

Saturday 4th August starting at 1.30 pm

Saturday 11th August starting at 1.30 pm

both at the Television Studio, Royal College of Art Film School,
Queensgate, London S.W. 7 (S.Kensington or Gloucester Rd. Tube)

We have to finish at 5.30 pm, so please be punctual at start
We shall rehearse "Jupiter" from the Planets by Holst - a new piece.
the 4th August session will also be a photographic session for the
record cover and press kit.

All recorded by Bob Woolford Sound
Full expenses paid. Please send in claims for York weekend, stating
whether cash or cheque is prefered. If we are satisfied with these
sessions, the record will be released in November. If anyone is
in a position to arrange any concerts please get in touch. We want
to play as much as possible around Nov- January.

PLEASE REPLY IF YOU CANNOT MAKE EITHER SESSION

 RPM

Portsmouth Sinfonia, 228 Elmhurst Mansions, London S.W.4 6HH
 01-622-7945

Wed. 28th November, 1973

With disappointment I have to report that the Sinfonia record will not
be released until 11th January, 1974.

The delay is because of an industrial dispute at the pressing factory,
and is beyond the control of the Sinfonia or Transatlantic.

A 45r.p.m. record (William Tell and Blue Danube) will be released two
weeks before the L.P. Also a booklet of photos, a very handsome
poster and a pin-on badge will be available for members. A package of
these will be sent (or can be collected) to you before the release
date. Please let me know if you have changed your address or would like
these sent to a particular address. These will be sent out after
Christmas, but can be collected from the above address or, if previously
arranged, from Transatlantic offices, before Christmas. If you are
interested in knowing when we are getting radio or television plays of
the record, or in which papers the record is being reviewed, please
ring 01 622 7945 near the release date.

A concert at a major London venue is being arranged for late January –
details will be posted as soon as it is confirmed.

Sorry no records for Christmas.

 Best wishes,
 Robin Mortimore.

228 Elmhurst Mansions Elmhurst St. London SW 4 01 622 7945

25th April
Dear Suzette,

 Hope everything is ok. and that you had a nice Easter.
Please let me know what your feelings are about the Majorca Orchestra
playing Ross and Cromarty Waltz No. 5 as part of ournormal repertoire
We start rehearsals soon on new pieces. We already have a programme
of twenty pieces, including some new and wonderful melodies!!
Hope you will be able two hear us soon.
The legal battle is still going on - very slow and very tedious
and an absolute waste of time.
love to all
from James and Ian as well

Robin

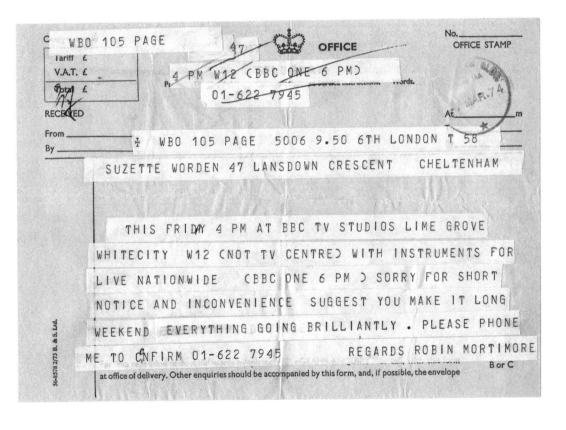

C WBO 105 PAGE

Tariff £
V.A.T. £
Total £

RECEIVED

47 👑 OFFICE

4 PM W12 (BBC ONE 6 PM)
01-622 7945

No.
OFFICE STAMP

MAR.74

At ____ m

From ____

By ____

☩ WBO 105 PAGE 5006 9.50 6TH LONDON T 58

SUZETTE WORDEN 47 LANSDOWN CRESCENT CHELTENHAM

THIS FRIDAY 4 PM AT BBC TV STUDIOS LIME GROVE

WHITECITY W12 (NOT TV CENTRE) WITH INSTRUMENTS FOR

LIVE NATIONWIDE (BBC ONE 6 PM) SORRY FOR SHORT

NOTICE AND INCONVENIENCE SUGGEST YOU MAKE IT LONG

WEEKEND EVERYTHING GOING BRILLIANTLY . PLEASE PHONE

ME TO CONFIRM 01-622 7945 REGARDS ROBIN MORTIMORE

B or C

at office of delivery. Other enquiries should be accompanied by this form, and, if possible, the envelope

56-8578 2/73 B. & S. Ltd.

Portsmouth Sinfonia, 228, Elmhurst Mansions, London S.W. 4 6HH
tel. 01-622-7945.

5:2:74.

Solo Concert for the Portsmouth Sinfonia.

SUNDAY 10th MARCH 1974 at the Mermaid Theatre, London E.C.4
(around the corner from Blackfriars tube). Concert starts at 8.00
The Sinfonia will meet at 3.30 for programme rehearsal.

SATURDAY 2nd MARCH 1974 - special rehearsal for concert at
 ACTION SPACE-65, Harmood Street, London N.W.1 from 1.00pm-6.00pm
(Chalk Farm tube- down hill passed Roundhouse on Chalk Farm Road-
3rd street on left).

At this rehearsal - some press photos at 2.00, after which we have
many old favourites,that have been rescored and printed, to rehearse.
These include:- 1812 Overture Zarathustra Nutcracker Suite
Beethovens 5th Blue Danube and a new piece the "Intermezzo from
Karelia Suite"by Jean Sibelius. If you would like copies of these
new scores before the rehearsal please ring or write.
All those who have music stands please bring them.

Before the rehearsal date you should receive in the post a copy of the
L.P. plus a poster, booklet(if you were at any of the recording session
If I have not got a definite address for you, these can be collected
at the March 2nd rehearsal or from the above address. For obvious
reasons I would rather not send records in the post.

Complimentary tickets for guests at the Mermaid are limited to
one each. Every person who appears in the credits on the record
sleeve gets one complimentary L.P.
If you are unable to attend the Mermaid concert please notify the
above address.
We would appreciate help with transport from above address to both
rehearsal and concert - anyone with van or car.
If you live outside London you are advised to consider travelling
arrangements well in advance, if Rail dispute is still on.
New members - any orchestral instruments - are always welcome-
especially woodwind and strings.
Make sure your local record dealers have copies of the PORTSMOUTH
SINFONIA plays the Popular Classics TRA 275.
best wishes Robin Mortimore.

P.S FULL TRAVELLING EXPENSES PAID ON BOTH DATES.

PORTSMOUTH SINFONIA 228 ELMHURST MANSIONS, LONDON S.W.4
tel. 01 622 7945
3:May 1974.

OUR VERY OWN PROM - TUESDAY 28th MAY 1974 at 7.30 pm
the Portsmouth Sinfonia in concert at the ROYAL ALBERT HALL.
Kensington Gore. London. (High St. Kensington tube)

REHEARSALS

Saturday 11th May 1.00-5.00 at COCKPIT THEATRE, Gateforth St.,
 off Lisson Grove N.W.8 (Marylebone tube)

Saturday 18th May 1.00-5.00 at Cockpit Theatre

Saturday 25th May 1.00-5.00 at Cockpit Theatre

Monday 27th May (evening) at Cockpit (to be confirmed)

Tuesday 28th May in ROYAL ALBERT HALL at 2.00pm
 Concert starts at 7.30

At the Cockpit rehearsals we shall run through all pieces
plus MARCHE MILITAIRE by Schubert- MARCH from NUTCRACKER Suite
and Piano Concerto No.1 both by Tchaikovsky X (Soloist, Miss
Sally Binding)
At the rehearsal in the Albert Hall on Tues. 28th afternoon
we shall do HALLELUJAH CHORUS by Handel . Male and female
singers are required at this rehearsal for the concert (free
tickets for the concert for all the choir)

Scores for all these pieces will be sent as soon as ready, if
not they will be handed out at the first rehearsal.
The concert will be recorded for use on next record.
The concert will be filmed by CBS (America) and Thames ITV
(Sinfonia album to be released in USA on CBS in August)
The concert is jointly promoted by Transatlantic and Derek Block
Promotions. Due to large costs of putting on such a concert, and
the enormous size of the orchestra and choir - no complimentary
tickets are available- sorry
ALL travelling expenses for the orchestra paid for all meetings.

Since we have a short time to prepare for such a momentous
occasion your cooperation at rehearsals and on the day will
be welcome

PLEASE REPLY if you can give an estimation on how many you can bri
for the choir - we want 200.

I would like to emphasis the importance of the rehearsals on this
occasion as we would dearly love to use some live recordings from t
the Albert Hall on the next album.

Many many thanks to all those who made the Mermaid a memorable
night.
 See you soon best wishes
 Robin Mortimore

Portsmouth Sinfonia

228 Elmhurst Mansions
Elmhurst Street
London SW4 01-622 7945

14th June 1974

A Newsletter to everyone giving recent developments and information
about the Portsmouth Sinfonia.

Firstly, the recordings of the Royal Albert Hall concert are so
good that it has been decided to release the second Sinfonia album
of live recording from the Concert.
On the record will be March from Nutcracker - Karelia Suite -
Marche Militaire - Piano Concerto - Overture 1812 - William Tell
and of course the Hallelujah Chorus.

On BBC 2 tv on Tuesday 18th June (if you have the letter by then)
can be seen film of the Hallelujah Chorus from the Albert Hall.
 Old Grey Whistle Test
The record should be out in late October.
Please thank all your friends who sang in the chorus

Eventhough details have not yet been fixed please keep free the
days between August 23rd and 26th 1974 as the Sinfonia is going
to Delft in Holland to play at a music festival. The concert is
on Saturday 24th in the afternoon, and the trip will include
probably a radio or tv appearance. The record is released in
Holland and distributed by BASF. Travel and accomodation details
will be forwarded very soon.

It seems likely that John Farley, Martin Lewis (our publicist from
Transatlantic) and myself will be representing the orchestra at
the CBS annual convention in Los Angeles in August, at which the
Sinfonia first album will be released. While there it is hoped
that we can try and fix a Carnegie Hall date for later this year.
But you must realise that there are many problems in getting an
organisation like the Sinfonia into America.

In view of these forthcoming events please check that I know where
you can be contacted at any time during the next months.
Any members who have joined since the making of the 1st record
can buy copies of it from the above address at £1.60 inc. postage
Everyone who played at the Royal Albert Hall in the orchestra will
receive a complimentary copy of record no.2
Transatlantic Records are compiling a set of our pressing cutting
and I should have copies to send out soon.

 best wishes

 Robin Mortimore

Portsmouth Sinfonia

228 Elmhurst Mansions
Elmhurst Street
London SW4 01-622 7945

20/9/74

Dear musician,

Since the Albert Hall in May much has happened concerning
the Portsmouth Sinfonia.

In August, I, accompanied by Martin Lewis from Transatlantic
Records, attended the Columbia Records Convention in Los Angeles, where
the Wombles and the Sinfonia were the only British acts to make an impres-
sion. Film from the Mermaid Theatre Concert was used for our present-
ation. Also we arranged showing of the Albert Hall film in Los Angeles
and New York. "the Portsmouth Sinfonia plays the Popular Classics" is
being released in U.S. in October, and depending on how it starts to
sell will be the invitation to play at the Carnegie Hall and other major
U.S. cities.

The film of the Royal Albert Hall is completed, and basic-
ally we are very happy with it. It is hopefully going to be shown
on ATV television in the next few months, and before then I shall arrange
a private showing in London for members of the orchestra. The film is
also proving very popular in Europe and many continental country's TV
companies have hired the film. It is also going to be distributed around
Universities and Polytechnics in U.K. If anyone can help with this
please get in touch.

Later this year the Portsmouth Sinfonia is to undertake
its first tour of the U.K. Promoters Ayris and Savage Associates are
to handle the proposed idea.

We are hoping to play six concerts on Saturdays and Sundays,
over the three weekends starting November 23rd to December 19. (It might
of course go outside these date depending how easy booking are to arrange.
This will involve sometimes spending a night out - hotels and transport
will all be arranged by the promoters, and full expenses will be paid
by the Sinfonia.

Dates already set are Sunday 24th Nov. Cardiff New Theatre
and other hopefuls are Guildhall Portsmouth - Bristol - Leeds University
Manchester - Birmingham and London. For London we wish to get the Royal
Festival Hall - but it is heavily booked. Some rehearsals will be
arranged before the first concert.

"Hallelujah" the Portsmouth Sinfonia at the Royal Albert
Hall (TRA 285) is at present being manufactured and should be in the
shops in early November. Pieces include all those not on 1st. record
plus William Tell. Everyone concerned is delighted with the results.
Enclosed with the record is a colour booklet of pictures of the great
occassion.
Details of all the Sinfonia's activities will be sent out soon. It is
going to be a busy time and will mark the end of the most wonderful year
in the history of the orchestra.

 from Robin Mortimore

Portsmouth Sinfonia

228 Elmhurst Mansions
Elmhurst Street
London SW4 01-622 7945

15th November 1974

SUNDAY 24th November 1974 at 8.00 pm in the New Theatre, Park Place
Cardiff - The Portsmouth Sinfonia in Concert

SATURDAY 23rd November REHEARSAL at Action Space 65, Harmood Street
London NW 1 (Chalk Farm tube- turn right walk passed Roundhouse and
Harmood Street is third street on the left)
Rehearsal starts at 1.00pm - 6.00pm After the rehearsal we shall show
the film made at the Royal Albert Hall.
Also those who played in the Royal Albert Hall Concert can collect
a complimentary copy of "Hallelujah" TRA 285

If you are coming to Cardiff please come to the rehearsal, as due to
transport limitations we can take 50 people only, and I must have
an exact list of who is coming.

For the rehearsal and concert we have to provide music stands.
Can anyone who wants a music stand please buy one (cheapest) and
bring it to both meetings. Then claim the money on expenses after
concert.

Travel arrangements for SUNDAY 24th NOV. will be confirmed on
Saturdays rehearsal. Approximately they will be;
Leave London (Euston coach park under main station)at 11.00 -meet 10.30
in morning.
Leave Cardiff soonest after concert- arrive back in London approx
1.00am.
If you wish to make your own way to Cardiff please ring me and give me
details.
At present no other concerts are arranged, but in the new Year we
shall be doing more.
Looking forward to seeing everyone again

 Robin Mortimore

Portsmouth Sinfonia

228 Elmhurst Mansions
Elmhurst Street
London SW4 01-622 7945

17.1.75

After much juggling with dates, at last, the Paris concert is fixed and
the PORTSMOUTH SINFONIA management has great pleasure in inviting you
to be part of a 35 piece orchestra to perform at the Paris Olympia
and on a television programme.
We will arrange a rehearsal for the orchestra travelling and exact details
of travel will be posted when I have an exact list of who is going.

The basic plan is:
meet at Heathrow Airport about 9.00am FRIDAY 28th FEBRUARY
arrive Paris about midday - rehearse at OLYMPIA 2-5pm
CONCERT at 6.00pm on FRIDAY 28th FEBRUARY
stay in hotel near concert hall Friday night
sometime on Saturday 1st March record a television item (approx 10mins)
return to Heathrow ~~Saturday evening~~ /probably Sunday morning.
Any queries please ring 01-622-7945

PLEASE COMPLETE AND RETURN SLIP BELOW BY NEXT POST

 best wishes

........................cut here...

COMPLETE SLIP AND RETURN BY NEXT POST - IMMEDIATELY
1) I,....................have a valid passport

2) and I will be available to come with the Portsmouth Sinfonia to
Paris.
3) I,.................... will not be available to come with the Port-
smouth Sinfonia on the trip to Paris.

If your slip is not returned a place on the trip cannot be reserved.

228 Elmhurst Mansions
Elmhurst Street
London SW4 01-622 7945

Looking back on 1974 I felt it would be a shame to see it pass
without reporting to you what an amazing year for the Portsmouth Sinfonia
it has been. At the conception in May 1970 none of the founder members
would have been prepared to speculate on the acheivements likely to befall
the orchestra. Neither would they have been so bold as to seriously mention
the likelihood of two albums being released, a Royal Albert Hall Concert,
another sellout concert in London, and an orchestra membership of nearly
a hundred.

 At the start of 1974 circumstances surrounding the Portsmouth Sinfonia
were not totally going to plan. Because of the three-day working week in
Britain, the release of the first album "The Portsmouth Sinfonia plays
the popular classics"(TRA 275) had been postponed from before christmas.
We felt that missing out on the Christmas market would be damaging to the
hopes of promoting the record and doing a major solo London Concert. As
it happened by the time the record was ready for release and a concert had
been fixed we were into March.
 At the time the Sinfonia signed contracts with Transatlantic Records
a Special Projects Manager joined the company, and the orchestra became one
of his first projects. In the build up for the Mermaid Concert and the
release of the record Martin Lewis was able to present the Portsmouth Sinfonia
through the media to almost every audience, and in doing this, many facets
of the Sinfonia were exposed. Within a week the Sinfonia had had air plays
and or interviews on Radio 1 2 3 4 Capital, LBC, Radio London etc. On the
Thursday before the concert Thames Television TODAY showed a filmed interview,
Southern TV a similar spot and Nation wide on BBC 1 had the orchestra
performing for about 20 seconds and a discussion with Frank Bough. All the
music trade papers ran reviews of the record and the Daily Mirror and News
of the World feature it as record of the week. The angles that emerged from
this extensive media coverage were controversy, news value, humour, uniqueness
and intellectualism. Such respectable radio figures as Jack deManio raved
about it - Richard Baker despaired - Lond Longford said it was delightful.
 And so on to the Mermaid Theatre in London, where on Sunday 10th
March the Sinfonia played to a packed house. The afternoon rehearsal was
filmed by ABC and CBS News from USA and subsquently was shown network through-
out the United States. Also while the orchestra was struggling away on stage
that evening a film clip was shown on BBC1 9.00 News. The concert went well
and after the publicity it was the first Sinfonia concert where the audience
was actually aware of what was in store for them. The 1812 Overture was
probably the highlight of the evening and only the second time that the
orchestra had played this new arrangement. The William Tell Overture was
announced as our latest single and John Farley snapped his baton over his
knees and threw it in to the audience to mark the end of the performance.
 Within weeks of the Mermaid concert, Transatlantic Records in
association with Derek Block promotions offered us a date at the

Royal Albert Hall. Before the concert six rehearsals were held (no concert
has ever demanded such careful preparation) and four new pieces were
arranged. These included a piano concerto and a choral piece - both
musical formats that were new to the Sinfonia but ideas that we had
wanted to do for ages. Miss Sally Binding had seen poster around
London for the Mermaid concert and made enquiries through Transatlantic
about the orchestra. She thought that we were an amateur provincial
orchestra, and asked if we were interested in doing a piano concerto.
John Farley and I met Sally one evening and exposed the Sinfonia in all its
glory to the unexpecting ex-Royal College of Music student. It came to pass
that Sally was certainly interested in playing with the orchestra, and when
I told her that the first performance would be at the Royal Albert Hall
she was flabbergasted. Since time was very short before the great night,
I asked Sally if she could play the first two movements of the B flat minor
piano concerto by Tchaikovsky in A minor as it was much easier for the Sinfonia
to play - like a real sport she agreed and soon an arrangement was ready for
our treatment. James Lampard undertook the task of arranging the Hallelujah
Chorus by Handel. He went down to Cornwall at Easter for a holiday armed
with manuscript paper and needless to say on his return an arrangement was
ready for the concert. I asked everyone in the orchestra to bring a guest
to sing on the night. We estimated that this would give us about a hundred
chorus and a reduced orchestra of about 30 would be ample. We decided that
a couple of hours rehearsal in the afternoon of the concert would be enough
time to learn the piece. At 3.00pm on 28th May 350 people turn up at the
stage door of the Royal Albert Hall in order to be the choir. With a biggest
ever orchestra of 82 we were ready to take on the Albert.

The weekend before the concert was a bank holiday, and on the Friday
there was very little movement of tickets. On the Sunday due to the tireless
efforts of Martin Lewis we had a photo-call at the Albert Hall. On the Monday
there were pictures of John Farley on the front page of the Daily Mirror,
pictures of the orchestra in the Daily Express and Evening papers. The morning
of the concert I did a Capital Radio interview with Tommy Vance and for the
next hour the box office was engaged. By the evening all had been done that
could be done to ensure a faultless performance. The grand piano had been
tuned - the canon effects for the 1812 had been tested - the flowers from
Interflora had arrived - the camera crews were in position - the recording
equipment was alive ready to capture the memorable occasion.

It was a triumphant evening and the Halleljah Chorus was a fitting
climax. The whole project of the Albert Hall concert was a tremendous gamble.
Only months before the Sinfonia had had satuartion publicity and the idea had
been sold - but would we command an audience at the majestic hall? Could we,
a rather limited orchestra in terms of experience of the big occasion rise
to meet the challenge? Would the performances of the new pieces be good
enough for a live album? Would the canons go off at the right time? Had
we rehearsed the Hallelujah enough? Naturally there was no need for concern.
It was to be John Farley's finest hour. The Portsmouth Sinfonia, thanks to
the generous support of Transatlantic Records, produced an unforgetable
evening of entertainment, humour, stimulation and beauty. A twenty minute
film was produced and has been invaluable for promoting the orchestra abroad.
The promoters immediately offered us another concert for November in Cardiff,
and I am sure everyone who was there will agree it was a successful event. A
recording of the concert (by Bob Woolford) had a certain magic quality never
heard before on a Sinfonia tape. There were no problem is producing
"Hallelujah -the Portsmouth Sinfonia at the Royal Albert Hall"(TRA 285)

It was impossible to imagine following the Albert Hall with another
concert in Britain for some time, and in the weeks following there was movement
on another front. Transatlantic had licensed the first record to Columbia
Broadcasting System in the United States. They were planning to release it

in October. Martin Lewis and I received an invitation to the CBS Convention
in Los Angleses. A short film made at the Mermaid Theatre was used for
the Portsmouth's presentation at the convention, and caused much interest.
After the week in Los Angleses we went to New York and met endless CBS
record men and discussed ideas for putting on a Sinfonia event in America.
We recommended that the only way to present the Sinfonia in the US. would be
to do a Carnegie Hall Concert and a mammoth publicity routine similar to
the Albert Hall project. Columbia, being the largest record company in the
world, were totally unable to materialise these ideas. No individual in
the company was able to free themselves from the bureaucracy and give the
Sinfonia the special treatment that it needs. Six weeks after the first
visit they invited us back (this time with John Farley) to do promotion.
We visited five cities in six days and did about twenty campus radio stations.
The response was good, but in many ways this was a wasted effort as the area
that became aware of the Sinfonia was limited to North east universities.
This promotion was not followed up with any publicity or offers to tour the
orchestra, and communications with CBS since the visit have been very few.
Recently we heard that they were not releasing the Hallelujah record. But
Nat Joseph, Managing Director of Transatlantic is confident of a more energetic
and suitable record company putting it out in the US. News has arrived of
extensive interest from South Africa and Australia, where Spike Milligan
had been using the record on a tv series he was doing. The records have been
released in all the European countries where Transatlantic have connections-
Germany, Sweden, Italy, Holland and France.
 One more concert was done in Britain during 1974, in Wales in fact.
It was at the New Theatre in Cardiff on 24th November, and being the first
since the Albert Hall one might have felt it would be an anticlimax. But
the concert produced, unlike the Albert Hall, a few vintage Sinfonia moments
Times when the complete audience and orchestra can enjoy the unexpected.
We presumed that the Sinfonia was completely unknown in Wales, eventhough
a few members of the orchestra come from the city, and on the Friday before
the concert Martin Lewis, John and I went to Cardiff. We did three radio
interviews and a television scoop which was very enjoyable. Simultaneously
John and I recorded interviews for local BBC Nationwide and local ITV Today
programmes. They were shown that evening within minutes of each other, and
we were able to sit in the tv lounge at the Beeb and watch them both .
The effect of these coupled with photos and articles in all the local news-
papers meant a satisfactory audience and an enjoyable concert. Some young
girls came to the stage door after to try and catch a glimpse of the conductor
and have since sent fan letters to John and have started a Sinfonia fan club
in Wales. The year ended with the release of "Hallelujah" on 28th November
exactly six months after the concert, and made an interesting double for
Brian Eno who has help the Sinfonia greatly with the production of both
records. It meant for him that he made two live albums in a week. Three days
after the Albert he played at the Rainbow with Kevin Ayres and friends.

 It will be impossible for 1975 to be better than 1974, as in many ways
the Sinfonia has done most of the things it is capable of. We hope that
1975 will see the orchestra travelling overseas to Europe and maybe the States.
Also more concerts in England will happen. I would like to thank all the
members of the orchestra for the help in making arrangements easy at concerts
and all those who found members for the choir, and we all looking forward
to the next meeting - keep practising.

February 1975 Robin Mortimore

228 Elmhurst Mansions
Elmhurst Street
London SW4 01-622 7945

7th Feb 1975

Before starting our "World Tour" in Paris on 28th February 1975,
the Portsmouth Sinfonia has been invited to play a charity concert
in the chapel of WANDSWORTH PRISON, Heathfield Rd., S.W. 18

This will be the one meeting before Paris and all those travelling
must attend. If you cannot please ring 01-622-7945 before Thursday
20th February

The date of the WANDSWORTH PRISON CONCERT is SUNDAY 23rd FEBRUARY
Check own travel arrangements as there is no nearby tube, but there
are buses.
We will meet opposite the main gate at 11.45am, where a photo-call
for national papers will be held. Also at this time a complete list
of players must be handed to the Prison Authorities. For obvious
reasons people will not be allowed entry to prison unless on orchestra
list. If you are going to arrive late please notify me before Thursday
20th February. After photo-call we will adjourn to the pub for lunch
before playing at 2,00pm.
At this meeting the exact travel details for the following weekend will
be announced,

Her Majesty's Prison Authority is very appreciative of the Portsmouth
Sinfonia for playing at the prison.

best wishes

Robin Mortimore

228 Elmhurst Mansions
Elmhurst Street
London SW4 01-622 7945

19th Feb 1975

Dear Suzette

 thanks for your letter. It is very disappointong but
the promoter in Paris has back out at the last moment and the
Trip has been cancelled yet again. It is no way the fault of
the Sinfonia or Transatlantic, and we are all very annoyed.
- and so much time has been wasted. I am writing this letter
especially to you as it might effeet your other arrangements

Do please come for the prison concert hope to see you

 love

228 Elmhurst Mansions
Elmhurst Street
London SW4 01-622 7945

23rd Feb 1975

IT IS WITH GREAT DISAPPOINTMENT THAT I HAVE TO REPORT THAT THE
PROPOSED TRIP TO PARIS NEXT WEEK HAS BEEN CANCELLED YET AGAIN
BECAUSE THE PROMOTER IN PARIS HAS SEEN FIT TO BACK OUT AT THIS LATE
TIME. I APOLOGISE FOR ANY INCONVENIENCE THAT THIS HAS CAUSED AND
I HOPE THAT YOU SHARE OUR ANNOYANCE AT THE INCONSIDERATE BEHAVIOUR
OF THE PROMOTER. THE TIME THAT I AND TRANSATLANTIC RECORDS HAVE
WASTED IN TRYING TO SECURE THIS DATE OVER THE LAST FEW MONTHS
HAS BEEN ENORMOUS; AND IN NO WAY ARE THE PORTSMOUTH SINFONIA
OR TRANSATLANTIC RECORDS TO BLAME FOR THIS CANCELLATION.
THIS IS THE SIXTH TIME THAT A DATE HAS BEEN FIXED AND THEN CANCELLED
BUT NEVER AS MUCH PREPARATION HAD BEEN DONE IN THE PREVIOUS CASES.
WE HAVE NOW CEASED ALL NEGOTIATION WITH THE PARIS PROMOTER.

Robin Mortimore

DISCOGRAPHY

"The commercial recordings became definitive versions of each piece, but since we unashamedly used the popular classic as our point of reference, this seemed appropriate. Also they had commercial value—people liked them, not a lot though! Some purists saw this as opportunistic and not 'politically correct,' even though that expression wasn't much in circulation in the early seventies.

At the Sinfonia's early performances, the audience was not expecting what they got and that was wonderful. That changed as audiences became more exposed to us. Some pieces were just uniquely beautiful—as unaccustomed fingers struggled for notes, for instance, and tempos varied considerably and the conductor failed to begin or end a piece. Maybe the next piece would just be hilarious, as the orchestra attempted the majesty of Beethoven's *Fifth Symphony*. A piece might then become so unrecognizable that the audience would be left bewildered. By the time of the Royal Albert Hall performance, the audience knew what was coming and that produced moments when they were too ahead of events, like laughing before the punch line. There were obvious cultural connections, too, for example: following the release of Stanley Kubrick's *2001: A Space Odyssey*, 'Also Sprach Zarathustra' became a space anthem. Our version would often find representation as the heroic failure of a symbolic space launch."

Robin Mortimore, Liner Notes from *The Best/Worst of the Portsmouth Sinfonia* (Australian repackage of *Plays the Popular Classics*, Transatlantic Records, 1977).

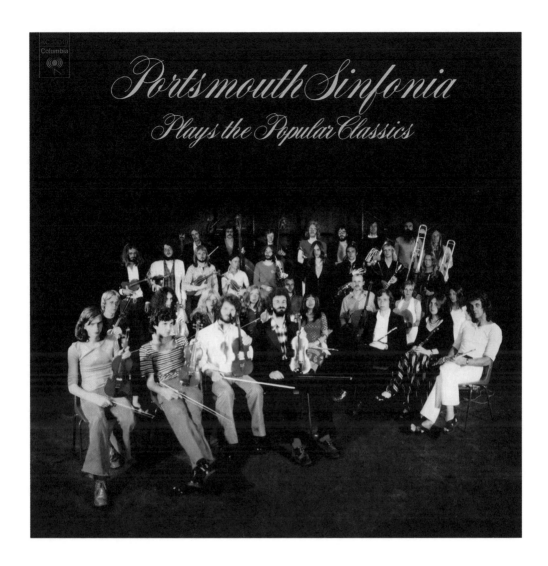

Portsmouth Sinfonia Plays the Popular Classics
LP (Transatlantic, 1973)
Produced by Brian Eno

Side One
1 From *Peer Gynt Suite No. 1*: "Morning" (Grieg)
2 From *Peer Gynt Suite No. 1*: "In The Hall Of The Mountain King" (Grieg)
3 From *The Nutcracker Suite*: "Dance Of The Sugar Plum Fairy" (Tchaikovski)
4 From *The Nutcracker Suite*: "Waltz Of The Flowers" (Beethoven)
5 *Fifth Symphony In C-Minor*, Op. 67 (Rossini)
6 *William Tell Overture* (Rossini)

Side Two
1 *Also Sprach Zarathustra*, Op. 31 (Strauss)
2 *Blue Danube Waltz*, Op. 314 (Strauss)
3 "Air," from *Suite No. 3 In D Major* (Bach)
4 "Farandole," from *L'Arlesienne Suite No. 2* (Bizet)
5 "Jupiter," from *The Planets*, Op. 32 (Excerpt) (Holst)

HALLELUJAH

THE PORTSMOUTH SINFONIA

CONDUCTOR JOHN FARLEY

AT

THE ROYAL ALBERT HALL

Hallelujah: Live at the Royal Albert Hall
LP (Transatlantic, 1974)
Produced by Brian Eno

Side One
1 *Mr. Michael Bond's Address*
2 From *Nutcracker Suite*, Op. 71a—March (Tchaikovsky)
3 From *Karelia Suite, Op. XI*—Intermezzo (Sibelius)
4 *Marche Militaire in D-Major* (Schubert)
5 *Piano Concerto No. 1 in B-Flat Minor*, Op. 23 (Tchaikovsky; soloist: Miss Sally Binding)

Side Two
1 *Overture 1812* (Tchaikovsky)
2 *William Tell Overture* (Rossini)
3 From *Messiah* (Part II)—*Hallelujah Chorus* (Handel) with The Portsmouth Sinfonia Choir

20 Classic Rock Classics
LP (Philips, 1979)
Produced by Martin Lewis

Side One
1 *Pinball Wizard* (Townsend)
2 *Apache* (Lordan)
3 *Leader Of The Pack* (Morton/Barry/Greenwich)
4 *A Whiter Shade Of Pale* (Reid/Brooker)
5 *You Really Got Me* (Davies)
6 *Uptown Top Ranking* (Thompson/Gibbs/Forrest/Reid)
7 *Glad All Over* (Clark/Smith)
8 *Heartbreak Hotel* (Axton/Durden/Presley)
9 *Telstar* (Meek)
10 *Bridge Over Troubled Water* (Simon)

Side Two
1 *Nut Rocker* (Fowley)
2 *Don´t Cry For Me Argentina* (Webber/Rice)
3 *(We´re Gonna) Rock Around The Clock* (De Knight/Freedman)
4 *You Should Be Dancing* (Gibb)
5 *It´s Only Make Believe* (Twitty/Nance)
6 *Nights In White Satin* (Hayward)
7 *My Boy Lollipop* (Roberts/Spencer)
8 *God Only Knows* (Wilson/Asher)
9 *(I Can´t Get No) Satisfaction* (Jagger/Richard)
10 *A Day In The Life* (Lennon/McCartney)

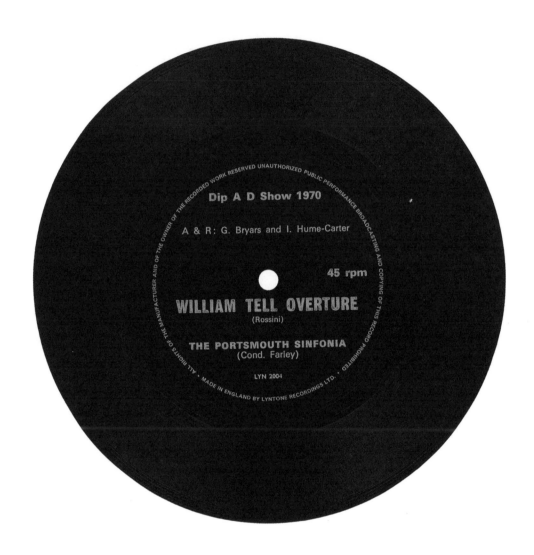

The William Tell Overture
7" flexi-disc (self-released, 1970)
Produced by Gavin Bryars and Ivan Hume-Carter

An Der Schönen Blauen Donau/Also Sprach Zarathustra
7" single (Transatlantic, 1974)
German release

Classical Muddly
7" single (Springtime, 1981)
Produced by Martin Lewis

Classical Muddly
7" single (Island, 1981)
Produced by Martin Lewis

AN EXPANDED CHRONOLOGY OF THE PORTSMOUTH SINFONIA

1962

Festival of Misfits, a two-week concert of Fluxus events and performances, is held at London's Gallery One, October 23–November 8.

1963

An Anthology of Chance Operations, edited by La Monte Young and designed by George Maciunas, is released.

As part of *The Little Festival of Music* at Goldsmiths College, Cornelius Cardew organizes a Fluxus concert.

Derek Bailey, Gavin Bryars, and Tony Oxley form the free-improvising ensemble, Joseph Holbrooke.

1964

American composer Terry Riley's *In C*, an early minimalist composition arranged for an indefinite number of players, is first performed by Steve Reich, Jon Gibson, Pauline Oliveros, and Morton Subotnick, at the San Francisco Tape Music Center.

The artist Henry Flynt pickets Karlheinz Stockhausen's performance of *Originale* at Charlotte Moorman's *Annual Avant Garde Festival of New York*, causing rifts among experimental and Fluxus artists.

1965

George Brecht leaves America for Europe.

The Spontaneous Music Ensemble (SME) is formed by British drummer John Stevens and saxophonist Trevor Watts. Future iterations of SME include Sinfonia member Nigel Coombes.

The performance artist Robin Page begins teaching at Leeds College of Art.

1966

The Canterbury-based band Soft Machine is formed.

UC Davis music teacher Larry Austin, along with his students Stanley Lunetta, Dary John Mizelle, Wayne Johnson, and Art Woodbury, sends out 5,000 invitations to new music composers and performers to contribute texts, scores, and documentation to a publication compendium. This eventually becomes *The Source: Music of the Avant Garde*, which runs for 11 issues, from 1967 to 1973.

George Brecht begins teaching at Leeds College of Art.

Cornelius Cardew joins the free improvising ensemble AMM, with Keith Rowe, Eddie Prévost, Lou Gare, and Lawrence Sheaff. AMM releases its debut record, *AMMusic* (Elektra Records).

Gustav Metzger and James Sharkey's *Destruction in Art Symposium* is held at the Africa Center in Covent Garden, London, September 9–11. Performances, lectures, and activities are presented by Yoko Ono and Raphael Ortiz, among others. Future Sinfonia member and sculptor Barry Flanagan constructs a giant sandcastle to be destroyed.

1968

Michael Nyman begins his career as a music critic, writing for the *Spectator*.

Soft Machine's eponymous album, *The Soft Machine* (Probe Records), is released.

The *Experimental Music Catalogue* (EMC) is founded by Christopher Hobbs, with the goal of providing an outlet for new music by composers from the English experimental movement, including Gavin Bryars and Michael Nyman, both of whom become central figures in the development of the EMC.

Cornelius Cardew begins teaching a course in experimental music at Morley College, an adult educational institution in South London. Michael Parsons and John Cale are among his students.

John White premieres his early repetitive minimalist composition, *Cello and Tuba Machine*.

▪ Indicates a performance by the Portsmouth Sinfonia

Future Sinfonia producer Victor Schonfield launches the *Music Now* concerts, with a series of four concerts, entitled "Sounds of Discovery."

1969

The Scratch Orchestra, a roving British ensemble of trained and untrained musicians, is founded by Cornelius Cardew, Michael Parsons, and Howard Skempton, in part, for the purpose of interpreting Cardew's opus, *The Great Learning*.

Soft Machine's *Volume Two* is released, featuring an introduction from Robert Wyatt, which labels the band "the official orchestra of the College of Pataphysics."

Sinfonia member Tom Phillips completes the score for his experimental opera *Irma*.

In collaboration with George Brecht, the Scratch Orchestra perform their first research project, "Journey of the Isle of Wight Westwards by Tokyo Bay," at Chelsea Town Hall.

1970

▪ May 7: Portsmouth College of Art, Hyde Park Road. First performance; part of *Opportunity Knocks*, arranged by Maurice Dennis.

▪ September 25: Purcell Room, Royal Festival Hall, London. *Beethoven Today Concert*, arranged by Michael Parsons.

▪ October 9: Concert at Portsmouth College of Art.

▪ December 2: Concert at Portsmouth Arts Workshop.

Gavin Bryars composes an early iteration of *The Sinking of the Titanic,* while working at Portsmouth School of Art.

Brian Eno is intermittently involved with the Scratch Orchestra, appearing on the Deutsche Gramophone recording of Cardew's *The Great Learning*.

Gavin Bryars leaves the Portsmouth School of Art at the end of the year for a senior lectureship at Leicester Polytechnic's Department of Fine Art; he is replaced by Michael Parsons and John Tilbury.

Visiting professor Noel Forster gives a lecture at the Portsmouth School of Art entitled "The Painting as a Measure of Its Own Performance" in which he describes ways in which error and deviation from a planned program contributed to his painting practice.

Brian Eno joins the British pop group Roxy Music.

Jeffrey Steele steps down as department head of Portsmouth College of Art.

The Promenade Theatre Orchestra (PTO) forms; its core membership consists of Alec Hill, Christopher Hobbs, Hugh Shrapnel, and John White. The PTO compose and perform primarily on toy pianos and reed organs.

1971

▪ January 26: Great Hall, Reading University. *Two Day Opportunity* event, arranged by Clive Robertson.

▪ January 27: Slade School of Art, London University, in support of the Campaign Against Museum Admission Charges.

▪ February 24: South Parade Pier, Portsmouth. Festival Hall with the Keef Hartley Band, Groundhogs, and the Spirit of John Morgan. Arranged by Portsmouth Polytechnic Students' Union.

▪ March 23: Newport College of Art, Wales. Arranged by Stuart Marshall.

▪ May 17: Bishop Otter College, University of Chichester. Arranged by Dick Beckett for the Chichester College Festival.

▪ May 25: Chelsea College of Arts, London. Arranged by Ian Southwood.

▪ June 12: Radical Arts Festival, University of Sussex, Brighton, part of the Radical Arts Festival.

▪ June 25: Portsmouth College of Art, with Satisfaction and Duffy Power.

▪ July 6: Diploma Ball at Bromley College of Art, Ravensbourne University London. Arranged by David Bowyer.

▪ August 7: Royal Tunbridge Wells, Sussex. Harmony Farm, an open-air free concert at Whitehouse Farm, with Brinsley Schwarz and Open Road.

• October 29: Kent University, Canterbury, in association with the New Moon Pornophonic Dada Society. Arranged by Roger Hewitt.

• November 13: Portsmouth Polytechnic Students' Union.

The first recording made by the Sinfonia, a flexi-disc of Rossini's *The William Tell Overture*, is sent out as an invitation for the Portsmouth School of Art's degree show.

The Ross and Cromarty Orchestra perform for the first time at Portsmouth Art College.

Steve Reich visits London, and by invitation from Gavin Bryars, plays versions of his *Four Organs and Phase Patterns* for the first time in the UK. According to those present, Reich was nonplussed when Bryars played the Sinfonia's recording of *The William Tell Overture* for him.

1972

• March 14: Moorgate London Union Hall, City of London Polytechnic University, with the Chris Macgregor Jazz Band.

• May 27: Cleveland Circus Bath. *The Other Festival*, arranged by Bath Arts Workshop, with the Ross and Cromarty Orchestra.

• June 22: Goldsmiths, University of College London. Cohesion, arranged by Nigel Rollings.

• August 26: Roundhouse, London. *ICES-72*, arranged by Harvey Matusow.

• November 21: Gulbenkian Hall, Royal College of Art, London. Arranged by Clifford Rainey.

• December 2: Global Village, London. Under the Arches.

• December 11: Queen Elizabeth Hall, London, with Gavin Bryars and the Music Now Ensemble.

The Ross and Cromarty Orchestra perform at the Portsmouth College student occupation on the lawn of the Havelin House. Soon after, they embark on a Highland tour of Scotland.

Sinfonia members Robin Mortimore and James Lampard move to London, determined to keep up the momentum of the ensemble.

Founding Sinfonia member Ivan Hume-Carter leaves the ensemble.

The Ross and Cromarty Orchestra break up following their Highland tour.

1973

• January 5: Studio 6, BBC TV Centre. "Omnibus File" recording for broadcast at 10:20 p.m. The Sinfonia is introduced by DJ and tastemaker John Peel. This performance marks the ensemble's first television appearance.

• March 24: Bedford Square, London. Architects' Association Annual Party, arranged by Paul Davis.

• July 7: St John's Hall, Wimbledon. First recording session with Bob Woolford Sound (BWS).

• July 8: Museum Gardens, York. York Arts Festival, with Roxy Music and Lloyd Watson.

• August 4: Television Studio at Royal College of Art, London. Second recording session with BWS.

• August 11: Art Film Studio at Royal College of Art, London. Third recording session with BWS.

Portsmouth Sinfonia Plays the Popular Classics is released by Transatlantic.

The Visual Research Ensemble is active at Portsmouth Polytechnic from 1972–1973. As described in Michael Parson's *The Scratch Orchestra and Visual Arts*, the group performed "(mainly) silent pieces, including *Looking Piece*, derived from a passage in Beckett's novel *Watt* . . . and *Wittgenstein Walk*, in which three performers walking in an open space represent the relative motions of the sun, earth and moon."

The cult British band Deaf School is founded, featuring Sinfonia flautist Clive Langer on guitar. Langer would later go on to become a notable record producer, working with David Bowie, Madness, and Dexy's Midnight Runners, among others.

Members of the Ross and Cromarty Orchestra form The Majorca Orchestra, who perform intermittently throughout the 1970s.

"What's that row?" " That's only my
ther, he's practising. Oh my brother
kes the noises for the talkies . . ." The
nd of the Portsmouth Sinfonia
inded some of us of that famed
oduction to one of the Bonzo Dogs'
st hits. The orchestra that murders
he William Tell Overture " amongst
er items in its repertoire can inflame
sions among those who think they are
er " funny " or " appalling."

PORTSMOUTH SINFONIA:
" William Tell Overture "
(Transatlantic). Brian Eno's
horrific production, which
my respected colleague
Steve Lake tells me is
" marvellous." Here we beg
to differ. In my view, all
those taking part should be
forced to send donations to
Rossini's descendents and
if they persist in this appal-
ling mockery, then their in-
struments should be taken
away and snapped into seve-
ral pieces. Peter Schikle has
done all this before, but his
work was both funny and
clever.

ROLL OVER, BEETHOVEN!
—Page 13

Extract from **Portsmouth
infonia** handout: "One of the
rchestra was caught practicing
ut was, of course, asked to
ave" . . . **Slack Alice** OK, says
ME's roving **Neil Spencer**,
rooling visibly over lady singer
. . **Kiki Dee's** new single
'Hard Luck Story") on
ocket penned by a certain

HOME-SPUN THOUGHTS ON RHYTHM, HARMONY

 Brodie's Close,
Lawnmarket.
Ross and Cromarty
Orchestra.

If your taste is for music
with rock-bottom simplicity
of harmony and ryhthm,
perhaps you should go
some lunchtime to Brodie's
Close in the Lawnmarket,
where you might enjoy
hearing the Ross and
Cromarty Orchestra. It is
composed of three violins,
a piano, three woodwind,
some percussion, and a
" red flag piano," a very
quiet instrument, more
political than musical,
whose effect is largely
visual.

HUMOUR

The style of the players
has all the stolidity of a
barrel organ but more
humour, and entirely suits
their repertoire of home-
made waltzes, songs and
other items.

The highlight is a short
opera with an innocent
Maoist message called "The
Foolish Old Man Who
Removed The Mountains,"
and the performance ends
with a few rousing choruses
of " Mao Tse Tung
Thought."

Inhabitants of Dingwall
and elsewhere will have an
opportunity of hearing this
" joy to the ear," as the
playbill calls it, during the
orchestra's Highland tour
early next month.

D. C. H.

The worst orchestra in the world gets its very own Prom

PLAYING IT BY EAR

ABOUT to go on record as the world's most bizarre -orchestra is the Portsmouth Sinfonia.

Few of its members can read music.

Others can't tell a fiddle from a flute.

The conductor was chosen because he has trouble playing an instrument.

An unusual composition who have scaled new musical heights and depths and are noted for discordant renderings of popular classics.

"We play by the same rules as the London Philharmonic," says John Farley, the 25-year-old conductor. "The only difference is the sound."

The music makers. in jeans and tee-shirts, are taking a bash at their most ambitious performance yet: A concert at London's Mermaid Theatre on Sunday.

Comedy Album of the Year
Portsmouth Sinfonia Plays the Popular Classics

Most Unnecessary Album of the Year
Creedence Clearwater Revival Live in Europe

Most Unnecessary Album, Runner-up
Having Fun with Elvis on Stage, an album comprised totally of Presley's between-numbers wit.

PORTSMOUTH SINFONIA: *"William Tell Overture/Blue Danube Waltz" (Transatlantic)* Everett: That's the greatest record I've ever heard. It's funny, naturally funny. Brilliant. Cash: These guys can't do anything. Can't play. Right on, there's a chance for us yet. E: I think that will be played to their friends .."Hey Jack! Listen to this ..." I don't think it'll be played at stoned raves. Maybe once to start the party off. C: Has the same sort of sound as Spike Jones. E: I love it. C: We're very tired today. It's going to be incredible boring for the readers because we're so blanged. E: We've been electioneering.

Others are on March 11, 13, 14 and 15.
PORTSMOUTH SINFONIA: Mermaid Theatre, Puddle Dock, London EC4. At last, the first completely non-musical ork. None of these guys, can you believe, actually know how to play their instruments. "Also Sprach Zarathustra" and "The William Tell Overture" positively bizarre. Should be a very, ahh, weird evening.
CLEO LAINE, JOHN DANK

Brian Eno releases his first solo record post-Roxy Music, *Here Come the Warm Jets* (Island Records).

The Sinfonia sign with eclectic British label, Transatlantic Records. Transatlantic's Martin Lewis becomes their manager.

The Majorca Orchestra perform with the Clapham Old People's Choir, Sidney Powsey's Accordions, and a demonstration of "Keep Fit for Retired People" at the *Grand Variety Concert* in Lambeth.

Brian Eno tells *Sounds'* Steve Peacock of his plans to record a compilation album, *Hysterical Hybrids and Musical Mutants,* featuring the Majorca Orchestra. This never comes to fruition.

The Sinfonia write to the BBC requesting a Promenade concert spot at the Royal Albert Hall. When their request is denied, the ensemble book the venue on their own.

1974

▪ March 8: BBC Lime Grove Studios. Live performance on BBC One.

▪ March 10: Mermaid Theatre, London. Solo concert promoted and co-arranged by Transatlantic Records and Charisma Agency.

▪ May 28: Royal Albert Hall, London. Solo concert promoted by Derek Block, in association with Transatlantic Records.

▪ November 24: New Theatre Cardiff, Wales. Co-arranged by Derek Block Promotions and the New Theatre.

Hallelujah: The Portsmouth Sinfonia at the Royal Albert Hall is released by Transatlantic.

The Sinfonia is featured in Alfons Sinninger's short documentary film, *Eno.*

Cornelius Cardew publishes *Stockhausen Serves Imperialism* (Latimer New Dimensions), his polemic Maoist critique of Karlheinz Stockhausen and John Cage.

The Scratch Orchestra effectively dissolve due to political rifts within the ensemble, formally changing its name to the Red Flame Proletarian Propaganda Team.

Brian Eno's Taking Tiger Mountain (By Strategy) (Island Records) is released. The album's "Put a Straw Under Baby," which features Eno sharing vocal duties with Robert Wyatt, also includes the Sinfonia's string section.

Martin Lewis and Robin Mortimore, representing the Sinfonia, attend CBS's annual Records Convention in Los Angeles.

Rolling Stone awards *The Portsmouth Sinfonia Plays the Popular Classics* "Comedy Album of the Year," along with a one-star review.

The Majorca Orchestra evening class begins at the Clapham and Balham Adult Education Institute.

Michael Nyman publishes his influential book of criticism, *Experimental Music: Cage and Beyond* (Schirmer Books). The Portsmouth Sinfonia is included in Nyman's chapter "Minimal music, determinacy and the new tonality."

1975

▪ February 23: HM Prison Wandsworth, London. Charity performance for prisoners.

Brian Eno, spending less and less time in England, no longer plays a consistent role in the Sinfonia.

Sinfonia violinist Nigel Coombes, bassist Angus Fraser, and trumpet player Chris Turner appear on the Spontaneous Music Ensemble's LP *SME + = SMO.*

Brian Eno launches his Obscure record label with the intention of bringing experimental music to a wider audience. Gavin Bryars's *Jesus' Blood Never Failed Me Yet* is Obscure's first release.

Brian Eno is struck by a taxi and spends several weeks recovering at his home. Shortly after the accident, he records his first ambient work, *Discreet Music*, which he self-releases on Obscure.

Obscure releases two other albums in 1975: *Ensemble Pieces* by John Adams, Christopher Hobbs, and Gavin Bryars, along with *New and Rediscovered Musical Instruments* by David Toop and Max Eastley.

The London Musician's Collective (LMC) is founded. Membership includes Sinfonia trumpeter Steve Beresford.

The LMC publishes the first issue of *Musics*, a magazine dedicated to covering free improvisation.

1976

Derek Bailey starts the free improvisation band, Company.

The omnivorously experimental New Wave act the Flying Lizards is formed, with Sinfonia members Steve Beresford and Dave Cunningham among its ranks.

The Michael Nyman Band is formed for a production of Carlo Goldoni's *Il Campiello*. The group soon after embarks on an eleven-film collaboration with the British filmmaker Peter Greenaway.

Music from the Penguin Cafe, the first album by the Penguin Cafe Orchestra, is released on Obscure, as are *Voices and Instruments* by saxophonist Jan Steele and composer John Cage, and *Decay Music* by Michael Nyman. Sinfonia trumpeter Steve Beresford and Sinfonia flautist Utako Ikeda perform on *Voices and Instruments*.

Jeffrey Steele's "Collaborative Work at Portsmouth" is published in the November/ December issue of *Studio International*, guest edited by Michael Nyman.

The Slits are formed by Viv Albertine, Palmolive Tessa Pollit, and Ari Up.

The final Music Now concerts, "Festival of Free Music," are held, with performances from Sinfonia members Nigel Coombes and Steve Beresford.

1977

Company Weeks, a series of annual week-long improvisational festivals organized by Derek Bailey, runs from 1977 until 1994.

Sinfonia viola player and classically trained violinist Neil Watson plays with the London Symphony Orchestra on John Williams' theme to *Star Wars*.

1978

The Best/Worst of the Portsmouth Sinfonia is released in Australia, a repackaged reissue of 1974's *The Portsmouth Sinfonia Play the Popular Classics*.

1979

▪ October 6: Rainbow Theatre, London. *Classic Rock Classics* concert.

The Sinfonia release *Classic Rock Classics*, an album of pop hits, from "Pinball Wizard" to "Don't Cry For Me Argentina." Michael Nyman plays piano on the recording of "Bridge Over Troubled Water."

The Sinfonia appear on an especially surreal episode of German television (the details of which cannot be found) performing the song "Apache" by the Shadows.

The Flying Lizards' cover of Barrett Strong's "Money" charts in both the UK and the US, peaking at number 5 in the UK and at number 50 on the Billboard Hot 100.

Sinfonia violinist Stephen Luscombe co-founds the synth-pop group Blancmange with Neil Arthur. Their song "Living on the Ceiling" reaches No. 7 on the UK charts.

1980

▪ October 28: RTE (Radio France) Concert Hall, Paris, as part of *Atelier de creation radiophonique*. John Farley and leaders of each section of the Portsmouth Sinfonia rehearse for three days with around fifty local musicians for the final "classical" concert performed by the Sinfonia.

1981

The Portsmouth Sinfonia effectively ceases performing.

The Sinfonia's *Classical Muddly/Hallelujah Chorus* single is released on Springtime Records.

Sinfonia trumpet player Steve Beresford plays on the Slits' *Return of the Giant Slits* LP and with the Raincoats' Vicky Aspinall on Vivien Goldman's "Lauderette/Private Armies."

Cornelius Cardew is killed in a hit and run accident.

1982

The Sinfonia appear as a topic on the Jack Palance-hosted *Ripley's Believe it Or Not?* television series.

1983

James Lampard's composition "The Caterpillar" is included on *Audio Arts Volume 3, Number 2: Recent English Experimental Music*.

1984

Sinfonia cellist Sue Evans wins the National Academy of Recording Arts and Sciences "Most Valuable Performer" award for percussion. She would go on to win the award again in 1984, 1987, and 1989.

1988

Sinfonia flautist Ann Shrosbee makes animal noises on Adrian Wagner's *Merak* LP.

1993

Selections from *The Portsmouth Sinfonia Plays the Popular Classics* are included on *Dead Parrot Society*, a compilation of British comedy. The album includes tracks by Dudley Moore and Monty Python.

CoMA (Contemporary Music for All) is established to encourage and provide opportunities for amateur musicians of all abilities to take part in contemporary music-making in the United Kingdom.

1994

The broadcast of a short film celebrating the Sinfonia is cancelled at the last minute by the BBC, following pressure from the Bournemouth Symphony Orchestra, who fear the public might confuse the two ensembles.

2009

The Sinfonia's rendition of "Also Sprach Zarathustra" becomes a meme as "Orchestra Fail," with three million views on YouTube.

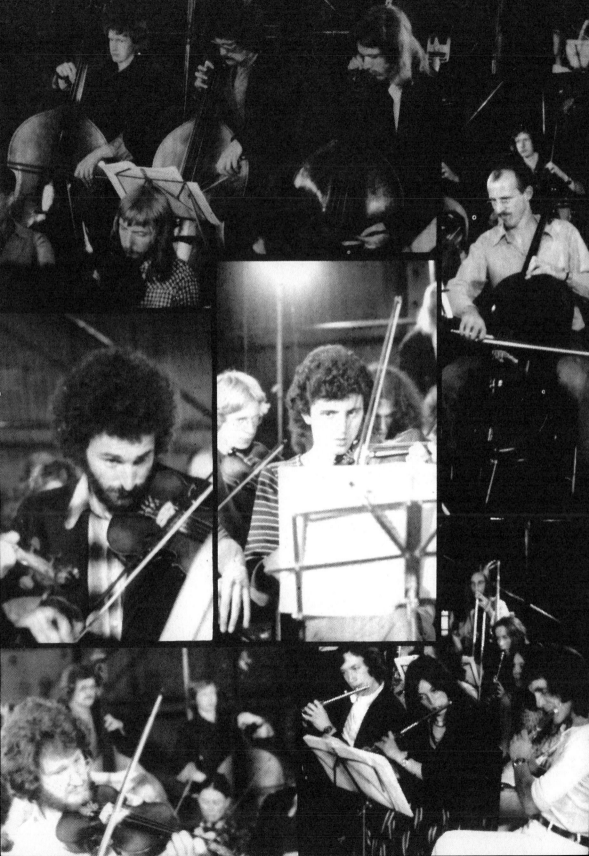

AN INCOMPLETE LIST OF PORTSMOUTH SINFONIA MEMBERS

Jennifer Adams
Jill Adams
Linda Adams
Patrick Allen
Michael Archer
Sue Astle
Phillip Austin
Peter Beresford
Steve Beresford
Hazel Bertram
Alvin Betteridge
Peter Best
Paul Beven
Sally Binding
Michael Bond
Ted Brum
Bruce Buckingham
Paul Buckton
Gavin Bryars
Robert Carter
Martin Champman
Alan Clayson
Peter Clutterbuck
Russell Coates
Nigel Coombes
Simon Dale
Maurice Dennis
Jackie Duckworth
Richard Ellin
Gerry Ellis
Brian Eno
Sue Evans
John Farley
Susan Featherstone
Gwen Fereday
Luc Ferrari
Simon Fisher-Turner
Barry Flanagan
Michael Flower
Noel Forster
Janet Fox
Angus Fraser
David Gale
James Gregg
Gary Gunby
Denise Hanson
William Hodgson

Nicky Holford
Printz Holman
Mark Hughes
Ivan Hume-Carter
Utako Ikeda
Maurice Joyce
Martin Kenny
Michaela Kenyon
Stefan Klima
James Lampard
Clive Langer
Dirk Larson
John Lawrence
Beverly Legge
Janet Lowe
Stephen Luscombe
Jeremy Main
Rachel Maloney
Chris Marriott
John McPherson
John Mitchell
Imogen Morley
Nigel Morley
Pip Morrison
Robin Mortimore
Pamela Niblett
John Nichols
Michael Nyman
Caroline Osbourne
Jackie Palman
Michael Parsons
Tom Phillips
Alex Potts
Tosh Potts
Stephanie Prichard
Tom Puckey
Rae Quirke
Clive Richardson
Gary Rickard
Adrian D. Rifkin
Sally Ridgway
Gioachino Rossini
Piers Rowlandson
Charles Russell
Marilyn Ryan
John Ryder
Christiane Sasportas

Noelle Sasportas
David Saunders
Savva Savva
David Sawyer
Stuart Semark
Ann Shrosbree
Christine Shrosbree
Andrew Smith
Cherril Smith
Deborah Smith
Christine Sobey
Ian Southwood
Barry Sparshott
Yvonne Spencer
Kate St. John
Jeffrey Steele
Mick Steele
Tamara Steel
Richard Strange
Robert Swales
Peter Swales
Tony Talbot
Alan Tomlinson
Andrew Tomsett
Joyce Trenherz
Susan Tunnicliff
Chris Turner
Joy Wadsworth
Niel Watson
Brian Watterson
Philip Wells
Barry Wills
Bob Woolford
Phil Woods
Maggie Wooton
Suzette Worden
Richard Wulliamy
Felicity Wyatt
Brian Young

Opposite: Page from a Portsmouth Sinfonia promotional booklet produced by Transatlantic Records, 1973. Courtesy of Suzette Worden.

ACKNOWLEDGMENTS

Our heartfelt thanks go out to the members of the Portsmouth Sinfonia, especially Gavin Bryars, Robin Mortimore, David Saunders, Ian Southwood, Jeffrey Steele, Suzette Worden, and publicist/manager Martin Lewis, for their invaluable contributions and candor. Suzette Worden, member and the de facto archivist for the ensemble, has also provided the majority of the photographs, scores, and correspondences reproduced in this book. We are so grateful.

Additional thanks go to Virginia Anderson and Christopher Hobbs at *Experimental Music Catalogue*; Richard Ascough, for sharing his archives with us; Scratch Orchestra members Bryn Harris, Michael Parsons, and Stefan Szczelkun, for generously responding to emails and aiding in locating materials; Anne Gerrish, who went out of her way to find an obscure 1970s article for us at the *Time Out London* archives; Anna Delaney at the Portsmouth College of Art archives, Rosemary Grennan at Mayday Rooms, photographer Doug Smith, and Simon Steele. Thanks to the Hafter Family Foundation for their support of this publication in honor of Joshua Rubin.

We would also like to thank Simon Anderson, Elise Archias, Ionit Behar, Lizzy DuQuette, Mark Harris, Hannah B Higgins, Colleen Keihm, Julia Klein, Chad Kouri, Davi Lakind, Jon Lorenz, Kristi McGuire, Curtis Miller, Nicoletta Rousseva, Julia Vaingurt, Deborah Stratman, Lauren Sudbrink, Claudia Weber, and the Luminary St. Louis, for all of their support, edits, and encouragement.

This book is an expansion of the zine *Classical Muddly*, compiled and self-published by Christopher M. Reeves and Aaron Walker in 2015.

IMAGE CREDITS

Uncaptioned images:

p. 9: Review of "Portsmouth Sinfonia Play the Popular Classics" by Frank Rose, as published in the 1979 *The Rolling Stone Record Album Guide*. Copyright © *Rolling Stone* LLC, 1979. All rights reserved. Used with permission. **p. 38: (Top)** The Portsmouth Sinfonia performing at Portsmouth College of Art, Summer 1971. Photographer unknown. Courtesy of Suzette Worden. **(Bottom)** Concert for Diploma show at Portsmouth Polytechnic, July 1973. Photographer unknown. Courtesy of Suzette Worden. **p. 43: (Top)** The Portsmouth Sinfonia at Queen Elizabeth Hall, December 11, 1972. Photographer unknown. Courtesy of Suzette Worden. **(Bottom)** The Portsmouth Sinfonia at Queen Elizabeth Hall, December 11, 1972. Photographer unknown. Courtesy of Suzette Worden. **p. 48:** Poster advertising the Portsmouth Sinfonia at the Mermaid Theatre, Sunday, March 10, 1974. Courtesy of Suzette Worden. **p. 59:** Promotional poster for the Ross and Cromarty Orchestra, c. 1973. Courtesy of Suzette Worden. **p. 71:** Portsmouth Sinfonia promotional flyer advertising free copies of the *William Tell Overture* record, October 1971. Courtesy of Suzette Worden. **p. 79: (Top)** The Ross and Cromarty Orchestra playing on the lawn of the Ravelin House, Portsmouth Polytechnic, during the Occupation, 1972. Photographer unknown. Courtesy of Suzette Worden. **(Bottom)** The Ross and Cromarty Orchestra at Bath's *Other Festival*, 1972. Photographer unknown. Courtesy of Suzette Worden. **p. 80:** Letter from James Lampard, 1974. Courtesy of Suzette Worden. **p. 86:** Cover for a Portsmouth Sinfonia promotional booklet produced by Transatlantic Records, 1974. Courtesy of Suzette Worden. **p. 90:** Program for Mermaid Theatre performance, March 10, 1974. Courtesy of Suzette Worden. **p. 109:** Poster for concert at the Royal Albert Hall, 1974. Courtesy of Suzette Worden. **pp. 110–111:** The Portsmouth Sinfonia in concert at the Royal Albert Hall on May 28, 1974. Photograph © Doug Smith. **p. 132:** Transatlantic Records Royal Albert Hall backstage pass dated Tuesday, May 28, 1974. Courtesy of Suzette Worden. **pp. 133–135:** Program for Portsmouth Sinfonia at the Royal Albert Hall, Tuesday, May 28, 1974. Courtesy of Suzette Worden. **p. 139:** Class schedule at Portsmouth College of Art, Summer Term, 1973. Courtesy of Suzette Worden. **p. 149:** Program for concert by Michael Parsons and Howard Skempton, Portsmouth Polytechnic Department of Fine Art, February 5, 1976. Courtesy of Suzette Worden. **pp. 150–151:** Majorca Orchestra program, c. 1973. Courtesy of Suzette Worden. **p. 159:** Portsmouth Sinfonia promotional booklet cover produced by Transatlantic Records, 1973. Courtesy of Suzette Worden. **p. 168:** Page from a Portsmouth Sinfonia promotional booklet produced by Transatlantic Records, 1974. Courtesy of Suzette Worden. **p. 171:** Advertisements for the Portsmouth Sinfonia at the Royal Albert Hall, 1974. Courtesy of Suzette Worden. **pp. 183–189:** Program pages from *Music Now* performance featuring Gavin Bryars and the Portsmouth Sinfonia with John Tilbury and Derek Bailey. Queen Elizabeth Hall, London, December 11, 1972. Courtesy of private collection. **pp. 191–193:** Pages from *Experimental Music Catalogue*. Courtesy of Suzette Worden. Used with permission of *Experimental Music Catalogue*. **pp. 194–211:** Portsmouth Sinfonia correspondence. Courtesy of Suzette Worden. **p. 213:** *Portsmouth Sinfonia Plays the Popular Classics*, vinyl LP (Transatlantic, 1973). Used with permission of PortsmouthSinfonia.com. **p. 214:** *Hallelujah: The Portsmouth Sinfonia at the Royal Albert Hall*, vinyl LP (Transatlantic, 1974). Used with permission of PortsmouthSinfonia.com. **p. 215:** *Twenty Classic Rock Classics*, vinyl LP (Philips, 1979). Used with permission of PortsmouthSinfonia.com. **p. 216:** *William Tell Overture*, 7" flexi-disc (self-released, 1970). Courtesy of Suzette Worden. **p. 217:** *An Der Schönen Blauen Donau/Also Sprach Zarathustra*, 7" single (Transatlantic, 1974). Used with permission of PortsmouthSinfonia.com. **p. 218:** *Classical Muddly*, 7" single (Springtime, 1981). Used with permission of PortsmouthSinfonia.com. **p. 219:** *Classical Muddly*, 7" single (Island, 1981). Used with permission of PortsmouthSinfonia.com. **p. 223:** Press clippings, c. 1971–1974. Courtesy Suzette Worden. **p. 224:** Press clippings, c. 1971–1974. Courtesy of Suzette Worden. **p. 224 (Middle right):** "Comedy Album of the Year" designation from *Rolling Stone* (issue dated January 16, 1975). Copyright © *Rolling Stone* LLC, 1975. All rights reserved. Used by permission.